American Realism and the Industrial Age

American Realism

A THEMES IN ART BOOK

Published by The Cleveland Museum of Art
in cooperation with Indiana University Press

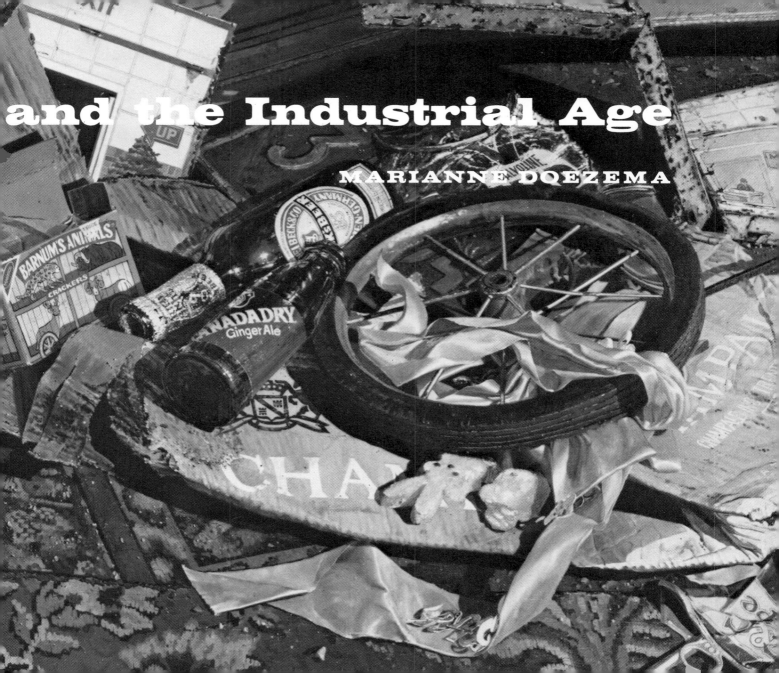

and the Industrial Age

MARIANNE DOEZEMA

Exhibition Schedule

Photographic Credits

Published with the support of
the National Endowment for the Arts

Front Cover:
Detail of **7** Thomas P. Anshutz,
Steamboat on the Ohio.

Back Cover:
21 Henry Reuterdahl,
Blast Furnaces, 1912.

Title Page:
Detail of Figure 20.
Idelle Weber, *Livery*.

The Cleveland Museum of Art
Cleveland, Ohio
November 12,1980 — January 18, 1981

Kenneth C. Beck Center
for the Cultural Arts
Lakewood, Ohio
February 18 — March 15, 1981

Columbus Museum of Art
Columbus, Ohio
April 11 — May 31, 1981

Geoffrey Clements: 27, 42a, 42b, 42c, 42d.
D. James Dee: 45; Figure 21.
eeva-inkeri: 17, 44.
Nicholas C. Hlobeczy: 6, 8, 9, 11, 12a,
12b, 13, 14, 15, 16, 23, 32, 33, 34, 35,
36, 38, 39, 40, 41, 46.
Martin Linsey: 18; Figure 10.
Michael Marlais: 10; Figures 9, 11, and
12.
Public Buildings Service, General Ser-
vices Administration: 19, 37; Figures
22a, 22b, 22c, and 22d.

Lenders to the Exhibition

The Brooklyn Museum
The Butler Institute of American Art
Museum of Art, Carnegie Institute
Cleveland Public Library
Columbus Museum of Art
Virginia Dehn
The Detroit Institute of Arts
Robert Lavin
Virginia E. Lewis
The Minneapolis Institute of Arts
New Jersey State Museum
Oshkosh Public Museum
The Pennsylvania Academy of the Fine
 Arts
The Putnam County Historical Society
National Collection of Fine Arts,
 Smithsonian Institution
Holly and Horace Solomon
The Toledo Museum of Art
Mr. and Mrs. Jerome M. Westheimer
Whitney Museum of American Art

Contents

Color plates follow page 32.

Acknowledgments

The exhibition American Realism and the Industrial Age and its catalog encompass an extensive period of American history and involve works of art from many different parts of the country. Considerable travel was therefore necessary to gain access to archival material and to study paintings and drawings pertaining to the industrial theme. Such an undertaking — and the transportation of objects utlimately selected for the show — was possible, to a great extent, because of federal funding. Financial assistance from the National Endowment for the Arts provided the opportunity not only to broaden the scope of the exhibition but also to expand its audience, permitting the show not only to take place in Cleveland, but to travel to other Ohio facilities: the Kenneth C. Beck Center for the Cultural Arts, in Lakewood, and the Columbus Museum of Art.

Preparations for this exhibition began nearly two years ago when Gabriel P. Weisberg, Curator of the Department of Art History and Education at the Museum, suggested the idea of organizing a thematic show about industry as a corollary to the major exhibition, The Realist Tradition: French Painting and Drawing 1830-1900. His continuing expectations and counsel during the gradual development of the idea into an exhibition were a source of strength and challenge.

The encouragement and support that are necessary in the realization of any undertaking such as this exhibition entailed came from another art historian, my husband Michael Marlais. As the first reader, he was des-tined to see many versions of the manuscript. He offered direction and, in some cases, helped to define ideas about industrial themes and individual paintings. Patricia Hills, Adjunct Curator at the Whitney Museum of American Art and Associate Professor of Art History at Boston University, read the essay in its final stages; the catalog as it now stands is, in part, the result of her insights. Joy H. Walworth, who edited the manuscript, also deserves special recognition for her help in refining and clarifying obscure ideas and in maintaining the consistency of the catalog as a whole.

The success of all Cleveland Museum exhibitions are in great measure due to the vision and guidance of Sherman E. Lee. It is because of his commitment to education that the extensive facilities of the Museum were made available to carry out such a didactic endeavor. The ready participation of a number of individuals within the Museum should also be noted. All of the objects in the exhibition were entrusted to the care and attention of Registrar Delbert R. Gutridge. William E. Ward and his assistant Joseph L. Finizia designed the installation to reflect its visual aspect as well as its didactic content. Marlene Goldheimer was a careful and cheerful typist.

Gratitude is also extended to the number of individuals and institutions who loaned their own works for the period of the exhibition.

Introduction

The first two hundred years of American history coincide with a period when technological civilization was spreading throughout the world. The development of this country as a cultural unit, therefore, reflects a unique relationship with the Industrial Revolution and all that it implied. Since the earliest colonial limners, artists and artisans responded to the technological aspects of their world, displaying everything from matter-of-fact acceptance to fascination or suspicion. An investigation of their attitudes constitutes the theme of *American Realism and the Industrial Age.*

The inspiration for this investigation was initiated by another, more comprehensive work, *The Realist Tradition: French Painting and Drawing, 1830-1900.* That exhibition catalog includes a consideration of the industrialization of France and of the work of a number of French realist artists who dealt with various aspects of industrialization in their country. The theme of the industrial age as it was viewed by American artists — beginning in the nineteenth century and continuing into the 1970s — is the focus here.

An inevitable dependence upon European examples determined to a large extent the development of the theme in the United States. At the same time, however, these American artists were increasingly independent of the Continent, and developed their own artistic tradition. The issue of an interaction between American and European artistic traditions is stressed in the first sections.

An exhibition of limited scale could not possibly include or even attempt to refer to all the American works of art that are linked to the theme of industrialization. A representative selection of paintings, prints, and drawings from several historical periods, however, illustrates the changing moods and attitudes of artists and of society at large as it was reflected in a realist tradition in American art.

Although it is not the intention of this publication to establish a definition of realism — a difficult problem at best — a preliminary consideration of the term is essential. Many types of realism have emerged in the history of American art, from the sharp-focus accuracy of still-life painters such as Raphaelle Peale (1774-1825) and William Harnett (1848-1892) to the penetrating psychological investigations of Thomas Eakins (1844-1916). Most important to the present investigation of artists who concerned themselves with the process of industrialization is their interest in the factual. One of the first historians of American art who attempted to criticize as well as document artistic development, Charles Caffin, noted a desire for recognizable content in the early development of public taste in this country. In his *Story of American Painting* (1907) he pointed out that Americans were attracted by the "subject matter of the picture. The first consideration is — 'What is it about?' Then if it is about something with which we are familiar, we take a curious delight in identifying all the little details of resemblance to reality — the bristles in

the blacking-brush, the label on the bottle, the seam of the breeches, and the stitches of the patch. It all looks 'so natural,' and we think it a wonderful piece of painting; because in our infancy of appreciation, just as in our infancy of age, we place a high value on the faculty of imitation."[1]

A taste for informational content continued well beyond the adolescent stages of America's cultural maturation. In a more recent survey, art historian Barbara Novak related the American "respect for fact" to a preoccupation with things and the reality of their existence. In her view, the inherent interest in the preservation of fact in American art is a manifestation of philosophical attitudes: "From the limners on, American artists had held, in one way or another, to the adamant control of idea. Enlisting measure, mechanics, and technology as aids toward a certainty that was often as ideal as it was real, American artists guarded the unbroken integrity of the objects or things of this world, which became, very often, vessels or carriers of metaphysical meaning."[2]

French curator François Mathey, who published an impressive volume entitled *American Realism,* distinguishes American realism from the philosophy of art associated specifically with the second half of the nineteenth century and the social and humanitarian concerns of French bourgeois society. He suggests instead that realism in this country "is not just a historical period of art . . . but an attitude and a way of acting in which there is a strain of pragmatism. . . . Thus American painting, after having yielded to the seductions of English, then French influence, appears to us as a long effort of fulfillment: of the representation or, literally, the illustration of the fact discovering and becoming identified with its inner reality. . . ."[3]

Such assertions about the distinguishing characteristics of American art are difficult to substantiate. The conceptual vision that Novak has convincingly shown to be an American quality is not necessarily unique to this country — nor is the pragmatism mentioned by Mathey. Finally, the problem of positively identifying generic artistic attributes may be insurmountable. An alternative method of describing what is American, however, focuses upon that which is in and of this country. Such a procedure sacrifices abstract definitions in favor of specific examples — the method used in this survey.

A small but cohesive group of works by American realist artists serves to demonstrate the continuing tradition of a concern for facts in American art. The Americanness of that art must be said to derive essentially from the American experience itself. One of the only definitive conclusions that can be made about its indigenous character was actually outlined as early as 1910 by Robert Henri, one of the leading exponents of American realism: "As I see it, there is only one reason for the development of art in America, and that is that the people of America learn the means of expressing themselves in their own time and in their own land."[4]

The other element shared by all the works in the exhibition is a relationship to the emergence of industrialization.[5] Each of the artists represented responded to the presence of industry in the environment or to its effect on the lives of their fellow Americans. In one way or another, each of them reflected attitudes about the compatibility of scientific and technical progress with national interests and human freedom.

The foundations of American culture were established during a period when material and spiritual values were generally felt to be reconcilable.[6] Misgivings about the implications of increased mechanization that did persist seldom interrupted the pattern of its development.

Technology was usually regarded as a symbol of mankind's ultimate domination over his material environment. The very concept of eventual emancipation from natural disasters and social ills and the gradual betterment of the conditions of life is a relatively new one in Western civilization. The new American republic, with its abundant and diverse natural resources — along with an intellectual climate and social order favorable to secular enterprise — provided an ideal atmosphere for cultivating the idea of progress.[7] Leading thinkers such as Benjamin Franklin rhapsodized about America's future: "It is impossible to imagine the height to which may be carried, in a thousand years, the power of man over matter. We may perhaps learn to deprive large masses of their gravity and give them levity, for the sake of easy transportation. Agriculture may diminish its labor and double its produce; all diseases may by sure means be prevented or cured, not excepting that of old age, and our lives lengthened at pleasure even beyond the antediluvian standard. O that moral science were in a fair way of improvement, that men would cease to be wolves to one another and that human beings would at length learn what they now improperly call humanity!"[8]

The idea of progress continued to function throughout the nineteenth century. In the United States suffrage was extended beyond the propertied classes, education was made universally available, and the innovative utilization of new technical processes in industry was bringing prosperity and material comforts — a whole people was becoming civilized. The actualities of life for many Americans fell short of such ideals, but the concept of progress retained its legitimacy even in the face of discrepancies between the real and the ideal. Accelerating mass production nourished by unparalleled natural resources was regarded as one of the manifestations of progress. A burgeoning industrial structure re-quired the support of a commensurately massive and expanding market — which in turn demanded a constantly rising standard of living for the masses.[9] The divine sanction of the entire process was presumed in 1873 by William Gilpin, when the western regions of the country were barely settled, let alone industrialized: "A glance of the eye, thrown across the *North American Continent*, accompanying the course of the sun from ocean to ocean, reveals an extraordinary landscape. It displays immense forces, characterized by order, activity, and progress. . . . Farms, cities, States, public works, define themselves, flash into form, accumulate, combine, and harmonize. . . . The American realizes that 'Progress is God.'"[10]

Such bold confidence was by no means without challenge in the nineteenth century and met with even more serious opposition in the twentieth. An investigation of these fluctuating attitudes must be viewed in terms of the social-historical context in which they were produced. Thus an examination of the history of the growth and development of industrialization in this country serves as a useful guide for an examination of the works of art included in this exhibition.

The exhibition American Realism and the Industrial Age was organized to contribute to an understanding of one facet of American painting. This catalog provides the background for considering the theme and for examining works of art. It may serve, too, as the starting point for a larger and more thorough study of industrial subject matter as well as other related themes in American art.[11]

1. Charles H. Caffin, *The Story of American Painting: The Evolution of Painting in America from Colonial Times to the Present* (New York: Frederick A. Stokes Co., 1907), p. 100.

2. Barbara Novak, *American Painting of the Nineteenth Century: Realism, Idealism, and the American Experience* (New York: Praeger Publishers, 1969), pp. 221, 262.

3. François Mathey, *American Realism: A Pictorial Survey from the Early Eighteenth Century* (New York: Rizzoli International Publications, 1978), p. 8.

4. Robert Henri, "The New York Exhibition of Independent Artists," *Craftsman* XVIII (May 1910): 161. Other sources that deal with American realism include Dorothy C. Miller and Alfred H. Barr, Jr., eds., *American Realists and Magic Realists*, exh. cat. (New York: Museum of Modern Art, 1943); Virgil Barker, *From Realism to Reality in Recent American Painting* (Lincoln: University of Nebraska Press, 1959); Axel von Saldern, *Triumph of Realism: An Exhibition of European and American Realist Paintings 1850-1900*, exh. cat. (New York: Brooklyn Museum, 1967).

5. Industry as a theme for artists has seldom been approached by art historians. The following studies are some exceptions: Emily Bardack Keis, "The City and the Machine: Urban and Industrial Illustration in America 1880-1900" (Ph.D. diss., Columbia University, 1971); Patricia Hills, *The Painters' America: Rural and Urban Life, 1810-1910,* exh. cat. (New York: Praeger Publishers in association with the Whitney Museum of American Art, 1974), pp. 114-23; idem, *Turn-of-the-Century America*, exh. cat. (New York: Whitney Museum of American Art, 1977), pp. 145-47; *The Butcher, the Baker, the Candle Stick Maker: Images of Labor*, exh. cat. (New York: Pratt Graphics Center, 1977); *Work: An Art Exhibition about Workers*, exh. cat. (Fine Arts Museums of San Francisco, Downtown Center, 1978); Patricia Hills, *The Working American*, exh. cat. (Washington, D. C.: Smithsonian Institution, 1979).

6. An example of European intellectual thought in the seventeenth and eighteenth centuries is Joseph Addison's acknowledgment of the presence of a divine "Original" manifested in the material firmament. See Morrell Heald, "Technology in American Culture," in *American Character in a Changing World: Some Twentieth-Century Perspectives* (Westport, Conn.: Greenwood Press, 1979), p. 158.

7. Charles A. Beard, ed. "The Idea of Progress," in *A Century of Progress* (New York: Harper & Brothers in cooperation with A Century of Progress Exposition, 1932), pp. 3, 11.

8. Ibid., p. 11.

9. Ibid., pp. 12-13.

10. William Gilpin, *Mission of the North American People* (Philadelphia: J. B. Lippincott & Co., 1873), p. 99.

11. Several areas need further inquiry. The present survey does not attempt to deal with the importance of photography in relation to the artists' vision and in relation to aesthetics as a whole. This complex issue is really the subject for an entire exhibition in itself. There is also a need for further research into the relevance of social history in the art of recent decades. Articles such as Patricia Hills, "Philip Evergood's 'American Tragedy': The Poetics of Ugliness, the Politics of Anger" and Susan Fillin Yeh, "Charles Sheeler: Industry, Fashion, and the Vanguard" — both published in the February 1980 issue of *Arts Magazine* — serve as excellent prototypes and should stimulate interest in more extensive investigations.

NOTE

Numbers in brackets refer to catalog numbers in the exhibition. Figure numbers refer to reproductions that appear only in the text, not in the exhibition.

Nineteenth-Century Views of Industrialization

The Industrial Age Comes to America

The mere prospect of industrialization was alarming to President Thomas Jefferson. The foundation for a system of manufactures had been established during the Revolutionary War, but it was Jefferson's hope that the country would hasten to return to its former dependence on European production. His *Notes on the State of Virginia*, published in 1787, contains a statement about his views. He argued that in Europe "manufactures must . . . be resorted to of necessity not of choice" because of a lack of open land and the need to support a surplus population, whereas "we have an immensity of land courting the industry of the husbandman. . . . Those who labour in the earth are the chosen people of God, if ever he had a chosen people, whose breasts he has made his peculiar deposit for substantial and genuine virtue. . . . While we have land to labour then, let us never wish to see our citizens occupied at a work-bench, or twirling a distaff . . . let our work-shops remain in Europe."[1]

In the same year the Philadelphia merchant Tench Coxe addressed a group at the University of Pennsylvania gathered "for the purpose of establishing a Society for the encouragement of Manufactures and the Useful Arts": "The importance of agriculture has long since recommended it to the patronage of numerous associations, and the attention of all the legislatures: but manufactures, at least in Pennsylvania, have had but few unconnected friends, till sound policy and public spirit gave a late, but auspicious birth, to this Society." While Coxe was diplomatic enough to stress that "nothing should be attempted, which may injure our agricultural interests, . . ." he went on to assert "that more profit to the individual, and riches to the nation, will be derived from some manufactures, which promote agriculture, than from any species of cultivation whatever."[2]

Much of Coxe's discussion of the advantages of manufactures was aimed at its critics, including those who charged that many machine-related occupations were injurious to health. He reminded his audience that a number of other occupations — such as the painting business, clearing swamps, or growing rice — "are even more fatal" to those involved in them but are condoned because society has taken for granted the services rendered and the products produced. He declared further that the United States did not plan to pursue the types of manufacturing that would involve manual and sedentary work and that, in many cases, horses and mechanical power would be used instead of human labor. The moral argument was also strong:

Extreme poverty and idleness in the citizens of a free government, will ever produce vicious habits, and disobedience to the laws; and must render the people fit instruments for the dangerous purposes of ambitious men. In this light the employment, in manufactures, of such of our poor, as cannot find other honest means of subsistence, is of the utmost consequence. A man oppressed by extreme want is prepared for all evil, and the idler is ever prone to wickedness; while the habits of industry, filling the mind with honest thoughts, and

11

requiring the time for better purposes, do not leave leisure for meditating or executing mischief.[3]

The proponents of domestic manufactures won out — more because of economic and political resentment against England than because of moral considerations. In succeeding years associations and resolutions were formulated from Massachusetts to North Carolina as industrial development gradually became associated with the welfare of the nation as a whole. Industry, it was argued, would help strengthen the country and promote independence from the Continent. Members of the Massachusetts General Court entered into an association in order to pressure political officeholders to wear only clothes of American manufacture in the performance of their duties. One firm even advertised their American-made hosiery specifically to appeal to those who had "patriotism enough to pay twelve and a half cents more for American than for imported stockings."[4]

The year 1815 marked a turning point in American history. A spirit of nationalism roused by the War of 1812 encouraged an increasing independence from European affairs — political as well as economic. President James Madison called for adequate military and naval forces, a protective tariff, and a new national bank. His recommendation the following year for a comprehensive system of roads and canals was part of a program of internal improvements that augmented the protection from foreign competition and encouraged the development of a home market. The Erie Canal was started in 1817, and funds were appropriated between 1822 and 1838 for a national road from Cumberland on the upper Potomac to Wheeling on the Ohio — both important routes to the West.[5] Steps were thus taken to shape the future of the young republic — steps that would lead to its position as a national power.

A Taste for Pictures of American Life and Work

American artists, too, were gaining a sense of identity. Despite a European artistic heritage, artists who came to maturity during the first decades of the nineteenth century grew up in a time of newly kindled nationalism. While Washington Allston (1779-1843) and John Vanderlyn (1775-1852) had hoped to cultivate in America the elevated artistic traditions of the Continent, the pragmatic merchants and farmers of the New World developed instead a taste for the straightforward, honest depiction of real life and actual places. An identifiably native imagery and style began to emerge, derived from a predilection for real subjects presented with as much clarity, precision, and honesty as the artist's skills permitted. Although scenes of everyday life and the American countryside had appeared on commercial signs, needlework, and book illustration in the eighteenth century, genre and landscape scenes were not treated with any regularity by the professional painters until well into the nineteenth century. But both the American artist and public were attracted by the "actuality" of such subject matter.

That spirit of innocent fascination was demonstrated in Charles Wilson Peale's (1741-1827) popular *Exhuming the First American Mastodon* (Figure 1). The artist, hearing about the discovery, purchased the rights to excavation and personally designed the huge wheel that was used to lift the buckets of mud and water from the swamp. His painting recorded the whole extraordinary story — including portraits of seventy individuals involved with the project and an exacting account of how it was actually carried out.[6]

Interior of a Smithy [1] by Bass Otis (1784-1861) also illustrates this American concern for reality. The attention to detail and the careful, if naive, realism of the painting appealed to a public who cared little for nude

1 Bass Otis, *Interior of a Smithy,* ca. 1815.

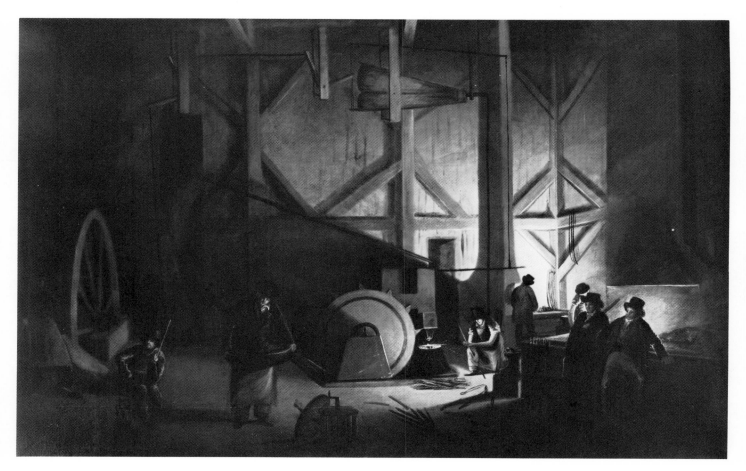

Figure 1. Charles Wilson Peale,
Exhuming the First American Mastodon, 1806.

Figure 2. Joseph Wright of Derby,
The Blacksmith's Shop, 1771.

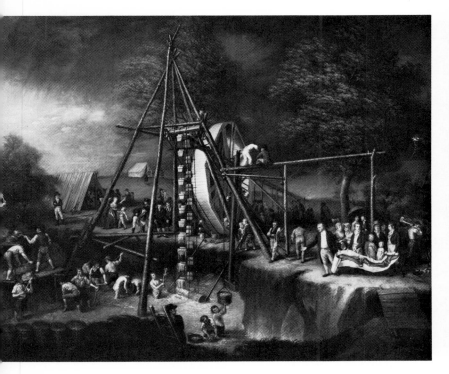

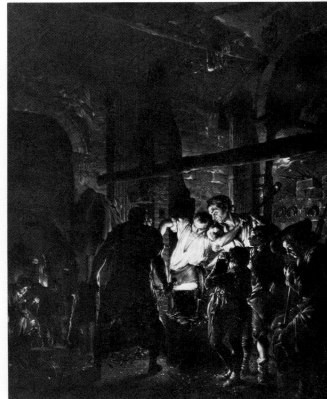

classical goddesses, grandiose allegories, or exotic flights of the imagination. *Interior of a Smithy* reveals a fascination with mechanical processes, as well as the potential drama of technology.

Otis might be considered a totally American artist. One of the most prolific portrait painters of the first half of the nineteenth century, he was self-taught. He turned to painting only after completing an apprenticeship with a scythe maker in 1805. He had also worked for a coach painter, and for three years continued to supplement his regular income from portraiture by painting signs and coaches during his travels through Massachusetts and Connecticut. Eventually he was able to depend entirely on his skills as an artist, and his election in 1812 to the Society of Artists of the United States confirmed his position and reputation as a professional among the relatively cultured society of Philadelphia.[7]

Interior of a Smithy was the only major genre composition Otis ever completed. It was listed in the 1815 catalog of the annual exhibition at the Pennsylvania Academy of the Fine Arts, where it was first shown, as "a Foundry in New England; with Operatives, Machinery &c."[8] The choice of an industry-related subject was not entirely unique in Otis's career. His paintings of the Eleutherian Mills (the Du Pont black powder plant) and the Brandywine Mills, while similar in theme, portray landscape settings with little attention to the activity actually taking place in the mills.[9] This emphasis on landscape was much more common in early nineteenth-century America. *Interior of a Smithy*, on the other hand — in all its twenty-eight square feet — is concerned with the activities taking place in a scythe maker's shop. It is interesting to speculate about the artist's reasons for creating such a picture.

Otis may have been inspired by engravings after the work of Englishman Joseph Wright of Derby (1734-1797). By the late 1760s and early 1770s, engravings of Wright's best pictures were widely distributed by leading printmakers in Europe and eventually America. His *The Blacksmith's Shop* (Figure 2), which was engraved and published in 1771, was innovative in its focus on the process of labor. As such, it is one of the earliest works to reflect an artist's interest in the Industrial Revolution.[10] Its treatment of scientific and industrial subject matter would have appealed to the pragmatic Bass Otis. His own interpretation of the subject differed in that he depicted his figures in a real, contemporary workshop while Wright had placed them in a crumbling classical-revival setting. The lighting in both pictures is romantic. Emanating from a hidden, artificial source, the warm half-light functions in each work to evoke a mood of wonder and excitement. Despite such similarities, of course, the works are distinctly different. The intensity of Wright's picture — derived from the interaction between the figures and the focus of their attention toward a centrally placed area in the composition — is lacking in Otis's altogether less sophisticated work. Whether his representation of the smithy was directly influenced by Wright or was primarily inspired by his own early experience as a scythe maker's apprentice, Otis was clearly interested in the drama offered by the subject as well as in re-creating the reality of the scene.

In the tradition of such artists as Otis and Peale, John Ferguson Weir (1841-1926) appealed to the American appetite for romantic realism when he sharpened the focus on technical detail and heightened the dramatic quality of *The Gun Foundry* [2]. Weir made studies for his picture in the West Point Foundry at Cold Spring, famous in the 1860s for its manufacture of Parrott guns. During the two years he worked on the painting, from late 1864 to 1866, the artist visited the foundry frequently and used as models the workmen he observed on the job. The dramatic and critical moment of the forging

process — when the molten metal is poured from the great cauldron into the molding flask — is illuminated in the painting only by the fiery glow of the furnace and the stream of white-hot iron. All figures are involved with, or observing, the main event.[11]

Weir's interest in the theatrical was freely expressed in personal correspondence to his fiancée, Mary French. A particularly stormy night brought Poe to his mind, and, from his room in the famous studio building on Tenth Street in New York, he wrote:

> A huge and dusky canvas — dark and sombre, spreads
> its surface opposite my table — opposite my table,
> near the wall. Charred and blackened seems its sur-
> face — impenetrable soot — but by gradual develop-
> ment unfolds its story to the eye — to the eye makes
> clear its subject — shows a forge, with grim men forg-
> ing — forging shafts for floating engines — huge and
> ponderous — glowing hot — seething beneath the
> ponderous hammer hammered till its form is got —
> swung in chains from huge cranes — fancy makes
> them groan and squeak — smiths do swing these great
> huge masses, glowing hot with flaming gas's — from
> the furnace to the anvil — to the anvil 'neath the
> hammers — Then in anger it sputters — as its ham-
> mered into shape — like a thing of life it mutters —
> groans and sputters, sputters flaming drops of sweat.
> . . .[12]

Although subject to such romanticized escapades in his writing, the artist did not depart from reality in his painting. Every detail of the scene — including each of the links in the great hanging chains — is depicted with meticulous care. Weir's conviction that a painting should convey the complete story was appreciated by American audiences. A critic for the *Nation,* reviewing the 1866 spring exhibition at the National Academy, favored Weir's work: "There is a very unusual coherence and distinct meaning to his picture. The work is really getting done; the men are really busy, and sensibly busy; the chains hang in real catenary curves and the windless rope is strained tight; . . . the picture is real. . . ."[13]

Many aspects of his treatment of the interior of the foundry are similar to paintings of industrial subjects produced in England and France. That Weir was aware of European prototypes is reasonable to assume since he certainly had access to the art library and print collection accumulated during his father's travels in Europe. His daughter also records that "when pictures in the European galleries were photographed in the mid-nineteenth century," her grandfather purchased portfolios of them.[14] Weir may have seen any number of images of industry in contemporary periodicals as well. English illustrators depicted cotton mills as fortress prisons and coal mines as hellish dungeons. In contrast to many of these possible sources, however, Weir's portrait of the forge is mysterious rather than hellish. Weir was obviously fascinated by the sense of excitement and energy that fills the vast space.

His composition has more in common with paintings of the forging process in France by Théodore Chasseriau (1819-1856) and François Bonhommé (1808-1881). Bonhommé, for example, frequently included a group of bourgeois observers in his interior factory scenes. The group of visitors to the forge at the extreme right of Weir's canvas is a detail that may have been inspired by an actual incident at West Point or observed from reproductions, perhaps of Bonhommé's work, that Weir may have studied in his father's art books. Whether his onlookers are proud proprietors or curious visitors, they nevertheless represent economic support of the means of production.[15]

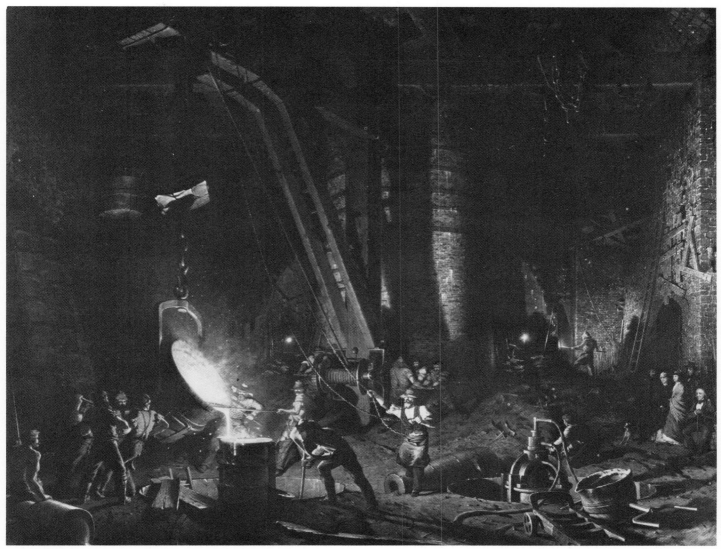

2 John Ferguson Weir, *The Gun Foundry*, 1866.

3 Alexis Jean Fournier, *Mill Pond at Minneapolis*, 1888.

Whatever Weir may have learned from French or English prototypes, he remained quite adamant about his independence. In reference to his painting, he later wrote: "I had confidence in the originality and significance of its subject matter and in its treatment — as something not hitherto attempted in this form of art; certainly not with any similar importance. . . ."[16] If his interest in the subject and the manner in which he rendered the overall scene suggests foreign influence, his painstaking attention to every aspect of the forging process developed from his own personal approach to the subject — an approach which may be considered typically American.[17]

The art of Alexis Jean Fournier (1865-1948) also points to an interaction between American and European influences. Fournier worked as a sign and scenery painter in Minneapolis and studied at the Minneapolis School of Art. *Mill Pond at Minneapolis* [3] was painted in 1888, five years before the artist left for Paris to study at the Académie Julian. The suggestion of Barbizon landscape painting already clearly evident in his work was derived from the then-current attitude at the Minneapolis School of Art promulgated by its director Douglas Volk (1856-1935) under whom Fournier probably studied — and supported by the wealthy Minneapolis patrons who sponsored Fournier's European study. Fournier's concern for rendering outdoor light and atmosphere suggests familiarity with contemporary French landscape paintings available in local art collections. Although Fournier was enamored of these examples, of their skillful brushstroke and fresh color, he was not able to emulate their style completely. He was not able to abandon the reality of what he observed for the sake of constructing a picture.[18]

The vantage point from which *Mill Pond at Minneapolis* was painted revealed some untidy details — the millpond itself being an inherently undecorous subject for painting. The diagonals presented by the train and tracks, the stone arch bridge of the St. Paul Minneapolis and Manitoba Railroad Company, and the log barriers crisscrossing the pond are all recorded as he saw them — without any adjustment to enhance the picturesque qualities of the landscape. In addition, the logs themselves, in the immediate foreground and in the pond, were never positioned by the artist to conform to an ordered compositional structure. At this point in his career Fournier was more concerned with the task of describing his subject than he was with the problem of composing a painting.

This emphasis upon the subject of a painting — to record the reality of the thing seen — is even more apparent in *Clark Match Works* [4] by J. Frank Waldo (1832-ca. 1902). The work of a self-taught painter, this portrait of a factory complex is naively straightforward.[19] The artist's primary goal was to convey information, and his choice of a bird's-eye view permitted him to include all the elements he considered integral to the subject. Each building in the Match Works complex is carefully described; and, in the background, some of the major landmarks of the city of Oshkosh are also recognizable.

If Waldo worked without the benefit of art instruction, he certainly was aware of maps and "prospects" that had been popular decorative furnishings in American homes since the seventeenth century. The introduction of lithography and steel engraving in the nineteenth century resulted in a proliferation of such views of prosperous cities, until the craze for such prints became a national obsession. *View of Columbus O. from Capitol University* (Figure 3) is a typical example.[20] The panoramic scene is elaborately descriptive and includes thirty-seven numbered references listed in the lower

4 J. Frank Waldo, *Clark Match Works,* 1883.

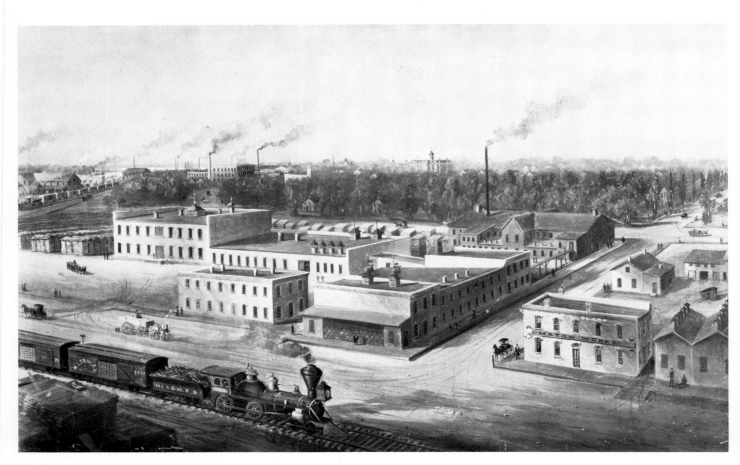

margin. American viewers were less interested in its aesthetic qualities than they were in its informational content.

An American preference for the factual rather than the imaginary seems to be corroborated by a similar taste in reading material. The late development of the novel as a literary form in the United States may be partially explained by the widespread availability of alternative types of writing. Personal accounts of life in unsettled regions of the country, true descriptions of Indian captivity, and adventures in the wild West found a ready market among American readers. Virtually every household, from time to time, made use of the advice, facts, anecdotes, remedies, and recipes provided by annual almanacs. "Doctor books" were also widely popular.

Figure 3. *View of Columbus O. from Capitol University,* ca. 1867.

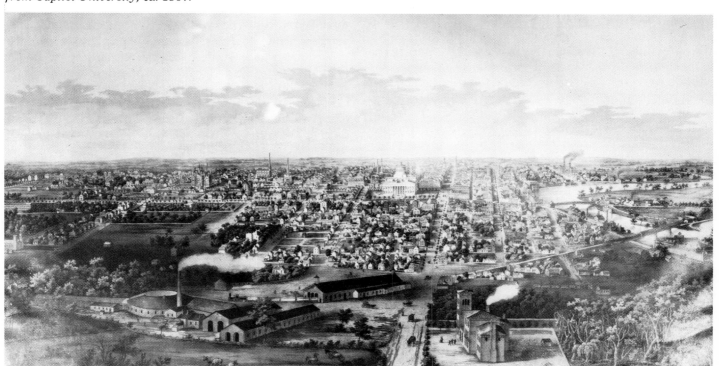

One of the most famous, *Dr. Chase's Recipes; or, Information for Everybody*, sold over seven hundred thousand copies between 1863 and 1876. A review of the book which appeared in the *Syracuse Journal* explained the reasons for its widespread appeal: eight hundred recipes were "interspersed with sufficient wit and wisdom to make it interesting as a general reading book, besides the fact that it embraces only such subjects as have a practical adaptability to 'Everybody's' everyday use."[21]

Frank Waldo instinctively catered to this same American taste for the factual. To the people of Oshkosh, *Clark Match Works* was a realistic depiction of a very real part of their lives, even though Waldo's composition was less skillfully rendered than many of the views and prospects produced by large, professional companies. No system of one-point perspective was used to organize the space in his painting. Instead, dependence on observed perspective resulted in an unconvincing relationship between the foreground and background planes. His treatment of the landscape gives the impression that each section was viewed from a different vantage point.

The artist's concern for realism, however, resulted in a fascinating record of early industrialization in Wisconsin. The lumbering industry, which was also celebrated in Fournier's painting, was critical to the economic development of the North Central states and of its cities. Match production in Oshkosh was a natural outgrowth of the availability of Wisconsin pine in the area. The match splints were cut by hand until 1863 when James L. Clark perfected a machine to perform the process more efficiently. A highly successful business developed because of this improvement in production and because of the high quality of the company's product. The painting of the match works may have been commissioned by the Clark family when the firm was sold by Clark's son in 1881.[22]

Artists Document the Progress of Civilization

Artists such as Fournier and Waldo were part of a trend in painting which emerged in the decades prior to the Civil War. At the same time that the Hudson River school artists were producing portraits of the unspoiled American wilderness, the contemplation of which were believed to provide religious instruction and moral edification, other artists were expressing different social values in their pictures. Man's presence in the landscape was acknowledged and recorded by a wide range of professional, commercial, and amateur painters who were conveying their optimism about the effects of civilization.[23] Advocating industrialization as a cultural advance, these artists reflected the outlook of upwardly aspiring American merchants and businessmen. Their philosophy was promulgated by such publications as the *Merchant's Magazine*. The very first issue of this periodical, in 1839, contained an article entitled, "Commerce as Connected with the Progress of Civilization," which declared: "Education, religion, freedom, morality — the diffusion of wealth — the diffusion of the useful and ornamental arts — the diffusion of knowledge — the dissemination of religious light and truth — the extension and cultivation of taste and refinement — a free, happy, and improving personal intercourse between country and city, between different parts of the same country, and between different countries — these things are all of them more or less within the province of commerce — at least, none of them are wholly beyond its power and influence."[24] Nearly a decade later another author in the same magazine redefined the issue: "if the discovery of steam, or rather, the development of its powers, in their application to commerce and manufactures, has been reserved for the nineteenth century, it is only because that era exhibits a higher degree of civilization, and there-

fore, a fitter field for its operations, than was ever before known in the history of society." In his article "The Moral Influences of Steam," he went on to evoke a bit of nationalist chauvinism for the sake of his argument: "steam, which has been long known in Europe as an agent of great power, was applied there with so little effect. So difficult was it to divert industry from its old and beaten tracks, that every effort to extend its usefulness by experiment, was deemed visionary, and therefore discountenanced. It was in the United States that the infant Hercules found a congenial atmosphere, and imbibed that vigor which has since characterized his labors and triumphs."[25]

Increasingly affluent American businessmen became increasingly important patrons of art. Their pragmatic attitude toward economic and financial matters found its reflection in a taste in art that might also be considered pragmatic. Many of these enterprising collectors desired realistic paintings about their life and surroundings.

W. T. Russell Smith (1812-1896) was one artist who responded to that need. His own personal convictions concerning the growth and expansion of industrialization in this country, however, are difficult to determine on the basis of his paintings. Historian Henry Tuckerman, in his *Book of the Artists* (1867), reported that Smith's paintings would appeal to "the lovers of American river and creek scenery,"[26] but at the same time, his compositions reflect equal enthusiasm for man-made elements of the landscape. His approach to his subject matter was that of a realist; his intention was accuracy.

Rembrandt Peale, a friend of the artist, reflected the taste of the period when he evaluated Smith's work for the *United States Gazette* (1839): "Without the advantages or prejudices of a foreign education, his landscapes were entirely American, and the style of his pencilling is expressive of the scenery peculiar to this country. . . ."[27]

Smith began his professional career painting theater scenery, but he also enjoyed exploring the vicinity of Pittsburgh and, later, Philadelphia in search of picturesque subjects for his own canvases. The artist recalled a favorite view of the Pittsburgh of his youth: "At that time [1828] nothing delighted me more than on a fine Sunday morning in Summer to cross the river, climb the opposite rocky wooded hill, and sit by the hour gazing down upon the city, the three rivers, and the far distant landscape; for then, the usually smoky, noisy, dirty place was purified by the day and the misty morning light, and for once in the week was quiet and the whole prospect really beautiful."[28] Among the paintings that record this panorama is *View of Pittsburgh from the Salt Works on Saw Mill Run* [5].

The oil sketch, however, was based on weekday observation. Clouds of smoke billowing from stacks in the foreground and middle distance hover menacingly in a dramatic, orange red sky. Although Smith usually found the smoke and dirt repugnant, here he turned the masses of black smudge and the angular contour of the salt works to pictorial advantage. By-products of industrialization were a real and ever-present aspect of nineteenth-century Pittsburgh — a city created by the economics of the Industrial Revolution. Accuracy of topographic detail, such as the inclusion of the aqueduct over the Allegheny and the courthouse dominating the cityscape, blend with the romantic qualities of Smith's rendering. That Smith was interested, at least secondarily, in historical documentation is suggested in some of his detailed and specific titles, such as *Looking up the Monongahela River from Coal Hill over Ormsby's Farm toward Birmingham,* and *Nelson's Island, view showing Monument Hill and Allegheny Water Front in 1840.*[29] In addition to his landscapes, he produced a limited number of city views, usually including some significant ar-

5 W. T. Russell Smith, *View of Pittsburgh from the Salt Works of Saw Mill Run,* 1838.

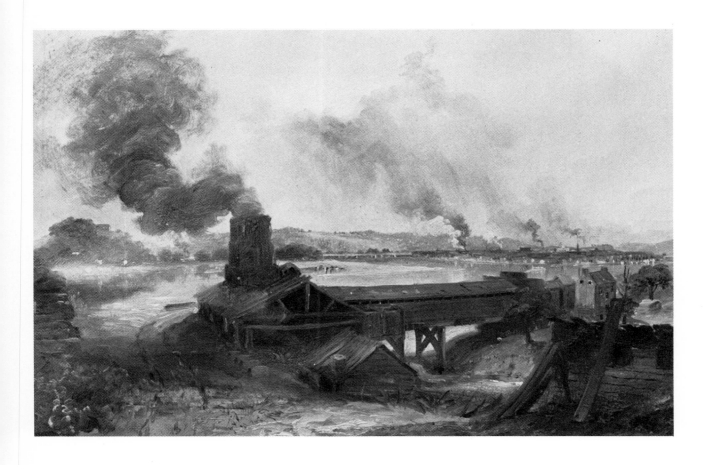

chitectural monument such as a capital building or a prominent private residence. Whatever the subject, his presentation was accurate as well as picturesque.

Thomas Moran (1837-1926) was also primarily a landscape painter. He devoted a large share of his long and productive career to adventures in search of magnificent scenes of nature. Less interested in accuracy than splendor, however, he thought nothing of altering color for the sake of harmony or combining various scenes to achieve a sublime effect. His education as an artist was derived from books. As a teenager he poured over engravings, mezzotints, and lithographs — most of them English — while devoting his spare time to drawing and watercolor painting. Finally in 1860 he made his way to England to see for himself the work of J. M. W. Turner. He found the color in Turner's painting more radiant than he could have imagined.[30] On returning to this country he continued to devote summer days to sketching out-of-doors. Many of his pencil sketches, often with washes added, were later used for oil paintings. By the close of the Civil War when the nation began to redirect its energy toward the exploration of the vast western territories, the time was right for his talents.

Four government surveys were commissioned to map and execute geological studies of the western interior. Stories about the findings and experiences of the adventurers frequently provided inspiration for popular magazine articles. In 1871 Moran joined Dr. Hayden's expedition in order to illustrate a story being written for *Scribner's* magazine. In addition to illustrations sold to the magazine, Moran produced a number of studies that were used for major oil compositions he painted after his return.

The United States government paid him ten thousand dollars for the celebrated *Grand Canyon of the Yellowstone*. A second painting, *Mountain of the Holy Cross*, moved one critic to note: "all who take an interest in the progress of American art must gratefully recognize the fact that at last we have among us an artist eminently capable of interpreting the sentiment of our wilder mountain-scenery in a style commensurate with its grandeur and beauty." The word "interpret" was well placed. As Moran himself said about the work, "My purpose was to convey a true impression of the region; and as for the elaborated rocks, I elaborated them out of pure love for rocks."[31]

To the twentieth-century eye, Moran's large, carefully composed canvases often fail to evoke the awe and wonder they inspired in contemporaries. Instead, they appear contrived and, at times, theatrical. His water colors, on the other hand, retain a freshness and immediacy that his larger works in oil somehow lack.[32]

Smelting Works at Denver [6] is one such intimate and spontaneous painting. In 1892 Moran had an opportunity to revisit many of the favorite vistas he had studied during his trips to Arizona, New Mexico, Colorado, and Wyoming. The Sante Fe Railroad had begun a program of reproducing paintings of scenes along its routes for advertisement. As a part of this project, the railroad provided Moran's transportation in exchange for the copyright on a single canvas. The view of the Grand Canyon he produced was spectacular and appropriate for the railroad's needs, but he also executed a number of more modest views during the trip.

His view of the iron works was based on drawings of the smelters on the outskirts of that city.[33] The painting marks one of the rare occasions in which the artist chose to depict a landscape transformed by industry. His interest in the subject may very well be explained by one of his own comments about his beloved Turner: "All that he asked of a scene was simply how good a medium it was for making a picture. . . ."[34] Despite Moran's confessed

6 Thomas Moran, *Smelting Works at Denver*, 1892.

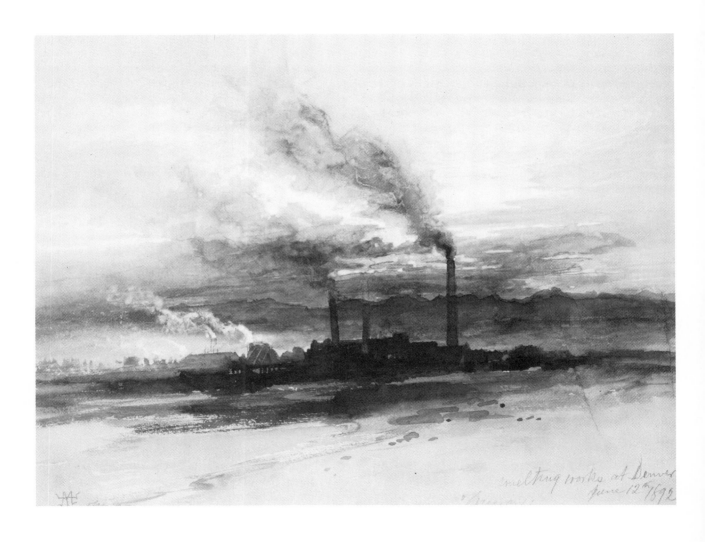

love of nature, he interjected no obvious symbols of evil into his interpretation of the scene. Rather, he used a delicate combination of yellows, oranges, and grays to evoke qualities of that western light that continued to fascinate him throughout his career. It might be said that by making the American people aware of their natural heritage through his art, Moran had participated in the inevitable taming of the West. These smelting plants were but another, more advanced aspect of that effort.

Moran, then, shared with Smith, Waldo, and Fournier a fairly detached interest in the visual aspect of the industrial landscape. The directness and enthusiasm that characterized their approach to that subject was generated by the visual spectacle which excited them. Their feelings about the phenomenon of industrialization were directly related to their feelings about it as a subject for their art.

Thomas P. Anshutz (1851-1912) also dealt with the industrial landscape, but his concern was centered on

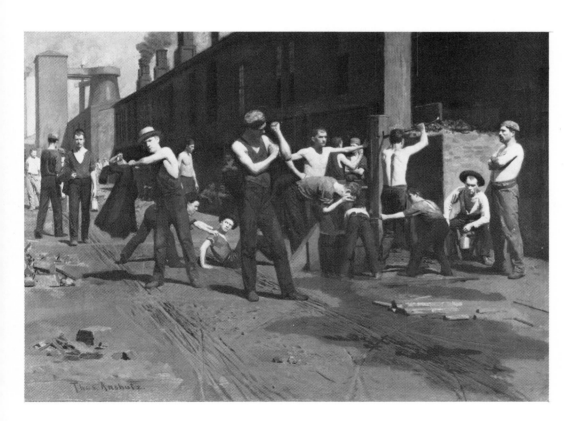

Figure 4.
Thomas P. Anshutz,
Ironworkers: Noontime,
1880/81.

7 Thomas P. Anshutz, *Steamboat on the Ohio,* ca. 1896.

Opposite: top left

Figure 5. Thomas P. Anshutz, *Steamboat on the Ohio,* ca. 1896.

Figures 6, 7, and 8. Photographs of boys on the waterfront, probably by Thomas P. Anshutz.

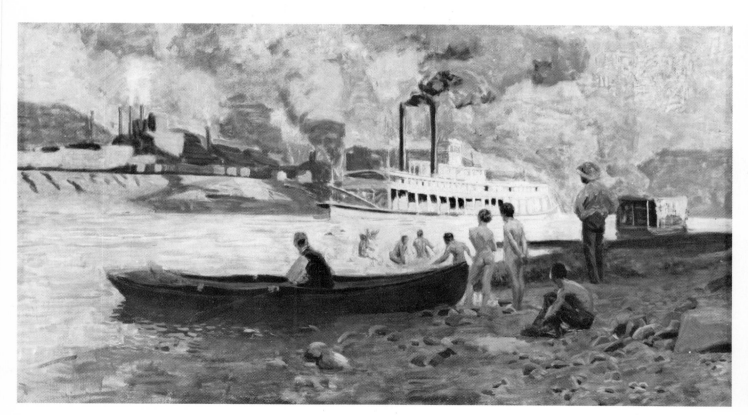

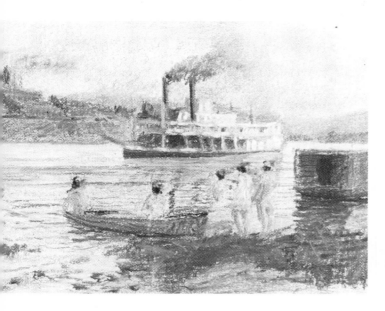 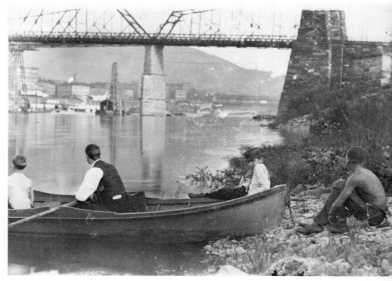
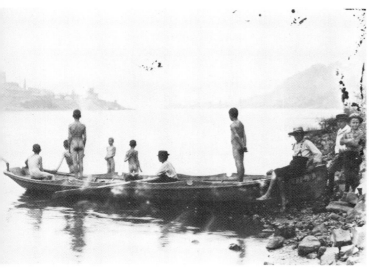 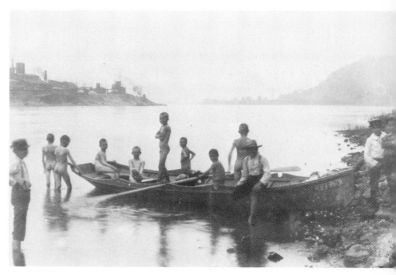

the figures within his composition — on their gestures as well as their "temperaments" and attitudes.[35]

Having studied drawing and painting at the National Academy of Design and with Thomas Eakins at the Pennsylvania Academy of the Fine Arts, Anshutz was inclined to concentrate on the anatomical correctness and convincing solidity of each of his figures. His almost single-minded dedication to anatomy detracted from the overall composition of *Ironworkers: Noontime* (Figure 4), his first industrial subject. The workers appear self-conscious, as if posed to present a number of different views of the male body. They are less successfully arranged in relation to each other and in relation to the organization of the painting as a whole.

Anshutz began to paint *Ironworkers: Noontime* while visiting relatives in Wheeling, West Virginia, in 1880. He used workmen from a local iron foundry as models, making "innumerable studies" of each in academic fashion. By the end of the century a critic recognized Anshutz's painting "as a departure in American art."[36] Indeed, its frank treatment of such an undecorous subject as steelworkers washing up for lunch anticipates the so-called Ashcan school of painting.[37]

Almost twenty years later Anshutz painted *Steamboat on the Ohio* [7]. In the interim he had visited Paris, where he was attracted to the work of Paul Albert Besnard (1849-1934). In light of Anshutz's own academic background, his interest in the fashionable portraiture and naturalistic figure studies of this artist is not surprising. Besnard was one of a group of French academic painters who, despite their conservative subject matter, employed an impressionistic style of paint application. This Impressionist interest in light and broken brushstroke stimulated the most noticeable change in Anshutz's work after his return to America.

Preparatory pastel sketches for *Steamboat on the Ohio* (Figure 5) reveal the influence of his Paris experience. Reflections of yellow and orange light across the river's surface are somewhat hardened in the final oil composition [7], but the dappled surface and bright colors demonstrate a sharp contrast to the staid surface and brushwork of his pre-Paris paintings.

Steamboat on the Ohio also seems to have been inspired by a series of photographs taken in 1890/91, probably by Anshutz himself (Figures 6, 7, 8).[38] Apparently, during an afternoon excursion in Wheeling, he took the opportunity to photograph a group of young boys bathing in the Ohio River. Figures in various postures from the photographs were combined and recombined in the sketches and final painting. The general configuration of the boat, the river, and the industrial section of Wheeling seen across the water in his photographs were also retained. The final version, however, presents a dynamic opposition between two halves of the canvas.

The contrast set up between the upper left and lower right sections of the painting emphasizes the portentous coming together of two eras. On one side of the river the belching smoke emitted from the steel refineries and the phosphorescence of their fires emblazon the landscape. The exaggerated scale of the factories as well as the clouds of smoke heighten the drama of the industrial segment of the environment. A steamboat derived from another of Anshutz's photographs was also incorporated into the scene. Here, this product and vehicle of the industrial era functions as a foil for the rustic wooden rowboat in the foreground. Warm earth tones provide an appropriate setting for innocence and youth represented on the near shore, but the way of life enjoyed by the bathers appears to be threatened by the light and steam and smoke across the river.

An overtly negative response to urbanization and industrialization was more common in literature than in painting. The steam engine had, for example, been used as a symbol of repressive civilization in Mark Twain's episode of *Huckleberry Finn*, published in 1844. Floating downstream on their raft, adrift from the hostile world on shore, Huck and Jim felt "mighty free and easy." Suddenly the sound of the steamboat was too close: "she bulged out, big and scarey, with a long row of wide-open furnace doors shining like red-hot teeth, and her monstrous bows and guards hanging right over us. There was a yell at us, and a jingling of bells to stop the engines, a pow-wow of cussing, and whistling of steam — and as Jim went overboard on one side and I on the other, she came smashing straight through the raft."[39]

The image of the machine intruding upon the peaceful and idyllic landscape was a literary motif employed by a number of American writers.[40] Their conception of reality as a struggle between opposing forces may be seen as a natural result of the radical developments that overtook the nation during the course of a few decades. The rapid advance of industrialization, the movement from an agrarian to a mechanized state, brought along with it radical changes in the American way of life.

During the nineteenth century, the majority of American artists reflected optimism about the idea of progress that had been established for their country. But increasingly, the ill effects of that progress were becoming apparent. By-products of industrialization were poverty, filth, and disease. The first American artists to respond to these aspects of "progress" were magazine illustrators.

1. Thomas Jefferson, *Notes on the State of Virginia*, ed. William Peden (Chapel Hill: University of North Carolina, 1955), pp. 164-65. *Notes* was originally written in response to a questionnaire circulated in 1780 by the French government in an attempt to gather facts and information about the American states. Soon after submitting a copy of the manuscript to the secretary of the French legislation at Philadelphia, Jefferson began adding material received from friends and informants and culled from his own continuing research, finally to publish what he considered to be a definitive version in 1787. Leo Marx interprets Jefferson's devotion to agriculture (reflected in "Query XIX") as the expression of a pastoral rather than an agrarian ideal in *Machine in the Garden* (New York: Oxford University Press, 1964), pp. 117-33.

2. Tench Coxe, *A View of the United States of America . . . between the Years 1787 and 1794* (Philadelphia, 1794; reprinted London: J. Johnson, 1795), pp. 35-38.

3. Ibid., pp. 41-42, 49.

4. *Patrons of Industry*, 29 June 1820, quoted in Samuel Rezneck, "The Rise and Early Development of Industrial Consciousness in the United States, 1760-1830," *Journal of Economic and Business History* IV (August 1932): 802.

5. Samuel Eliot Morison, Henry Steele Commager, and William E. Leuchtenburg, *A Concise History of the American Republic* (New York: Oxford University Press, 1977), pp. 172-73.

6. John Wilmerding, "The First Half of the Nineteenth Century," *The Genius of American Painting* (London: George Weidenfeld and Nicolson, 1973), p. 94.

7. Gainor B. Davis, "Bass Otis: Painter, Portraitist, and Engraver," in *Bass Otis: Painter, Portraitist and Engraver*, exh. cat. (Wilmington: Historical Society of Delaware, 1976), pp. 11-12.

8. Ibid., p. 14; Gordon Hendricks, "A Wish to Please, and a Willingness to Be Pleased," *American Art Journal* II (Spring 1970): 18.

9. *Bass Otis: Painter, Portraitist and Engraver*, exh. cat. (Wilmington: Historical Society of Delaware, 1976), cat. nos. 48, 74.

10. Francis D. Klingender, *Art and the Industrial Revolution*, rev. and ed. by Arthur Elton (New York: Schocken Books, 1970), pp. 51, 61. The technique of mezzotint engraving permitted a wide variety of tonal contrast and clarity of detail and therefore lent itself to the accurate reproduction of Wright's striking use of light and dark. *The Blacksmith's Shop* was exhibited in London in 1771 and engraved the same year by Richard Earlom (1743-1822). See Charles F. Buckley,

"Joseph Wright of Derby in Mezzotint," *Antiques* LXXII (November 1957): 440, 442.

11. Henry T. Tuckerman, *Book of the Artists* (New York: G. P. Putnam & Sons, 1867), p. 487; Theodore Sizer, ed., *The Recollections of John Ferguson Weir: Director of the Yale School of the Fine Arts, 1869-1913* (New York and New Haven: New York Historical Society and The Associates in Fine Arts at Yale University, 1957), pp. 52-54.

12. Microfilm no. 529, frame 937, John F. Weir Papers, Archives of American Art, Smithsonian Institution, Washington, D.C.

13. "Fine Arts: The Forty-first Exhibition of the National Academy of Design," *Nation* II (11 May 1866): 603. Also microfilm no. 530, frames 937-38, Weir Papers. Perhaps stimulated by the success of *The Gun Foundry*, Weir began a second painting in 1867, this time based on another phase of the operations of the West Point Foundry. *Forging the Shaft* is also a highly charged industrial scene replete with carefully observed details. The original version of the painting was destroyed by fire. The replica now in the collection of The Metropolitan Museum of Art was completed in 1877.

14. Microfilm no. 530, frames 4-5, Weir Papers. Weir received his art instruction in the studio of his father, a portrait painter and drawing instructor at the United States Military Academy at West Point.

15. Klingender, *Art and the Industrial Revolution*, 104-33; Michelle Evrard, *La Représentation du Travail*, exh. cat. (Le Creusot-Monceau: Château de la Verrerie, 1978), pp. 9-19. Engravings after paintings by Bonhommé of a foundry interior were reproduced in *Magasin Pittoresque* in a two-part article entitled "Fabrication du Fer" in October and November, 1848. *Magasin Pittoresque* was regarded as one of the most important magazines for the middle class in France, and this article could have been available in the United States. See also Gabriel P. Weisberg, "François Bonhommé and Early Realist Images of Industrialization, 1830-1870," *Arts Magazine* LIV (April 1980): 132-35; and idem, *The Realist Tradition: French Painting and Drawing, 1830-1900*, exh. cat. (Cleveland Museum of Art, 1980). Weir may also have seen engravings after Joseph Wright's paintings which, as noted previously, were widely circulated in America. Interestingly, in *The Iron Forge* (1772) the newly forged, white-hot iron bar provides the source of light in the interior of the shed. There is a distant relationship between the placement of the three figures and dog at the right rear of the shed and the placement of the visiting group in Weir's painting.

16. Sizer, *Recollections*, p. 56.

17. It should be noted that although such attention to accurate and specific detail is a persistent characteristic of the work of American artists, it cannot be seen as an exclusively American tendency. Compulsiveness about detail is also evident in the work of nineteenth-century European artists such as the Pre-Raphaelites in England and certain French academic artists. See J. P. Crespelle, *Les Maîtres de la belle époque* (Paris: Hachette, 1966); Francis Jourdain, "Vingt Ans de grand art, ou la leçon de la niaiserie," in *L'Art officiel de Jules Grevy à Albert Lebrun, Le Point: Revue Artistique et Littéraire* XXXVII (April 1949); Timothy Hilton, *The Pre-Raphaelites* (New York: Harry N. Abrams, 1970); Linda Nochlin, *Realism* (New York and Baltimore: Penguin Books, 1971).

18. Rena Neumann Coen, *Painting and Sculpture in Minnesota, 1820-1914*, exh. cat. (Minneapolis: University of Minnesota Press, 1976), pp. 106-8,112-14.

19. Judith A. Barter and Lynn E. Springer, *Currents of Expansion: Painting in the Midwest, 1820-1940*, exh. cat. (St. Louis Art Museum, 1977).

20. I. N. Phelps Stokes and Daniel C. Haskel, *American Historical Prints: Early Views of American Cities, Etc.* (New York Public Library, 1932), p. xv. The university is spelled *Capital,* despite the discrepancy in the inscription.

21. John A. Kouwenhoven, *Made in America: The Arts in Modern Civilization* (Garden City, N.Y.: Doubleday & Co., 1948), pp. 142-46. For further discussion of this aspect of American literary history, see Daniel J. Boorstin, *The Americans: The Colonial Experience* (New York: Randon House, 1958), pp. 319-40; and James D. Hart, *The Popular Book: A History of America's Literary Taste* (New York: Oxford University Press, 1950), pp. 22-66.

22. The Diamond Match Company assumed control of the plant in January 1882. "Oshkosh Match Making Factory Among Largest," *Oshkosh Daily Northwestern*, 25 October 1928, Oshkosh Public Museum Archives.

7 Thomas P. Anshutz, *Steamboat on the Ohio,* ca. 1896.

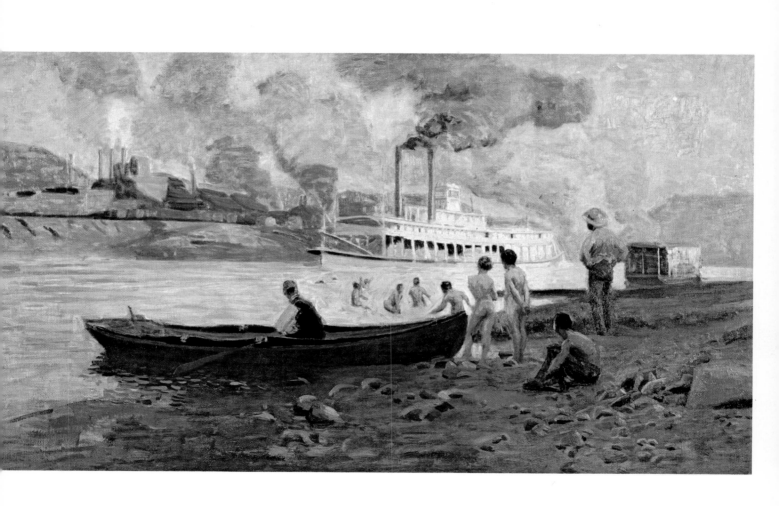

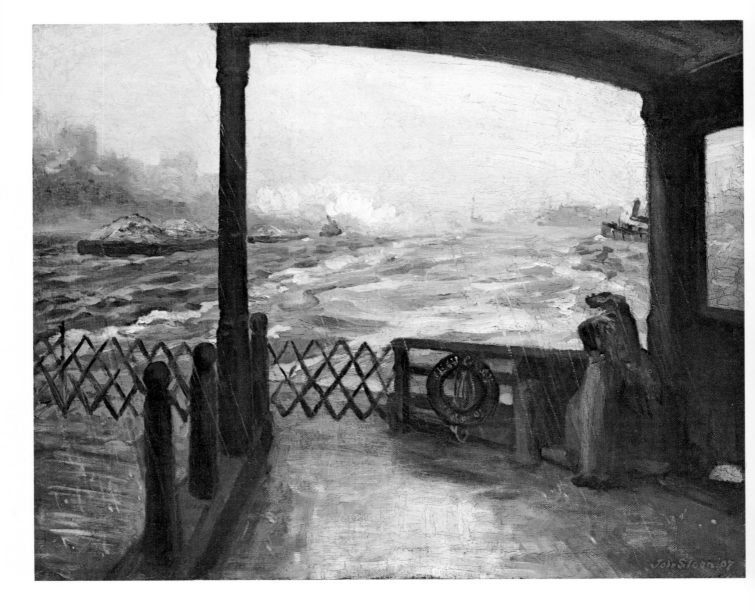

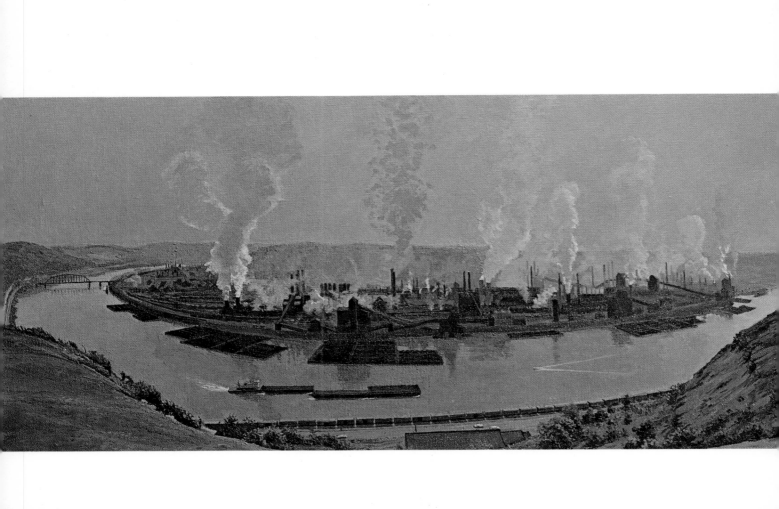

23. Jay E. Cantor, "The New England Landscape of Change," *Art in America* LXIV (January-February 1976): 51.

24. Daniel D. Barnard, "Commerce, as Connected with the Progress of Civilization," *Merchant's Magazine* I (July 1839): 27.

25. Charles Frazer, "The Moral Influences of Steam," *Merchant's Magazine* XIV (June 1846): 503, 504.

26. Henry Tuckerman, *Book of the Artists: American Artist Life* (New York: G. P. Putnam & Son, 1867), p. 518.

27. Virginia E. Lewis, *Russell Smith: Romantic Realist* (University of Pittsburgh Press, 1956), pp. 69-70.

28. Lewis, *Smith*, p. 17. A finished painting of almost the same scene, *View of the Salt Works on Saw Mill Run, ca. 1834*, is in the collection of the Museum, Carnegie Institute, Pittsburgh.

29. Ibid., cat. nos. 18, 19.

30. Ruth B. Moran, "The Real Life of Thomas Moran," *American Magazine of Art* XVII (December 1926): 646; Thurman Wilkins, *Thomas Moran: Artist of the Mountains* (Norman: University of Oklahoma Press, 1966), pp. 20-56.

31. G. W. Sheldon, *American Painters* (New York: D. Appleton and Co., 1879), pp. 122, 123, 126.

32. Moran regarded his water colors as studies of nature, some of which he may have intended to use later as the basis for large-scale paintings executed in his studio. Carol Canda Clark discusses Moran's watercolor painting in relation to nineteenth-century aesthetics in *Thomas Moran: Watercolors of the American West*, exh. cat. (Fort Worth, Tex.: Amon Carter Museum of Western Art, 1980), pp. 23-36.

33. Wilkins, *Moran*, pp. 198-200.

34. Sheldon, *American Painters*, p. 123.

35. Sandra Denney Heard, *Thomas P. Anshutz, 1851-1912*, exh. cat. (Philadelphia: Pennsylvania Academy of the Fine Arts, 1973), p. 7.

36. Francis J. Ziegler, "An Unassuming Painter — Thomas P. Anshutz," *Brush and Pencil* IV (September 1899): 280.

37. As a member of the faculty of the Pennsylvania Academy, Anshutz had the opportunity to stress the importance of direct observation to students John Sloan, George Luks, Robert Henri, and William Glackens who would later form the core of the New York group of realists known as the Ashcan school.

38. The photographs were discovered by Ruth Bowman among memorabilia and other photographs found on the property where Thomas Anshutz and his wife had lived after the turn of the century. Bowman published some of her findings in "Nature, the Photograph and Thomas Anshutz," *Art Journal* XXXIII (Fall 1973): 32-40. Although the photographs are not dated, they can be assigned with certainty to the years 1890-91 on the basis of Figure 4 in her article. This photograph, attributed to Anshutz and titled "On the Banks of the Ohio River," clearly reveals a bridge in the process of construction. Historical photographs in the archives of the Mansion Museum in Wheeling reveal that the "Old Steel Bridge" was in construction during the years 1889-91. The author is grateful to Gary E. Baker, Curator at the Mansion Museum, for his assistance in the location and examination of these photographs. Baker also aided in the identification of the steel mills seen in the background of the photographs — mills which Anshutz included in his painting. Although Bowman suggested that LaBelle Iron Works might have been located here, reference to the *Atlas of the City of Wheeling/West Virginia: Compiled and Drawn from Official Records, Private Plans and Actual Surveys . . .* (Philadelphia: A. H. Mueller, 1901) indicates that the Riverside Iron Works and the Belmont Nail Company were the factories visible along this particular section of the river.

39. Samuel L. Clemens, *The Adventures of Huckleberry Finn* (New York: Harper & Brothers, 1896), pp. 155, 126.

40. Marx, *Machine*, p. 229.

44 Rackstraw Downes, *The Coke Works at Clairton, Pa.*, 1975 (detail).

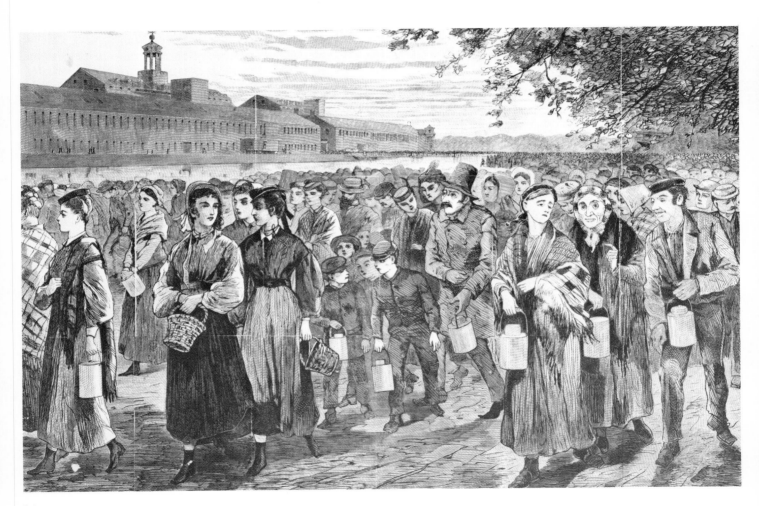

Illustration

The Popularity of Illustrated Magazines

Several illustrated periodicals emerged during the middle decades of the nineteenth century. Depictions of everything from the pleasures of the rich to the hardships of the poor enlivened otherwise monotonous columns of text.[1] The popularity of illustrated weeklies such as the *Illustrated American News, Gleason's Pictorial, Frank Leslie's Illustrated Newspaper, New York Illustrated News,* and *Harper's Weekly* played a part in stimulating public interest in pictures, especially of contemporary life and society. New subjects continually demanded the attention of reporters as well as artists. The construction of new buildings and factories, changing working conditions in those factories, and the growing dissatisfaction of labor were all themes which suggested the use of a straightforward, documentary drawing style. As the effects of mechanization began to involve a larger proportion of the American population, subjects related to industry became more and more prominent in periodical literature. Thus, illustration became an important link in the realist tradition in American art.

Harper's Weekly began publication in New York in 1857, running serial stories as well as news. Illustrations were related to news articles, essays, fiction, or American life in general. Able to attract the best journalists and the best illustrators and political cartoonists, the magazine soon became the leading publication of its kind in the country.

Winslow Homer (1836-1910) sold his first drawing to *Harper's* in 1858 and for sixteen years continued to earn his living chiefly from drawings which appeared in that magazine. He declined a permanent position on the staff, preferring the flexibility of free-lancing. At a time when most illustrators were not permitted the luxury of personal preference in their assignments, Homer maintained a large margin of freedom in both the choice of, and approach to, his subjects. He also maintained control over his work during the initial stages of the reproduction process. Invariably he drew his own designs onto the woodblock rather than submitting his sketches to be redrawn by staff artists.[2] Even the obvious shortcomings of the assembly-line engraving process failed to obscure the freshness and clarity of the best of Homer's designs. The artistic superiority of his drawings separates them from most magazine illustrations of the mid-nineteenth century. The corpus of Homer's drawings — which appeared over the years in *Harper's Weekly* as well as *Galaxy, Appleton's Journal, Hearth and Home,* and others — therefore provides a vivid and specific record of certain phases of the social history of the period and includes images which relate to the industrial theme.

The Ranks of Labor

Winslow Homer's talent lay in his ability to distill from a scene the essence of a moment of life. His drawings were rarely associated exclusively with a particular

news event but were pictures in their own right, independent of the text. His drawing entitled *New England Factory Life — "Bell-Time"* [8], which was engraved for *Harper's* and published 25 July 1868, appeared as an illustration for an article that discussed Charles Dickens's views of the New England factory system. While Dickens had "heartily condemned some other of our less terrible national crimes and social peculiarities," he spoke favorably about the laborers in the mills at Lowell, Massachusetts, comparing them with their counterparts in Manchester, England. The same article also quoted his *American Notes:* "from all the crowd I saw in the different factories that day, I can not recall or separate one young face that gave me a painful impression."[3]

In light of the Dickens quote, the pale and saddened face of the young woman that predominates the right foreground seems contradictory. Clutching her tattered shawl, she gazes listlessly to her left, inclining her head toward the figure of the gaunt old woman pointing a gnarled finger back at her young companion. The juxtaposition of this pair is made even more disconcerting by the penetrating stare of the old woman. She is the only figure in the scene who looks directly out at the spectator — as if to emphasize that her gesture, too, is intended for an audience beyond the picture frame.

It seems unlikely that *"Bell-Time"* was a commissioned drawing. The artist probably chose the subject as a result of his own interest. Homer sketched the scene of the dispersion of hands at the Washington Mills in Lawrence, Massachusetts — less than ten miles down the Merrimack River from the factories Dickens had visited in Lowell. *Harper's* made use of the drawing in its 25 July issue, despite the subtle discrepancies between the mood of the drawing and the tone of the article about New England factory life. The style of the work was a departure from the strong, rhythmic quality and crisp

contrast between blacks and whites that characterize many of his drawings from this period. Instead, an unpunctuated gray tonality prevails here — from the prison-like facades of the bleak factory complex in the background to the seemingly endless procession of spiritless workers departing from it.

Despite early optimism about the future of industrialization in this country, mechanization did not liberate the American worker from drudgery. The textile industry was no exception. Increasingly automated processes resulted in high-speed, continuous production, forcing workers to keep up with the pace of the machine while performing repetitive, menial functions as efficiently as possible. Many jobs became not only more monotonous but more dangerous, for slight miscalculations or inattentiveness often brought disaster. The typical attitudes of management reinforced the machine's tyranny over the lives of its operators. As one Fall River mill owner expressed it: "I regard my people just as I regard my machinery. So long as they can do my work for what I choose to pay them, I keep them, getting out of them all I can. . . . When my machines get old and useless, I reject them and get new, and these people are part of my machinery."[4]

There was relatively little evidence of protest against working conditions by mill employees in the early nineteenth century. Their passivity may be explained by the policing tactics of employers or by the frequent turnover of the labor force. The protests and strikes which began to erupt in the 1840s were usually prompted by wage issues rather than working conditions. That workers should daily be subjected to the very real hazards to health posed by inadequate ventilation and by poor air were taken for granted although one physician of the period described the factory setting as "one floating mass of cotton particles, which none but those accustomed to

it, can breathe, for an hour together, without being nearly suffocated."[5]

As mechanization increased, conditions worsened rather than improved. Controls were tightened, work hours lengthened, but wages were reduced. The effects of rapid industrialization were not confined to the textile industry alone. Competition forced shoemakers, printers, and cabinetmakers out of their shops and small enterprises, and into new factories. The abundant supply of cheap labor was as responsible as the introduction of ever newer machinery in keeping wages low. Millions of immigrants streamed across the Atlantic and settled in the manufacturing centers. They were readily available and eager for all kinds of work and accepted lower wages than those which native artisans and mechanics considered essential to support decent living conditions.[6]

The rising tide of immigration, combined with the harsh effects of industrialism, prevented any real consolidation of the ranks of labor. But a growing consciousness of the need to organize for mutual help began to develop. Strikes did occur. Some were spontaneous walkouts in response to wage reductions or working conditions, and some were directed by union organizations specifically to achieve improvements. The 1851 strike by Pittsburgh iron workers in response to a reduction in wages, for example, was typical. Despite violent clashes between strikers and strikebreakers, however, within six weeks enough strikebreakers were back at work in the mills to effectively mitigate the strength of the walkout.[7] Progressive newspapers and journals reported strikes; some also covered the plight of the workers and outlined the circumstances which led to their uprisings. As a result, the public gradually became aware of the real reasons for the restlessness of the workers. The *Trenton Daily State Gazette*, 24 April 1857, noted with approval the settlement between master and jour-neymen carpenters: "Men should always have a fair compensation for their labor, and we believe it is seldom that they demand more."[8]

News of one group in particular helped to awaken the American public to the seriousness of labor problems in this country — the Molly Maguires. The Mollies were a secret society operating in the anthracite coal regions of eastern Pennsylvania. Their agitation increased in the early 1870s when the peaceful Workingmen's Benevolent Association failed to win improvements during a series of negotiations. When the Association dissolved during a six-month strike protesting a ten-percent wage reduction in 1874, the Mollies stepped in.[9]

The Irish had immigrated in large numbers to the Pennsylvania coalfields, especially as a result of the famine in 1846-52. Although many had farming experience in Ireland, they were fearful of the isolation of Western farmlands and were drawn instead to the close-knit communities that grew up around many mine shafts. But life was very difficult — wages were low and rent prices at the company store were high. And, in one sense, their old antagonists — the landlords who had controlled their lives in Ireland — were reincarnated in America, where their adversaries were the mine owners and mine bosses. The secret society, itself a revered Irish institution, was reborn in Pennsylvania.[10]

The Molly Maguires was not a labor organization. Its members were resolved "to promote friendship between Irish Catholics and to assist one another at all times."[11] They did occasionally punish harsh and overbearing supervisors, but their program of retaliatory measures was directed more broadly at individuals deemed to be unjustly oppressing the Irish community as a whole, although sometimes their actions were directed at dissidents within their own group. Innumerable acts of arson, assault, and murder were attributed to members of the

Molly Maguires, but their involvement in the frequent eruptions of violence among mining communities — particularly during strikes — was certainly exaggerated by contemporary legend.

An illustration by Paul Frenzeny (active 1868-ca. 1889) and Jules Tavernier (1844-1889), published in *Harper's Weekly* on 31 January 1874, reflects some of the romantic attitudes that surrounded the society.[12] In *Meeting of the 'Molly M'Guire' Men* [9], the figures are resolute, dignified, even monumental — their bold faces emerging sharply against the blackness of an abandoned mine. The gesturing speaker at the center of a gathering of attentive listeners is reminiscent of the traditional motif of Christ preaching to his disciples.[13] *Harper's* readers may even have taken a moment to confirm that there were indeed twelve men in the strike leader's audience. The informality of his pose as well as the forebearance evident in the postures of some of the listeners, however, confirms the contemporaneity of the image. Though modified by these realistic details, the biblical association was certainly intended to inspire sympathy for the Mollies.

The *Harper's* article, in its coverage of the miners' strike over wages, featured the Molly Maguire secret society, its power, and its reason for being: "The coal fields of Pennsylvania are entirely under its control. . . . Through this secret society strikes are organized and put in execution, and woe to the miner who refuses to comply with the order of the council. Warnings come first, then threats; if the daring miner still disobeys, he is formally sentenced to death, and the sentence is carried out unless averted by submission. . . . It is not surprising that the miners should form such an organization as the best means in their knowledge of resisting the oppressive conditions which the coal companies often seek to impose upon them."[14]

For the quarter of a century after the Workingmen's Benevolent Association was forced out of existence, when no union functioned in the anthracite coalfields of Pennsylvania, the strikes continued, and magazines such as *Harper's Weekly* continued to print stories about the miners' plight. An article in *Harper's* on 21 January 1888 not only outlined a current wage controversy but went on to explain that the seemingly trifling increase of twenty cents per day was critical to miners who could work only two thirds of the year. William Allen Roger's (1854-1931) dramatic illustration, *The Pennsylvania Strike — Miners Calling a Meeting* [10], made the story even more compelling for thousands of urban readers. The winter landscape of the eastern Pennsylvania mountains underscored their struggle for survival. The miners seem dwarfed by the terrain and the black structure of the shaft house itself that juts out of the mountainside. Two dark figures in the foreground form a dramatic contrast to the lighter surrounding area as they crouch over a map scratched on the face of an exposed rock.[15] Plans had to be made surreptitiously, and meetings held in secret. As the article concluded: "the story that is here told of the atmosphere of the strike, of the poverty and misery which bred discontent, is essential to a just appreciation of the men who are now struggling against their employers to the discomfort of us all."[16]

Improvements in labor conditions were slow and painful during the last quarter of the century. While the American population rose more than 100 percent, the number of people involved in industry rose even more rapidly — from 3.5 to 14.2 million between 1870 and 1910. Such a rate was far too rapid for an equitable social adjustment. The benefits of the expansion and mechanization of industry were reaped by capital rather than labor. Machinery reduced manufacturing costs, but

9 Paul Frenzeny and Jules Tavernier, *The Strike in the Coal Mines — Meeting of "Molly M'Guire" Men,* 1874.

THE STRIKE IN THE COAL MINES—MEETING OF "MOLLY M'GUIRE" MEN.—Drawn by Frenzeny and Tavernier.—[See Page 106.]

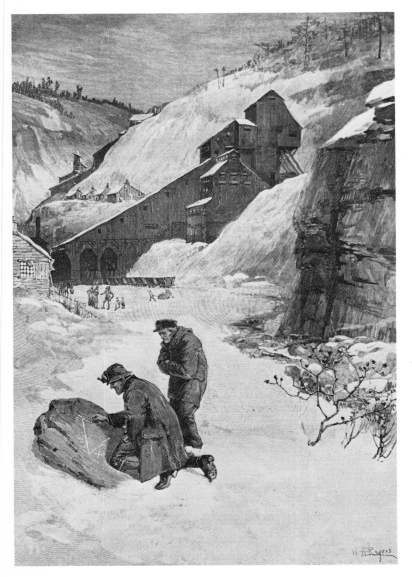

the savings were not passed on to workers. At the same time, the imperturbable forces of an economic revolutio were in operation and the process of industrialization and mechanization became irreversible. A network of railways crisscrossed the country, linking farms and ra materials to commercial centers — thus creating a national market. A growing population demanded an ever increasing supply of manufactured goods. The application of electric power and the introduction of the intern combustion engine further accelerated the growth and development of industry. By the turn of the century many firms were operating on a national scale, and the great corporation had become a permanent part of the process.[17]

The concentration of business into trusts, corporatior and holding companies tended to eliminate competition and to facilitate manufacturing, transportation, and marketing. Such big business organizations had little trouble winning battles with labor. They continued to operate under the outmoded conception of the employer as the host inviting workers to use his property under conditions dictated by the owner. In order to perpetuate this system and counter the growing strength of labor, small industries resorted to joining national employer associations, such as the League for Industrial Rights and the National Association of Manufacturers. Thus, despite overall improvement during the nineteenth cer tury, workers continued to suffer the constant threat o unemployment, and almost half of the nation's laborers existed on incomes just above the poverty level. They endured the squalor of urban life — living close to thei place of work, under chimneys that poured black smok

10 William Allen Rogers, *The Pennsylvania Strike — Miners Calling a Meeting,* 1888.

into the air. Industrial towns, as a rule, financed municipal improvements by levies on residents who benefited from the projects. Workers' neighborhoods, however, provided only a small tax base and were usually sorely lacking in sewer systems, water, and lighting.[18]

Late nineteenth- and early twentieth-century periodicals such as *McClure's, Arena, Scribner's, Collier's,* and *North American Review* published articles promoting reform of the conditions caused by industrialization and capitalism. Excerpts from Jacob Riis's examination of life in tenement housing, *How the Other Half Lives* (1890), appeared in *Scribner's* in 1889, and, beginning in 1903, Lincoln Steffen's exposure of political corruption, *The Shame of Our Cities* (1904), appeared in *McClure's Magazine. McClure's* also published installments of Ida Tarbell's *History of the Standard Oil Company* (1904), prefaced by an editorial stating that its intention was "to give its readers a concrete example of how a modern trust, aiming at monopoly, is made and sustained."[19] The series analyzed the methods used by Standard Oil to crush competition, seize natural resources, obtain rebates from the railroads, and purchase legislative favors.

During the height of the muckraking era, the public's eagerness to read about corruption and injustice stimulated and supported investigative journalism. *McClure's,* which continued as a leader in the progressive reform movement, maintained a reputation for publishing only articles based on painstaking investigation. The magazine commissioned two journalists, Ray Stannard Baker and Francis H. Nichols, to visit the coal counties of Pennsylvania, to study conditions, and to make reports on their findings. "Children of the Coal Shadow," written by Nichols, was one of the articles to come out of the project and was published in the February 1903 issue. The poignant story of youngsters deprived of their childhood, their happiness, and their health was illustrated by Frank E. Schoonover (1877-1972). The murky darkness of the depths of the mine, illuminated only by torchlight, was convincingly evoked by the initial drawing (Figure 9). The recent development of photomechanical processes made possible the faithful reproduction of such tonal subtleties.[20] Despite its small scale, only 2-1/2 by 6 inches, the illustration effectively presented the tone of the article. A simply conceived but effective composition evokes the idea of confinement. The figure crouched in the extreme left of a narrow, horizontal space hunches his shoulders as if in response to actual pressure — the top of the image pressing down upon him. The gaunt face of a boy hardly ten years of age reflects the misery and despair of all children so incarcerated.

Figure 9. Frank E. Schoonover, untitled, 1903.

Child labor laws — placing restrictions on the age at which children might be employed, limiting their hours of work, and assuring health and safety — were not adopted by many states until after the turn of the century. Meanwhile, in textile towns, mining communities, and lumber camps, a type of industrial feudalism continued to fester. This double standard of social morality between labor and capital existed throughout the nineteenth century. Combination of labor was widely regarded as conspiracy, while combination of capital was considered to be in accordance with natural laws.

The dawn of the industrial age coincided with the popularization and wide dissemination of ideas about evolution. It was not long before evolutionary ideas were advantageously applied to a study of society and to industrial America. Science and technology were paving the avenue of progress. Business America had confidence in itself, and industrialists were eager to adopt a philosophy that justified their activities — that equated their profit with the national good. Their accountability for social hardship might be mitigated by a philosophy that justified a certain number of victims in the struggle for survival. It was all in the name of progress.[21]

Although a significant number of American illustrators were sympathetic to liberal reform movements and were attracted to subjects related to the life of the working class, the greater majority were caught up in the mood of economic determinism that characterized the Gilded Age. They were fascinated by various types of industrial technology, and their treatment of subjects drawn from industry most often reflected a visual excitement in response to the world of the machine.

In the Name of Progress

Forces that would lead the country to become the world's foremost industrial power by the first decade of the twentieth century were already evident at the United States Centennial Exhibition held in Philadelphia in 1876. During the Exhibition, Machinery Hall was visited by more people than any other building. It housed the industrial and mechanical exhibits. The vast hall was dominated by the famous Corliss engine — a huge, double-acting, duplex, vertical-beam machine that stood 40 feet high, with 44-inch cylinders of 10-foot stroke. Theodore R. Davis (1846-1896) sketched for *Harper's* the exact moment, 1:22 pm, on the afternoon of 10 May, when President Grant and Emperor Dom Pedro of Brazil officially opened the fair by setting the engine into action [11]. Its 1500 horsepower propelled some 8000 lathes, grinders, drills, weaving machines, printing presses, and other mechanisms throughout the building. The largest and most powerful engine that had been built up to that time operated as quietly as a watch.[22]

America's first world's fair was intended to demonstrate that the nation compared favorably with all other countries in science, industry, business, and even the arts. As the President pointed out in his opening address, during the first hundred years of the nation's history, "our necessities have compelled us to chiefly expend our means and time in felling forests, subduing prairies, building dwellings, factories, ships, docks, warehouses, roads, canals, machinery, etc., etc."[23] The result was that the country's energy and creative instincts were directed to the design of useful things. Tools brought from Europe were adapted to an American environment. When they wore out, however, local blacksmiths hammered out the new ones. Modifications of design were not at first apparent. But a report by the British Commission at the Centennial Exhibition con-

tained a comparison of British and American tools. One commissioner noted, for example, that in contrast to the more bulky English ax the American ax was thinned considerably below the eye, a shape which "enables it to be more easily drawn out after the blow is given, and the body of the axe, being much firmer, is not liable to twist in working."[24]

American tools and machines were developed with an eye to efficiency and economy. The great Corliss steam engine was a masterpiece in this tradition of pragmatic design. The editor of the *Scientific American* erred in predicting that the engine would be a disappointment to the general public, devoid as it was of Gothic arches or other ornamental effects that customarily graced European machines. Even the correspondent from the *Manufacturer and Builder*, who criticized the "undoubted clumsiness" of its design, admitted that the engine looked "much better in motion than it did when standing still." Despite such projections, the public was exalted — not merely in the face of its power and efficiency but by its aesthetic impact. The poet Harriet Monroe, who attended the fair as a teenager, recalled being far more impressed by the Corliss engine "turning its great wheels massively" than by any of the art exhibitions.[25] Davis's illustration, though somewhat stiff and mechanical in its execution, evokes a similar attitude. Although multitudes of spectators are included, the machine easily dominates this scene. Its central placement in the composition is further reinforced by two ascending diagonals formed by railed steps that converge near the top of the engine. The structure is actually defined in the picture within the confines of an al-

11 Theodore Russell Davis,
*Our Centennial — President Grant and Dom Pedro
Starting the Corliss Engine,* 1876.

most equilateral triangle that finds its apex in the rafters above.

The Corliss engine was assigned a status beyond that of its awesome mechanical function. The *Atlantic Monthly*, for example, concluded that "surely here, and not in literature, science, or art, is the true evidence of man's creative power." Although machines and factories were not directly referred to as art until early in the twentieth century, a special regard for technology and the products of work was clearly apparent already in 1876 — a regard that was prophesied thirty-five years earlier by Ralph Waldo Emerson:

> Beauty will not come at the call of a legislature, nor will it repeat in England or America its history in Greece. It will come, as always, unannounced, and spring up between the feet of brave and earnest men. It is in vain that we look for genius to reiterate its miracles in the old arts; it is its instinct to find beauty and holiness in new and necessary facts, in the field and road-side, in the shop and mill. Proceeding from a religious heart it will raise to a divine use the railroad, the insurance office, the joint-stock company; our law, our primary assemblies, our commerce, the galvanic battery, the electric jar, the prism, and the chemist's retort; in which we seek not only an economical use.[26]

American artists gradually began to take note of the new forms of a technological age. They were drawn to the "field and road-side" and to the "shop and mill" in search of subjects for their art. Industrial expansion attracted business and people — and therefore artists — to the urban centers. What had been an agrarian and provincial nation was transformed by 1900 into a land of big cities connected by railroad, telegraph, and telephone. Industry and technology were changing the shape of America.

The population in greater New York City increased by thirty-eight percent between 1890 and 1905. The Pennsylvania Railroad sought to gain controlling interest in the transportation of that population as early as 1871 when it secured the United Railroads of New Jersey that terminated in Jersey City. It was not until 1900, however, that the company was able to purchase the Long Island Railroad. The connection between the two lines necessitated the spectacular feat of tunneling under two rivers as well as Manhattan itself. Excavations for the monumental Pennsylvania Station near Herald Square were described by one journalist as the "great $25,000,000 hole." In an area that stretched two blocks on both sides of Eighth Avenue, hundreds of men dug, drilled, and blasted their way down to the depth required to lay the foundations for the underground station. The spectacle was photographed, sketched, and painted. One series of drawings by G.W. Peters (active 1895-1910) was reproduced as a pictorial essay in the September 1907 issue of *Century Magazine*. While the grand plan of the McKim, Mead and White terminal building certainly promised an unprecedented architectural and engineering achievement, the bold spirit of American ingenuity itself was expressed in more blatant terms, in the actual excavation and construction process [12a-b].[27]

The steel industry was another indicator of industrial expansion and technological development in America. At the time of the Civil War, construction in the United States was limited to wood, stone, and a little iron. Within forty years, new fuel, new ores, and new technical processes, along with a protective tariff and an American genius for organization all combined to usher in the age of steel. The increase in American production, almost twice that of England or Germany, transformed the geography of many midwestern cities. For example,

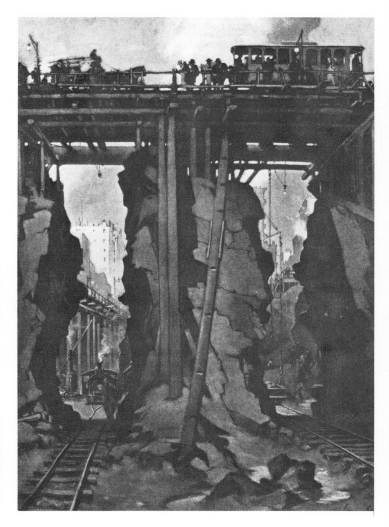

12a and **12b** G. W. Peters, *Excavation for the New Pennsylvania Railway Station*
and *The Pennsylvania Station Excavation, at Seventh Avenue and Thirty-third Street, (Looking East),* 1907.

13 Joseph Pennell, *Edgar Thompson Steel Works, Bessemer,* 1908.

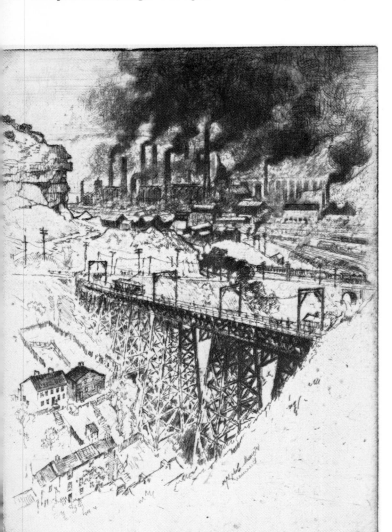

the discovery of an excellent grade of coal near Pittsburgh helped to establish that city as one of the centers of large-scale production.[28]

Andrew Carnegie is credited with laying the foundation for efficient organization in the iron and steel industry. He brought together the vast mineral resources of the Lake Superior region and the Bessemer process of converting iron into steel.[29] He acquired ore mines, coalfields, lake steamers, the entire Conneaut Harbor in Ohio, and the railroad line connecting that harbor with his Pittsburgh plants — the great J. Edgar Thompson steel works.

A view of these mills, seen on a trolley ride out of Pittsburgh, suggested an artistic composition to Joseph Pennell (1857-1926). Blast furnaces appeared to "group themselves under their canopy of smoke."[30] A steel bridge in the foreground functioned as an appropriate landmark in an era that proved the superiority of steel over wood and iron as construction materials. Exhilarated by this display of industrial power, he recorded the scene *Edgar Thompson Steel Works, Bessemer* [13] from the newly found vantage point. By the date of this work, Pennell was in the habit of executing most etchings on the spot without preliminary sketches or notes. He seldom attempted to reverse the drawing on the plate, fearing he might lose the spontaneous freedom of line so characteristic of his mature prints. He carefully developed the impression of dense haze hovering over the mills through painstaking attention to each stage of the etching process.[31]

Pennell considered himself a born illustrator, and his etchings and lithographs were widely reproduced in magazines and newspapers of the day. He, more than any other American graphic artist, may have demonstrated that the feats of the steel maker and the civil engineer were an appropriate subject for art. Whatever he

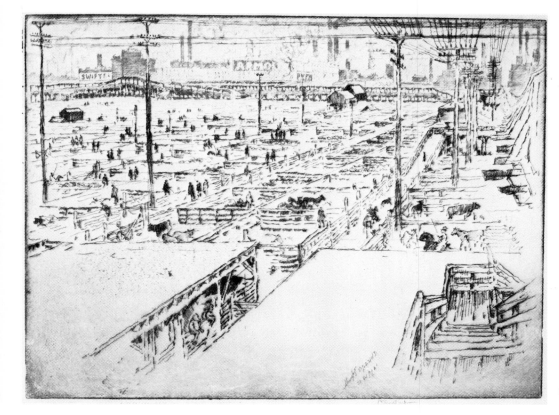

14 Joseph Pennell, *Stock Yards, Chicago,* 1910.

chose to depict — railway stations, steel works, skyscrapers under construction, grain elevators, shell factories — he communicated his fascination with the scene before him in its entirety, capturing the sense of movement and atmosphere of the industrial environment. The artist often made declarations about industry at work as a symbol of the contemporary age. In a short statement published in *Harper's Monthly*, for example, he wrote: "The mills and docks and canals and bridges of the pres-

ent are more mighty, more pictorial, and more practical than any similar works of the past; they are the true temples of the present."[32]

Pennell recorded the monuments of labor. Builders and workers seldom appear in his pictures. He frequently felt compelled to defend the objectivity of his position as an artist rather than an industrial reformer. In reference to his *Stock Yards, Chicago* [14], Pennell unabashedly admitted: "I have never been in them, don't

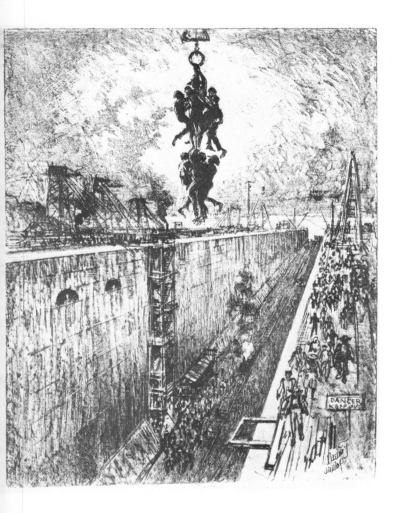

15 Joseph Pennell,
Panama: The End of the Day, Gatun Lock, 1912.

want to go, and have no interest in the social, financial, or sanitary condition of them. I am always being criticized for lacking interest in such matters, but my critics do not realize I am simply an artist searching for the Wonder of Work — not for morals — political economy — stories of sweating — the crime of ugliness. I am trying to record the Wonder of Work as I see it, that is all."[33] The artist must certainly have been aware of Upton Sinclair's scathing indictment of the meatpacking industry that was published only four years before the date of his own etching. *The Jungle* outlined in brutally realistic terms the laxity of government inspection, the techniques of slaughter, and the sale of diseased animals. That the factories of Armour and Company were one of Sinclair's targets (specifically identified in rebuttals about his book that he wrote for magazines)[34] was certainly of no consequence to Pennell. The Armour signboard is clearly visible in the background of *Stock Yards, Chicago.*[35]

The artist's continued search for subject matter brought him in 1912 to the Panama Canal, hoping that the "greatest engineering work the world has ever seen" would provide the "greatest artistic inspiration" of his life. The idea for the adventure was his own. *Century Magazine* and the *Illustrated London News* offered to print some of the drawings he made. Pennell's own description of the first scene he recorded, *The End of the Day, Gatun Lock* [15], conveys an immediate sense of his initial uncertainties and then the splendid fulfillment of all his imaginings:

> The locks are only a hundred yards or so away from the [train] station, and over to them I went with my sketching-traps, determined to do as much as I could before I was stopped — as I fully expected I should be. From a rough wooden bridge — bearing the legend that all used it at their own risk — spanning the locks

I looked down into a yawning gulf. Away below were tiny men and tiny trains. To the right the gulf extended to a lake; to the left rose great gates. On them pygmies were working; huge buckets and cranes rushed and creaked across the chasm. As I looked a whistle blew. Everyone instantly dropped their tools, and long lines of little figures marched away or climbed wooden stairs and iron ladders to the top; and as I looked, from the depths a long chair rose and clinging to the end of it, grouped as Cellini would have loved to group them, were a dozen men swinging up to the surface — the most decorative, yet real, motive in the Wonder of Work I had ever seen.[36]

Pennell's enthusiasm for any given subject was communicated chiefly by means of his choice of vantage point and, in *The End of the Day, Gatun Lock,* the moment he selected to portray. His own conception of his role as an illustrator was to convey to his audience exactly what the scene itself would have conveyed, without interpretation or judgment. Pennell never claimed that his vision was totally objective, but rather that he saw things "through a temperament."[37]

Industry and Commerce

Like Pennell, Louis Orr (1879-1966) had initially been attracted to traditional picturesque subjects of old Europe, and he became a specialist in the etching of Parisian scenes and cathedrals. He was born in Hartford, Connecticut, and received his first artistic training there but in 1906 immigrated to France, where he spent most of his artistic career. Although aspiring most consciously after eighteenth- and nineteenth-century French artists, he must have been aware of Joseph Pennell's widely publicized etchings of French cathedrals as well as his images of the Wonder of Work. As might be expected, Pennell's influence is most obvious in

a series Orr executed back in the United States — a series that brought him, in the words of a contemporary journalist, "to the very foundation heads of utility — the docks and wharves of commerce." His fourteen etchings of *Ports of America* included views of New York, Chicago, Cleveland, New Orleans, and Seattle. It would seem that visiting these "solid, utilitarian trade centers" inspired him to depart from his usual subject matter and to depict those aspects of American cities he considered most characteristic.[38] The great granaries that loom in his portrait of *Buffalo* [16] convey a sense of monumentality that rivals his treatments of Reims Cathedral or Saint Sévérin in Paris.

Orr's work illustrates the coming together of two traditions in American culture — one inherited from Europe and the other emerging in response to the actualities of a modern technological civilization. The authority of the historic traditions of Europe dominated the ambitions of many American artists. A significant number of American-born painters and sculptors became expatriates, disillusioned by what Nathaniel Hawthorne described as a land where "actualities" were so "terribly insisted upon."[39] Orr was following the example of Copley, Benjamin West, Whistler, Sargent, Mary Cassatt, and others who preferred to spend their creative lives in England, France, or Italy. Orr's interest in the great cathedrals, arches, and public buildings that still retained an aged glory was only natural, for architecture generated some of the most overwhelming impressions of European culture to Americans abroad. The stability and permanence of the antique — or even the old — was unknown in America, where forms of unembellished simplicity emerged quickly out of necessity. During most of his career, Orr avoided the challenge presented by the developing, vernacular tradition in America.[40] On his return, however, he sensed almost instinctively that a

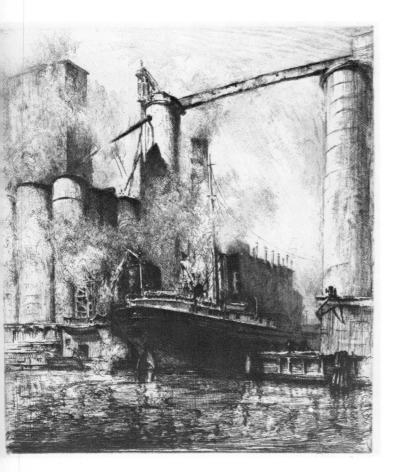

fruitful subject lay in the new cities, the new bridges, the hustle and bustle of commerce, manufacturing, and transportation. He perceived visually what Oscar Wilde had observed, that beauty existed in America "only where the American has not attempted to create it."[41] Even while he recorded the power and pulse of the city in his etchings of the *Ports of America,* he himself chose culture over materialism by keeping his residence in Paris.

Americans were by no means of one mind about the forms of industry and commerce they saw rising around them. Many took for granted the shapes of steel, concrete, and smoke that Pennell had found so stimulating. Others were awed, dazzled, even repulsed. Adolf Dehn (1895-1968) experienced a combination of all these sensations when he came to New York from the midwestern town of Waterville, Minnesota. His visual response to this machine-age urban center, however, was further complicated by his political leanings. As a student at the Minneapolis Art Institute he closely followed the Greenwich Village journal the *Masses*, which promoted artistic freedom as well as social revolution.[42] Although the *Masses* ceased publication in 1918, shortly after Dehn arrived in New York, he became associated with the group of artists and intellectuals who created its successor, the *Liberator*. [43] Several of his drawings were reproduced in the magazine, including a drawing of oil refineries along the East River entitled *The Petroleum Age* [17]. [44] A gargantuan storage tank overwhelms all surrounding buildings, including churches, apartments, and other industrial structures. Its menacing, almost organic shape seems capable of continued growth, effectively portraying the petroleum industry as a symbol of the crushing domination of big business over the masses.

Years later, Dehn's antipathy to, and suspicion of, industrial technology was somewhat mitigated, and in

1943 he accepted a commission from the Standard Oil Company of Louisiana to visit their refinery at Baton Rouge. The water colors he painted there were reproduced in the *Lamp,* a magazine published by the Standard Oil Company for its employees and stockholders. The fantastic forms of industry, such as the butadiene storage spheres seen at night that he depicted at this later period appear eerie, but benign (Figure 10).

Industrial patronage of small-scale illustration projects as well as major art works became an increasing source of artists' commissions throughout the 1940s — and has since continued to increase.[45] Labor, on the other hand, was hesitant to allocate funds for art.[46] One of the major exceptions to that tendency was the formation of the Graphic Division of the Political Action Committee established in 1943 by the CIO (Congress of Industrial Organizations). Ben Shahn (1898-1969) regarded his position as chief artist of the Graphic Division as a useful function. He described himself as "the communicative rather than the purely expressive sort of artist."[47] His determination to convey a message to a broad audience is evident in his poster *Welders* [18].

Shahn derived the image from a photograph.[48] The figure on the right was transcribed almost literally while the figure on the left was completely reinterpreted — a white, goggled face was replaced by a black worker whose downcast eyes are unobstructed. Brought directly into the foreground of the picture plane, the figures are monumentalized to a scale usually associated with mural painting. The heroic vantage point — looking up into the faces of the figures portrayed — is also associated with larger-than-life wall murals. As a youth, the artist had studied frescoes by such artists as Sassetta, the Lorenzetti, and Piero della Francesca in library books. In 1933 he was invited by Diego Rivera to work on an enormous fresco mural for the Rockefeller

17 Adolf Dehn, *The Petroleum Age,* 1921.

Figure 10. Adolf Dehn, *Butadiene Storage Spheres*, 1943.

Center. These experiences reinforced his desire to make his own art accessible.

The *Welders* poster was used as part of the Political Action Committee's campaign to achieve an influential political voice.[49] One of its immediate goals in the 1944 campaign was to help returning servicemen readjust to civilian life. The poster carried the words "for full employment after the war — register, vote," but the image Shahn created was invested with implications far beyond that isolated election-year issue. Shahn's portrait of the two welders was penetrating and individual, yet generalized enough to evoke the dignity of every working man and woman.

It is because Ben Shahn wanted to communicate through his art that his skills were so congenially adaptable to illustration. Communication is the task of the illustrator. It is his goal to convey an idea or a narrative moment through visual images. The reporter-

18 Ben Shahn, *For Full Employment After the War (Welders)*, 1944.

illustrator of the nineteenth century grasped the essence of an event as it was happening and translated that content quickly to paper. Illustrators of investigative stories or essays — whether concerned with the injustice of child labor, life in tenement housing, or the amusements of Coney Island — sought to evoke the reality of the subject through their drawings.

The illustrator's subjects have traditionally related to people and, most often, to their lives in the urban environment. The immediacy of the subject and the realistic, straightforward manner of presentation make illustration a logical and widely available source of imagery for American artists. The relationship between this indigenous, vernacular tradition and the development of American realism became most evident in the art of a group of artists who were painting city life at the turn of the century.

1. Drawings and paintings had to be reproduced in mass quantities as the demand for picture magazines increased. The usual method of reproducing illustrations was wood engraving, a process which permitted direct combination with the type-printed page. The individual blocks were approximately 3-1/2 x 2 inches, and several were usually joined together to produce a woodblock the size of the required reproduction. The polished woodblock was coated with white to create a smooth, paper-like surface on which the picture was drawn in reverse. After the drawing was transferred, the entire block was taken apart and each section given to a separate engraver in order to speed up production. See Frank Luther Mott, *A History of American Magazines*, 4 vols. (Cambridge, Mass.: Harvard University Press, 1957), vol. 2: *1850-1865*, pp. 43-45; E. Maurice Bloch, Introduction to *The American Personality: The Artist-Illustrator of Life in the United States, 1860-1930*, exh. cat. (Los Angeles: Greenwald Center for the Graphic Arts, University of California at Los Angeles, 1976), pp. 16-17.

2. E. P. Richardson, "Winslow Homer's Drawings in *Harper's Weekly*," *Art in America* XIX (December 1930): 39; Lloyd Goodrich, *The Graphic Art of Winslow Homer,* exh. cat. (New York: Museum of Graphic Art, 1968), p. 9.

3. "New England Factory Life," *Harper's Weekly* XII (25 July 1868): 171. Dickens's chapter on New England factories is quoted at length in Michael Stater, ed., *Dickens on America & the Americans* (Austin, Tex.: University of Texas Press, 1978), pp. 158-60.

4. Steve Dunwell, *The Run of the Mill* (Boston: David R. Godine, 1979), pp. 99-101.

5. Testimony recorded in the *Pennsylvania Senate Journal* (1837/38) and quoted in Anthony F. C. Wallace, *Rockdale: The Growth of an American Village in the Early Industrial Revolution* (New York: Alfred A. Knopf, 1978), pp. 181-82; Herbert G. Gutman, *Work, Culture, and Society in Industrializing America* (New York: Alfred A. Knopf, 1976), pp. 26-27.

6. Foster Rhea Dulles, *Labor in America: A History*, 2d rev. ed. (New York: Thomas Y. Crowell Co., 1960), pp. 76-80.

7. Philip Taft, *Organized Labor in American History* (New York: Harper & Row, 1964), p. 42.

8. Dulles, *Labor in America*, p. 90.

9. Taft, *Organized Labor*, pp. 70-73.

10. Wayne G. Broehl, Jr., *The Molly Maguires* (Cambridge, Mass.: Harvard University Press, 1964), pp. 83-86.

11. Ibid., p. 167.

12. Paul Frenzeny illustrated mostly New York and Pennsylvania views for *Harper's Weekly* between 1868 and 1873, sometimes collaborating with Jules Tavernier. *Harper's* commissioned the two artists to make a series of frontier illustrations on their journey from the East to the West Coast. The series was reproduced in *Harper's* from 1873 to 1876. Frenzeny biography in *The American Personality: The Artist-Illustrator of Life in the United States, 1860-1930* exh. cat. (Greenwald Center for the Graphic Arts, University of California at Los Angeles, 1976), p. 156. See also Gene Hailey, ed., "California Art Research," Abstracts from WPA Project 2874 (San Francisco, Calif., 1937), vol. 4, pp. 1-26, in microfilm no. NDA/Cal 1, Archives of American Art, Smithsonian Institution, Washington, D.C.

13. Patricia Hills noted the resemblance of the group to Christ-preaching images. Hills to the author, 30 June 1980.

14. "Coal Miners' Strike," *Harper's Weekly* XVIII (31 January 1874): 106.

15. For a further discussion of Roger's illustration style as well as biographical information, see Emily Bardack Kies, "The City and the Machine: Urban and Industrial Illustration in America 1880-1900" (Ph.D. diss., Columbia University, 1971), pp. 78-97, 187.

16. "The Coal Strike," *Harper's Weekly* XXXII (21 January 1888): 45.

17. Richard B. Morris, ed., *The U.S. Department of Labor History of the American Worker* (Washington, D.C.: U.S. Government Printing Office, 1977), pp. 109-17; Samuel Eliot Morison, Henry Steel Commager, and William E. Leuchtenburg, *A Concise History of the American Republic* (New York: Oxford University Press, 1977), p. 361.

18. Thomas C. Cochran and William Miller, *The Age of Enterprise: A Social History of Industrial America,* rev. ed. (New York: Harper & Brothers, 1961), p. 239.

19. "Editorial Announcement of Miss Tarbell's History of the Standard Oil Company," *McClure's Magazine* XXII (November 1903): 108. Riis's article was illustrated by pen drawings after photographs that Riis had taken. Steffen's articles were accompanied by photographs of the personalities involved in his exposés as well as by a few drawings, and Tarbell's series appeared with documentary photographs.

20. Before the development of photomechanical processes, such tonal gradations were difficult, if not impossible, to reproduce. Gray areas were created on the woodblock with fine, crosshatched lines — a time-consuming and exacting task if executed effectively. The invention of the halftone screen, in common use after 1890, finally freed the illustrator from the limitations of the line block and the intervention of the engraver. An original work in any medium could be directly translated into a printing surface by means of the screen, which used dots of varying size, clustered in various densities, to interpret tonal areas. From a normal viewing distance, the tones appeared continuous. Although the uniformity of the screens sometimes resulted in dull, shallow effects, the mechanical reproductive methods nevertheless did convey a more faithful representation of the artist's original work. Linda S. Ferber, "American Illustration: 1850-1920," in *A Century of American Illustration,* exh. cat. (New York: Brooklyn Museum Press, 1972), p. 15; Bloch, Introduction, p. 20.

21. For a concise discussion of Herbert Spencer's philosophy of progress and its influence in the United States, see Cochran and Miller, *Age of Enterprise,* pp. 119-28. Also see Richard Hofstadter, *Social Darwinism in American Thought,* rev. ed. (New York: George Braziller, 1959).

22. John W. Oliver, *History of American Technology* (New York: Ronald Press Co., 1956), pp. 300-301.

23. *A Facsimile of Frank Leslie's Illustrated Historical Register of the Centennial Exposition, 1876* (New York: Paddington Press, 1974), p. 77.

24. David McHardy, *United States Centennial Commission, Reports and Awards, Group XV* (Philadelphia, 1877), quoted in John A. Kouwenhoven, *Made in America: The Arts in Modern Civilization* (Garden City, N.Y.: Doubleday & Co., 1948), pp. 18-19.

25. Responses to the Corliss engine quoted in Kouwenhoven, *Made in America,* pp. 29-30.

26. Ibid., p. 30; Brooks Atkinson, ed., *The Complete Essays and Other Writings of Ralph Waldo Emerson* (New York: Modern Library, 1940), pp. 314-15.

27. Grace M. Mayer, *Once upon a City* (New York: Macmillan Co. 1958) pp. 285-89; Alfred Hoyt Granger, *Charles Follen McKim: A Study of His Life and Work* (Boston: Houghton Mifflin Co., 1913), pp. 76-77.

28. Oliver, *History of American Technology,* pp. 314-17; Morison, Commager, and Leuchtenburg, *Concise History,* pp. 365-66.

29. The Bessemer process involved driving air through holes in the bottom of the converter to burn out impurities in the molten iron ore. Oliver, *History of American Technology,* p. 318.

30. Joseph Pennell, *Joseph Pennell's Pictures of the Wonder of Work: Reproductions of a series of drawings, etchings, lithographs, made by him about the world, 1881-1915, with impressions and notes by the artist* (Philadelphia: J.B. Lippincott Co., 1916), pl. XII.

31. Elizabeth Robins Pennell, *Joseph Pennell,* exh. cat. (New York: Metropolitan Museum of Art, 1926), p. 23. Pennell's method of biting in the plate produced the particular effects he achieved. While working with Whistler during the summer of 1893 he learned to paint acid on the plate rather than to submerge the entire plate in the acid bath. By working over the entire plate in this manner he was able to control the action of the acid in each and every line in his design. Elizabeth Robins Pennell, Introduction to *Catalogue of the Etchings of Joseph Pennell Compiled by Louis A. Wuerth* (Boston: Little, Brown, and Co., 1928), p. xvii; the artist also discussed his etching methods in Joseph Pennell, *Etchers and Etching* (London: T. Fisher Unwin, 1920), pp. 251-52.

32. Joseph Pennell, "The Wonder of Work in the Northwest," *Harper's Monthly Magazine* CXXXII (March 1916): 591.

33. Pennell, *Wonder of Work,* pl. VIII.

34. See especially Upton Sinclair, "The Condemned-Meat Industry," *Everybody's Magazine* XIV (May 1906): 608-16.

35. Pennell also illustrated an Armour Year Book in 1919, a publication intended to provide the public with a "broader knowledge of Armour service" and to demonstrate that the company's function is a necessary one to the country's prosperity."

36. Joseph Pennell, "Joseph Pennell's Lithographs of the Panama Canal," *Print Collector's Quarterly* II (1912): 291, 299-300. The canal drawings were made in Panama on lithographic transfer paper, but transferred to stone in Philadelphia. Ibid., p. 312.

37. Ibid., p. 300. It was Zola who made famous the definition of art as "Nature seen through a temperament."

38. Both quotations taken from a syndicated news story that was printed in the *Akron Times Press,* 26 November 1928.

39. Nathaniel Hawthorne, Preface to *The Marble Faun* (1859; reprint ed., New York: New American Library, Signet Classics, 1961), p. vi: "Italy as the site of his [the author's] Romance, was chiefly valuable to him as affording a sort of poetic or fairy precinct, where actualities would not be so terribly insisted upon as they are, and must needs be, in America. No author, without a trial, can conceive of the difficulty of writing a romance about a country where there is no shadow, no antiquity, no mystery, no picturesque and gloomy wrong, nor anything but a commonplace prosperity in broad and simple daylight, as is happily the case in my dear native land."

40. Kouwenhoven, *Made in America,* especially chaps. 2, 6, 8, and 9, discusses the tradition of the vernacular in America.

41. From a lecture by Oscar Wilde entitled "Impressions of America," which he delivered in September 1883, shortly after returning to England; ibid., p. 211.

42. Richard Cox, "Adolph Dehn, Satirist of the Jazz Age," *Archives of American Art Journal* XVIII, no. 2 (1978): 11, 12. The *Masses* was an important organ of the assault championed by such younger artists and intellectuals as Max Eastman, Floyd Dell, Claude McKay against the American moral and cultural establishment. Largely realistic drawings by Robinson, John Sloan, George Bellows, Art Young, Maurice Becker, and others were reproduced in big formats usually independent of articles or poetry. See William L. O'Neill, ed., *Echoes of Revolt: The Masses, 1911-1917* (Chicago: Quadrangle Books, 1966), pp. 17-19.

43. The editors of the *Liberator* continued to expound their demands for a fundamental reconstruction of the social order. Acting as spokesman for the magazine and its staff, Max Eastman declared in the initial issue of 1918 their intention to direct an "attack against dogma and rigidity of mind upon whatever side they are found." He cited specifically their fight "for ownership and control of industry by workers," for "the immediate taking over by the people of railroads, mines, telegraphs and telephone systems, . . . for complete independence of women," etc., *Liberator* I (February 1918): 3.

44. *The Petroleum Age* appeared in the July 1921 issue of the *Liberator* on p. 11 (not on the cover, as Cox's 1978 article indicated).

45. See Walter Abell, "Industry and Painting," *Magazine of Art* XXXIX (March 1946): 82-93, 114-18; Richard Sedric Fox, *The Corporation and the Arts* (New York: Macmillan, 1967); Mitchell Douglas Kahan, ed., *Art Inc.: American Paintings from Corporate Collections,* exh. cat. (Montgomery, Ala.: Museum of Fine Art in association with Brandywine Press, 1979).

46. See Walter Abell, "Art and Labor," *Magazine of Art* XXXIX (October 1946): 231-39, 254-63. A notable example of a labor union's involvement in the arts is District 1199 of the National Union of Hospital and Health Care Employees. They are the only union with an art gallery, and they sponsored the exhibition and catalog *The Working American* (Washington, D.C.: Smithsonian Institution, 1979). This exhibition was only one of many art exhibitions, along with musical and dramatic performances, and poetry readings that comprise their Bread and Roses project. See, for example, "A Union Crusades for Rank-and-File Culture," *Business Week,* 15 January 1979, p. 108.

47. Seldon Rodman, *Portrait of the Artist as an American* (New York: Harper & Brothers, 1951), p. 54.

48. Photograph reproduced in Rodman, *Portrait of the Artist,* p. 65.

49. Shahn originally designed the poster while working for the United States Office of War Information. It was intended for use in an antidiscrimination effort, but was rejected by the OWI. For a description of the goals and activities of the CIO Political Action Committee, see James Caldwell Foster, *The Union Politic: The CIO Political Action Committee* (Columbia, Mo.: University of Missouri Press, 1975), pp. 2-21.

The City in the Industrial Age

Go Out into the Streets and Look at Life

By the time an author in the magazine *Brush and Pencil* (September 1897) decreed that "Art must step out of the picture gallery and go into the streets," a number of artists had already acted on that advice. They were newspapermen on assignment, drawing visual reports of life in the modern city, factories and bridges under construction, and new industrial processes. A group of Philadelphia illustrators found that experience provided the training ground for their life work. Under the charismatic influence of Robert Henri (1865-1928), their daily newspaper work became a critical ingredient in the formulation of their mature artistic styles and a significant factor in the emergence of a new art movement.

The group of young artists who gathered for discussions at Henri's studio in Philadelphia included John Sloan (1871-1951), William Glackens (1870-1938), George Luks (1866-1933), and Everett Shinn (1873-1958). Henri moved easily into a position of leadership, for his students were eager to emulate his energy, his idealism, and his sympathy for things new. His open-mindedness and his confident belief in progress was consistent with the optimism of his time. Economic growth in the last decades of the nineteenth century was coupled with an imperturbable faith in science, technology, and democracy. The twentieth century promised unlimited opportunity, and the American society responded. They committed themselves to self-improvement in unprecedented numbers — reading books, buying magazines, attending night classes. As an artist, Henri was stimulated by the promise of reform and the quest for a better life. He told his students: "The battle of human evolution is going on. There must be investigations in all directions. Do not be afraid of new prophets or prophets that may be false. Go in and find out. The future is in your hands."[1]

He believed, "All art that is worthwhile is a record of intense life. . . ."[2] It was his encouragement that convinced Sloan, Glackens, Shinn, and Luks that the subject matter they dealt with every day — subject matter drawn from life — was the real raw material for art. He also redirected their attention from English illustrators such as John Leech and Charles Keene to the work of masters such as Goya, Daumier, and Manet. It was their particular choice and treatment of subject matter that was important, although their stylistic qualities were appreciated, too. Henri had collected a few works by these artists, especially Daumier lithographs. His students were immediately attracted to Daumier's penetrating and sympathetic treatment of Parisian life.[3]

A strong realist tradition stemming from the influence of Thomas Eakins and transmitted through his student Thomas Anshutz at the Pennsylvania Academy of the Fine Arts may partially account for the emergence of a realist movement in Philadelphia.[4] The particular character of that movement, however, was determined to a large degree by the experience of its leading exponents in illustration. John Sloan worked for the *Philadelphia*

Inquirer and later for the *Press*. Luks worked for the *Bulletin*; Glackens, for the *Record,* the *Public Ledger,* and the *Press;* and Shinn for five different newspapers.[5] During the years they spent in news offices they developed a proficiency for quick, decisive observation and an ability to isolate those points critical to establishing location and a precise moment of life. Years later each of them testified to the value of their work as illustrators, Sloan, for example, urging his students at the Art Students League to: "Draw what you see around you. . . . Make life documents, plastic records about life. . . . Do illustrations for a while. It won't hurt you. Get out of the art school and studio. Go out into the streets and look at life. Fill your notebooks with drawings of people in subways and at lunch counters."[6]

The nucleus of artists that followed Henri to New York continued to rely on illustration as their main source of income. They were most successful selling their drawings to some of the inexpensive popular magazines. While thirty-five-cent literary periodicals such as *Harper's, Atlantic, Galaxy, Century,* and *Scribner's* continued to cater to an educated, monied audience, a group of more recently established ten-cent magazines soon became overwhelmingly popular with middle-class and lower-middle-class readers. The *Saturday Evening Post, McClure's,* and *Munsey's* dealt with the common life of the people and popular ideas of the time. They carried not only the fiction of some of the most noted authors of the day, but informative articles about developments in science and transportation and breathtaking stories of adventures and explorations. They also capitalized on the ready appeal of human-interest stories with serial biographies and character sketches. As a result, they closely mirrored the currents of the time. They also supported the progressive reform movements and liberal causes that were of particular interest to their audience.[7]

The Philadelphia realists received most of their assignments from these new, inexpensive, and widely circulated publications — partly because they soon became known for the types of subjects they portrayed. They were stimulated by themes drawn from the life of the working classes and minority groups of New York's Lower East Side and Greenwich Village. Their approach to these subjects was straightforward, their depictions of city life characterized by sympathy and understanding rather than sentimentality.[8]

William Glackens was considered the best draftsman of the group. Shinn later described his friend's ability to convey the character and quality of contemporary life: "If historians of the future wish to know what [the] America of city streets was like at the turn of the century, they have only to look at those drawings. Glackens mirrored life and reported it realistically."[9] His figure style was a departure from the attenuated, elegantly posed ladies and gentlemen featured in the fashionable illustrations of the day by artists like Charles Dana Gibson (1867-1944). The gestures and movements of the figures Glackens drew appeared much more natural and more convincingly expressive. His direct, blunt style was also appropriate in the context of the muckraking exposés that they often accompanied. His drawings were reproduced in the *Saturday Evening Post* in 1906 to illustrate a series of articles on child labor in the cotton-mill towns of Maine, New Hampshire, Georgia, and Alabama (Figure 11). With judicious economy of means, he described the plain garments, the joyless expressions, and stooped shoulders of boys and girls aged by their labor.

Sloan was the last of the Philadelphia group to move to New York City. A brief stay there in 1898, when Glackens arranged a position for him at the *New York Herald,* dissuaded him from making the change for some years. Recognized for his poster-style design, which was

a personal adaptation of art nouveau, he became the *Philadelphia Press's* leading artist between 1898 and 1903. During that time he used his linear, two-dimensional style to design a series of Sunday supplement cover pages. But the heyday of the newspaper artist was coming to an end. When the *Press* discontinued its own Sunday supplement, Sloan decided to free-lance as a magazine illustrator in New York.

While executing newspaper illustrations in his poster style, he also continued sketching and drawing in a realist manner. His continued admiration for the traditional illustrations of Leech and Keene is evident in his early New York illustrations (Figure 12). He also admired Forain and Steinlen, French illustrators whose drawings he saw in the journal *Le Rire.* Through Henri, he learned of Frans Hals, Goya, and Manet, and later remarked that his early work was influenced by these artists "who interpreted life with speed and spontaneity."[10] Although Sloan was never as commercially successful as Glackens, he devoted painstaking care to each assignment. He researched subjects with which he was unfamiliar and sketched specific New York locations for stories set in the city.[11] In time, roaming the streets of Manhattan became a regular activity.

Being a devotee of Walt Whitman, the artist was surely conscious of that poet's habit of immersing himself in the atmosphere and the life of the city. Sloan recorded in his diary that a walk in Brooklyn reminded him how well Whitman had known that place. The same afternoon he crossed the Brooklyn Bridge for the first time and recalled Whitman's account of crossing to Brooklyn by ferry.[12]

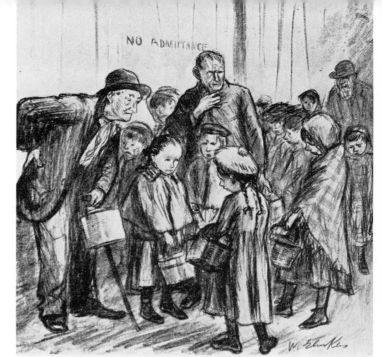

Figure 11. William Glackens, *The Old and the Young Stand Side by Side,* 1906.

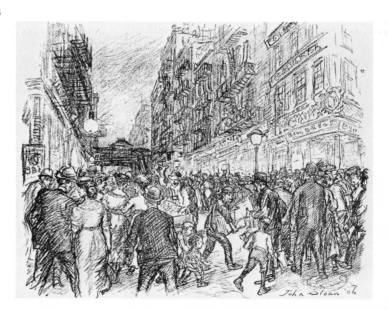

Figure 12. John Sloan, *At Six o'Clock the Waves of People Sweep Across Broadway,* 1907.

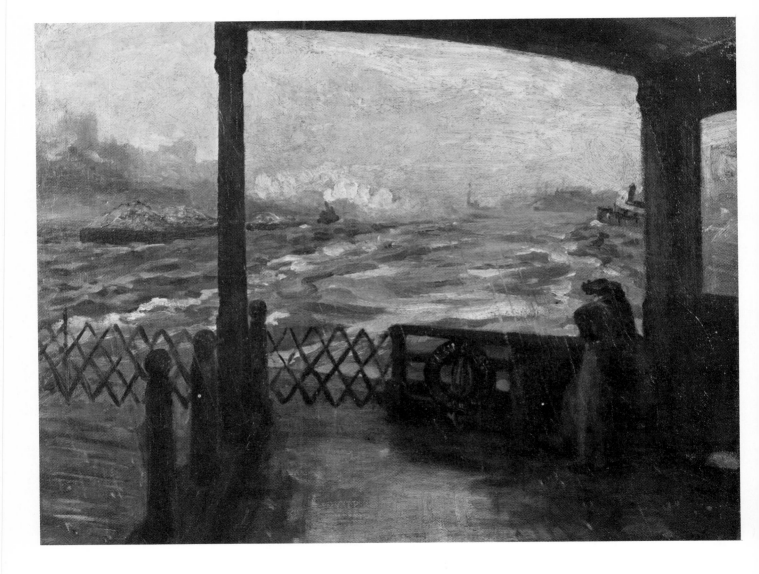

The white wake left by the passage, the quick tremu-
lous whirl of the wheels,
The flags of all nations, the falling of them at sunset,
The scallop-edged waves in the twilight, the ladled
cups, the frolicsome crests and glistening,
The stretch afar growing dimmer and dimmer, the
gray walls of the granite storehouses by the docks,
On the river the shadowy group, the big steam-tug
closely flank'd on each side by the barges, the hay-
boat, the belated lighter,
On the neighboring shore the fires from the foundry
chimneys burning high and glaringly into the night,
Casting their flicker of black contrasted with wild red
and yellow light over the tops of houses, and down
into the clefts of streets.[13]

On another date, Sloan noted in his diary a similar
trip to and from Jersey City: "Back from the ferry ride, I
made a start on a canvas. 'The Wake of the Ferry' it
might be called if it is ever finished."[14] This title indi-
cates that from the earliest stages of his work on the pic-
ture [19] he was concerned with the image of the
broadening wake. But other elements — the steam and
smoke, the urban buildings in the background, and the
barges and tugs on the Hudson — are also part of the
character of that ferry crossing. On one level, Sloan's de-
piction of the harbor scene was analogous to Whitman's
poetic record of the pulse and beat of the burgeoning
urban center.

Opposite

19 John Sloan, *Wake of the Ferry, No. 1*, 1907.

Right

Figure 13. G. W. Peters, *The Twentieth-Century Woman
on a New York Ferry-Boat*, 1907.

Sloan, however, felt mixed emotions about the ferry ride to Jersey City. For one thing it was "the first leg of the road home." He often saw his wife, Dolly, depart from here when she made her frequent trips to their native Philadelphia to consult with doctors about her nervous condition. On the present occasion he was escorting his friend and acquaintance Mary Perkins, who had been visiting for a few days with Sloan and his wife. Over time, that ferry crossing had come to be symbolic of departures, and despite the artist's growing love of New York, he later acknowledged that the painting he began when he returned home that day was a subject "perhaps evoked by some nostalgic yearning for Philadelphia."[15]

The emotive power of the image he created in *Wake of the Ferry* must have been due to the emotional overtones associated with the ferry crossing to Jersey City. The artist had not seen it as a pictorial motif, however, until 19 March 1906. He might have been stimulated by a magazine illustration. That week's issue of *Leslie's Illustrated* carried a cover illustration entitled *The Twentieth-Century Woman on a New York Ferry-Boat* (Figure 13). [16] A number of elements present in Sloan's painting are similar to the magazine illustration: the wooden roof, the window at the right, and the guardrail on the back of the ferry. Even the stance of the woman, with her foot resting on the lowest rung of the guardrail, seems remarkably aggressive — almost masculine. Sloan may have recalled the bold "twentieth-century" women on the magazine cover who dared to allow their shoes to be shined on board despite the disapproving glance of at least one gentleman.

Sloan, however, did not copy the illustration or structure his own painting on the basis of its composition. If he did see the publication (which is highly likely), his own deep involvement with illustrations about city life would have been enough to cause him to take note of the cover picture. He himself said that during the early period of his painting career his subjects "were chosen with an illustrative point of view. . . ."[17] It would have been only natural that such an image would have activated his own artistic imagination. *Wake of the Ferry* has a mood and tonal quality of its own — quite apart from the *Leslie's Weekly* illustration. Sloan's painting is somber and nostalgic, while the illustration, executed by a much less talented artist, is matter-of-fact and reportorial. Sloan conveyed a feeling for a particular moment in time through atmosphere and nuance rather than anecdote. Nonetheless, the approach to the subject and the motivation for creating a realistic image that is a record of life was related to the approach and motivation of an illustrator.

Creating a National Style

By 1908 the work of John Sloan and the other realists who continued to gravitate to Henri was beginning to express a style indigenous to America. In the view of Mary Fanton Roberts, an important critic and friend of several of the artists, their one purpose was "to paint truth and to paint it with strength and fearlessness and individuality. . . ." Qualities of brashness and forthrightness were considered appropriate to a civilization that Roberts referred to in the same 1908 article as "crude, brilliant, selfish, kind, self-conscious, amiable, born out of physical conditions of a country of boundless wealth and boundless space, without traditions." The artists credited with creating a national art for America were thus defined as "men who [were] not afraid to put into their work the big, vital, simple conditions and experiences of life."[18]

George Wesley Bellows (1882-1925) conformed perfectly to the specifications of the archetypal American artist. The public immediately sensed in his work the radiance of a zest for life and appreciated his direct, almost boisterous approach to subjects they could relate to. Critics used words like "action," "force," "ponderous," "powerful" to describe not only the paintings but also the painter. One writer in his opening remarks summarily encompassed the largeness of Bellows's art: "Strength — a great, broad, bulging, muscular strength with all its imperfections and crudities, its advantages and its disadvantages largely thrown at you in the raw, so to speak, by an apparent sincerity of purpose."[19]

If any one contemporary phenomenon reflected the bigness, brashness, and boldness of what was considered to be the collective American personality, it was the construction in New York of the subterranean terminal of the Pennsylvania Railroad. The spectacle of that project served as the subject of at least three paintings by Bellows. A version executed in 1909, *Pennsylvania Station Excavation* [20], epitomizes the exuberance and vitality of his approach to his subject. His confrontation with current history and his coarse, impulsively applied brushstroke impart a sense of immediacy to his paintings. Those same qualities point up what he learned from illustration.[20] "He suggests to me the alertness of American journalism turned painter, the reportorial spirit armed with palette and brush," wrote one of his contemporaries. Another observed in him "the ideal illustrator's faculty of observation and a good deal of the illustrator's instinct for the telling action."[21] These abilities were seen to go hand in hand with qualities that branded his paintings as American — "traits of breadth, simplicity, sincerity and blunt truth which Bellows drew from the soil."[22] A tribute to that artist, written for *Scribner's* three years after his death, defined his contribution to art as "a strain of life comparable to what Abraham Lincoln gave to politics."[23]

Bellows was the most successful of the group of artists who came to be known as the Ashcan school — perhaps because his artistic personality was perceived as being so typically American.[24] One of his paintings was admitted to the National Academy of Design exhibition in 1907, and two years later he became the youngest artist in history elected as an Associate to that venerable institution. Along with the Society of American Artists, the Academy supervised comings and goings of note in the art world and marshalled established and aspiring artists alike to the task of emulating European academies. Many different tendencies and permutations of style were tolerated by the Society as long as they were legitimized by European precedent. The academic naturalism of French artists such as James Tissot (1836-1902) and Alfred Stevens (1817-1875), among others, were widely imitated.

The official presiding art bodies — despite their approval of Bellows — were increasingly hostile toward Ashcan artists such as Luks, Glackens, Sloan, and Shinn. Their departures in subject matter and social attitude presented a challenge to the established artistic authority, and their work was consistently rejected by the National Academy as well as the Society of American Artists. Hopes for a slackening of official resistance were temporarily raised when Henri was appointed a judge for the National Academy spring exhibition in 1907, but those hopes were shattered when Henri was unable to convince the jury to accept any of his students' paintings. Two of Henri's own entries were given a "number 2" rating, which meant that they were not to be hung in preferred positions "on the line," but above or below eye level.[25] Henri therefore withdrew his entries and, along with Glackens and Sloan, initiated plans for a

counter-exhibition. The works exhibited by "Eight Independent Painters" at the Macbeth Gallery thus signified the first widely visible sign of revolt in American art. Strengthened by success, that spirit of reaction produced a number of independent exhibitions in the next few years and eventually led to the Armory Show in 1913.[26]

One of the artists marginally associated with the Henri group, Henry Reuterdahl (1871-1925), was frustrated time and again by rejections from the National Academy. His studio was adjacent to Sloan's studio-apartment on West Twenty-third Street in New York, and it was Sloan who noted, in particular, that Reuterdahl was "extremely grouchy over his exclusion from the N.A.D. exhibition" in 1907. By the time he was asked in December of 1911 to be a member of the Association of American Painters and Sculptors, which was planning and organizing the Armory Show, he had already left his New York studio and was working at his home in Weehawken, New Jersey, just across the Hudson River.[27] Perhaps that move separated him somewhat from the activities of the New York art circles. In any case, he made no response to the Association. But later, when none of his paintings were selected for the exhibition and when publicity aroused interest in the show, he and a number of other artists protested their exclusion. In the end, the Association decided to allow artists to submit works to the Domestic Committee, chaired by Glackens. Acting as a jury, the committee selected works by artists such as Maurice Becker, Stuart Davis, Edward Hopper, Joseph Stella, and William Zorach, along with one painting by Henry Reuterdahl — *Blast Furnaces* [21].[28]

20 George Bellows,
Pennsylvania Station Excavation, 1909.

Reuterdahl had little formal, artistic training. He entered the American art scene initially as an illustrator — sent by the Swedish weekly *Svea* to illustrate the World's Columbian Exposition in Chicago. Afterward he remained in Chicago and joined the staff of *Leslie's Weekly* as their Western artist. Moving to New York in 1897, he earned his living as an illustrator but, like the other New York realists, he also devoted attention to painting. His specialization in the illustration of marine and naval subjects determined to a large extent the direction of his painting career. He did, however, occasionally illustrate subjects related to the urban environment, landscape scenes, and seaports around the world.[29] The attitude with which he usually approached his work is suggested in a letter addressed to the editor of *Century Magazine*. Inquiring about possible interest in an illustrated article about a new British battleship, he pointed to the "great deal of romance about the whole affair," and indicated his willingness to deal with the subject "in a picturesque manner."[30]

The subject of *Blast Furnaces* was a departure from the themes he usually favored, although his interest in the steam and smoke and the romantic aspects of the scene is not surprising. The theme itself may have arisen out of his fascination with the building of battleships. An energetic, sketchy brushstroke, acquired in his years as an illustrator, conveys a feeling for the activity of the huge steel-making complex sketched at Sparrow's Point, Baltimore.[31] Quick, sure gestures of the brush describe the basic elements of the composition. The overall impression presented in his treatment of the industrial environment, however, is a continual shifting of colorful reflections in the surface of the water and rising clouds of vapor.

Romantic tendencies already evident in early nineteenth-century American painting remained a fac-

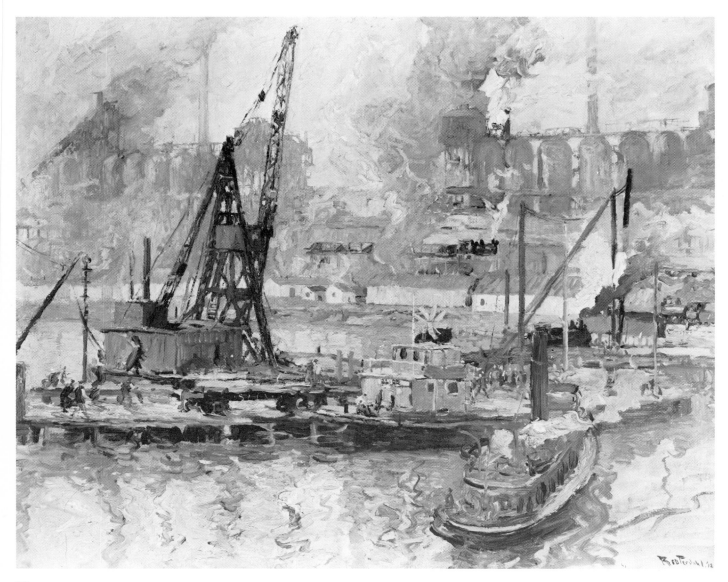

66

21 Henry Reuterdahl, *Blast Furnaces,* 1912.

22 Joseph Stella, *Pittsburgh Night,* 1920.

tor in the realist tradition throughout its resurgence in the early twentieth century. Although journalistic in approach and viewpoint, Reuterdahl, like Sloan and Bellows, went beyond a physical description of the scene as he observed it to give expression to inanimate features of the landscape. The fluctuating waves of smoke and fog in *Blast Furnaces* — like the evocative atmospheric effects in *Wake of the Ferry,* for example — betray the artist's feelings and emotions.

The same tendency to convey a personal, emotional level of response in the subject is apparent in the work of Joseph Stella (1877-1946). His drawings were not purely reportorial, even when he was actually on assignment.

Stella did work as an illustrator, like Henri's followers, and he must have known and associated with these young realist artists. He was also enrolled at the New York School of Art during part of the time Henri was teaching there. That he was either influenced by these contacts or had an innate interest in imagery observed in the streets of the city seems apparent from his own autobiographical notes written in 1946. His chief concern during his early years in New York, as he himself later recounted it, was "to catch life flowing unaware with its spontaneous eloquent aspects, not stiffened or deadened by the pose."[32] In 1908, the year of the landmark exhibition at the Macbeth Gallery, the *Survey* assigned Stella to do a series of drawings of steel mill workers and miners in Pittsburgh. The experience moved him deeply: "I was greatly impressed by Pittsburgh. It was a real revelation. Often shrouded by fog and smoke, her black mysterious mass — cut in the middle by the fantastic, torturous Allegheny River and like a battlefield, ever pulsating, throbbing with the innumerable explosions of its steel mills — was like the stunning realization of some of the most stirring infernal regions sung by Dante."[33] The sensibilities communi-

cated by an expressive literary style, colored by suggestions of powerful visual images, were portrayed even more eloquently in more than one hundred drawings inspired by the Pittsburgh visit. Expanding areas of black and gray were invested with his own feelings about "the black sky eternally black and throbbing with black smoke."[34]

His early impressions of the American industrial scene — of its "grandiose horror and beauty" — were renewed ten years later when the *Survey* commissioned another series of industrial drawings.[35] The editors were interested in illustrations showing the American industrial worker involved in the war effort, but had not taken into account the shift of emphasis in Stella's work toward futurism and cubism during the intervening decade. He included very few figures in these drawings; the artist was more concerned with the geometry of space and the interpenetration of planes. Despite his departure from their intentions, the editors did admit that "perhaps he has done something more important than his actual commission for us."[36]

In addition to the illustrations executed specifically for the *Survey*, a new group of industrial paintings and drawings were produced as a result of the commission. Many were characterized by an overall design composed of geometric shapes, but a charcoal drawing entitled *Pittsburgh Night* [22] was one of an additional group that revealed a tendency toward more realistic representation. Though simplified and generalized, the forms relate to recognizable factory and urban shapes. *Pittsburgh Night* also demonstrates a continuing preoccupation with formalist concerns. The composition is carefully

23 Carl Frederick Gaertner, *The Pie Wagon,* ca. 1926.

centralized. Strong contrasts of light and shadow concentrated in the middle-left and center of the paper emphasize the placement of two vertical elements — a pair of smokestacks to the left balancing the greater mass of the steeple at the right. Taken together with the white area rising behind them, these shapes form the pinnacle of a centrally placed triangle that emerges from the lower extremities of the composition.

By the 1920s modernism was an accepted fact in most American art circles, and ideas about the exploration of fundamental form served as points of departure for new developments. The influence of the Armory Show and the repeated pilgrimages to Paris on the part of American artists fostered a tendency toward abstraction on this side of the Atlantic. Cubism had gained a few exponents such as Max Weber (1881-1961) and Stuart Davis (1894-1964); Morgan Russell (1886-1953) and Stanton Macdonald-Wright (b. 1890) launched an offshoot of orphism called synchromism. But at the same time, innumerable regional artists all over the United States continued to work in a realist style.

One of the best known practitioners of the realist manner from the Midwest was Carl F. Gaertner (1898-1934). He painted the industrial elements of his native Cleveland and the landscape around his home in nearby Chagrin Falls. When his work was brought East for one of numerous shows at the Macbeth Gallery — the birthplace of the Ashcan school — a New York critic called attention to the "sincerity and honesty" of his work and said it was "quite in the American vein."[37]

A painting representative of his early mature work is *The Pie Wagon* [23], executed in 1926. The title was based on a common lunchtime occurrence observed in the steel-mill region of Cleveland — workers gathering around a horse-drawn bakery wagon. A spot of color and brightness attracts attention to the group of figures and the wagon itself, but the real subject of the picture is the steel mills. The prevalence of industrial subjects that Gaertner concentrated on throughout his career suggests his attraction to the atmosphere of the factory environment, but he was also inspired on an aesthetic level by the bold and interesting shapes of the buildings themselves. In connection with a somewhat later painting, he explained that he chose the subject because it suggested to him a "pattern of light and dark."[38]

Although Gaertner had no direct ties with the New York realists, his treatment of subject matter and bravura brushstroke reflects the wide popularity of the Ashcan style. This candid realism was a natural model for representational artists throughout the country. Gaertner's teacher at the Cleveland School of Art, Henry Keller (1870-1949), had studied in Munich and then Cincinnati. Those combined experiences would explain a tendency toward a dark and somber palette, but browns, ochres, and slate blues are more prevalent in his student's work than in his own.[39] Gaertner's realism must be attributed to his personal response to an art training which emphasized individual stylistic development and to his own observation of life around him.

The subject matter he selected was banal and commonplace almost without exception, the views he chose prosaic. Yet, like the Ashcan artists, he invested these subjects with poetry and importance. Despite his tendency to compose and structure a canvas from a composite of ideas and observations, his works were perceived as "the real thing." He was appreciated for his "direct" approach and his "ruggedness of thinking."[40] Contemporary criticism reveals that these hallmarks of a homegrown art were still widely appreciated in America. The following statements in a *Brooklyn Daily Eagle* column in 1927, for example, are typical:

The American scene, so called, has become of late years an increasingly popular theme with American painters who want to give their pictures the tang and flavor of nationality. Frequently, however, the native quality lies no deeper than its subject matter — skyscrapers, New England villages, slums and amusement parks, treated in any one of the self-conscious mannerisms which go to make up that phenomena known as modern art. And in consequence the result is more frequently Modern Art than American. . . .

That a truly indigenous quality can only be attained by a diligent search for reality, set down with simplicity and directness, is too little appreciated. And so the American scene, for all the number dedicated to expounding it on canvas had found only a few who were able to give it its special quality."[41]

Artists "expounding" on the American scene in the early twentieth century were primarily interested in the city. Commercialization, the growth of industrialization, and the increasing concentration of the population in urban centers was transforming the physical aspect of cities across the country. Rising skylines and a quickened pace of life came to represent progress and the future. As one New Yorker, writing for *Scribner's Magazine,* declared in 1903: "The crudeness and potentialities of our architecture afford a fit symbol of the universal city of the twentieth century." He was speaking particularly about his own home town. Its Brooklyn Bridge, its Flat-iron Building, and the pulsating crowds on Madison Square were prominent images of modernity. But the same author recognized the potential eloquence of urban forms in general and, in a sense, predicted the emphasis of early twentieth-century realism: "What our American cities most need to render them beautiful is an artist who will body forth to our duller eyes the beauties already there."[42]

Artists such as John Sloan, George Bellows, and Carl Gaertner indeed saw beauty in the stark, bold forms they depicted in their paintings. Their primary intention, however, was not to convey the picturesque aspects of the urban scene, but rather to portray the real life and atmosphere of specific people and places.

1. Robert Henri, *The Art Spirit* (Philadelphia: J. B. Lippincott Co., 1928), p. 103.

2. Ibid., p. 220.

3. Edgar John Bullard III, "John Sloan and the Philadelphia Realists as Illustrators" (Master's thesis, University of California, Los Angeles, 1968), pp. 39-41.

4. Eakins was influenced by French and Spanish realism. He studied at the Ecole des Beaux Arts in Paris under the celebrated Jean Léon Gérôme. He also observed the work of Spanish artists such as Velázquez and Ribera in the Louvre. He was attracted to the works of Léon Bonnat, who had lived in Spain and very much admired Spanish masters, and he terminated study with Gérôme in order to work for a time in Bonnat's studio. In 1869/70 Eakins traveled to Spain to see for himself Spanish paintings, which he described as "so good, so strong, so reasonable, so free from every affectation." See Gordon Hendricks, *The Life and Work of Thomas Eakins* (New York: Grossman Publishers, 1974), p. 58. See also Gerald M. Ackerman, "Thomas Eakins and His Parisian Masters Gérôme and Bonnat," *Gazette des Beaux Arts* LXXIII (April 1969): 235-56.

5. Milton W. Brown, *American Painting from the Armory Show to the Depression* (Princeton University Press, 1955), p. 11.

6. John Sloan, *Gist of Art* (New York: American Artists Group, 1939), p. 81.

7. Frank Luther Mott, "The Magazine Revolution and Popular Ideas in the Nineties," *Proceedings of the American Antiquarian Society* LXIV (21 April 1954): 196-98.

8. For a discussion of the Henri group and their sympathy for socialist concerns, see Patricia Hills, *Turn-of-the-Century America,* exh. cat. (New York: Whitney Museum of American Art, 1977), p. 166.

9. Everett Shinn, "Glackens as Illustrator," *American Artist* IX (November 1945): 22.

10. The statement originally appeared in the catalog for the Seventy-fifth Anniversary Exhibition at the Art Students League of New York. Also quoted in Forbes Watson, "John Sloan," *Magazine of Art* XLV (February 1952): 62. For a discussion of the subject matter and realist graphic style of Jean Louis Forain and Théophile Steinlen, see Gabriel P. Weisberg, *Social Concern and the Worker: French Prints from 1830-1910,* exh. cat. (Salt Lake City: Utah Museum of Fine Arts, University of Utah, 1973).

11. Edgar John Bullard III, "John Sloan: His Graphics," in *John Sloan 1871-1951,* exh. cat. (Washington, D.C.: National Gallery of Art, 1971), pp. 28-30.

12. Bruce St. John, ed., *John Sloan's New York Scene* (New York: Harper & Row, 1965), p. 428.

13. Walt Whitman, *Leaves of Grass,* ed. Emory Holloway (Garden City, N.Y.: Doubleday & Co., 1926), pp. 133-34.

14. St. John, *Sloan's New York,* p. 113.

15. Sloan, *Gist of Art,* p. 209.

16. The illustration appeared on the cover of *Leslie's Illustrated Weekly,* 21 March 1907, but the magazine was probably available at newsstands several days in advance of that date. There is, however, no indication in Sloan's letters, notes, or diaries that he actually saw the illustration.

17. Sloan, *Gist of Art,* p. 3. Only a few days after completing *Wake of the Ferry,* he threw a rocking chair at the canvas and ripped the upper left-hand corner. A second version of the painting is now in The Phillips Collection, Washington, D.C.

18. Giles Edgerton [Mary Fanton Roberts], "The Younger American Painters: Are They Creating a National Art?" *Craftsman* XIII (February 1908): 521, 512, 522.

19. Charles L. Buchanan, "George Bellows: Painter of Democracy," *Arts and Decoration* IV (August 1914): 370.

20. Bellows began studying with Robert Henri at the New York School of Art soon after he arrived in New York from Ohio. Although younger by about ten years than Glackens and Sloan, he was listed among these " 'historians' of modern American civilization" in "Foremost American Illustrators: Vital Significance of Their Work," *Craftsman* XVII (December 1909): 266-80. See also Louis H. Frohman, "Bellows as an Illustrator," *International Studio* LXXVIII (February 1924): 421-25.

21. Buchanan, "George Bellows," p. 371; Royal Cortissoz, "The Field of Art," *Scribner's Magazine* LXXVIII (October 1925): 446-47.

22. Ibid., p. 441.

23. Rollo Walter Brown, "George Bellows — American," *Scribner's Magazine* LXXXIII (May 1928): 585.

24. The term Ashcan school is most commonly used to refer to the New York realists, although the designation developed only gradually. An interview with Robert Henri in the *New York World,* 10 June 1906, is usually regarded as the earliest printed reference to ashcan-related subject matter: "It takes more than love of art to see character and meaning and even beauty in a crowd of east side children tagging after a street piano or hanging over garbage cans. . . ." Cartoonist Art Young was quoted in the *New York Sun,* 8 April 1916, as saying: "They want to run pictures of ash cans and girls hitching up their skirts in Horatio street. . . ." The specific wording "Ashcan school" appeared for the first time in Holger Cahill and Alfred H. Barr, Jr., eds., *Art in America* (New York: Reynal & Hitchcock, 1934), p. 89. See also Bennard B. Perlman, *The Immortal Eight: American Painting from Eakins to the Armory Show (1870-1913)* (New York: Exposition Press, 1962), p. 202.

25. Ibid., pp. 158-61.

26. Also called The International Exhibition of Modern Art, the Armory Show was the first comprehensive presentation in the United States of European and American twentieth-century avant-garde art. For a full account, see Milton W. Brown, *The Story of the Armory Show* (New York: Joseph H. Hirshhorn Foundation, 1963).

27. St. John, *Sloan's New York,* pp. 48, 221, 106.

28. Brown, *Armory Show,* pp. 35, 66-67; William Hutton, ed., *The Toledo Museum of Art: American Paintings,* catalog by Susan E. Strickler (Toledo, Ohio: Toledo Museum of Art, 1979), p. 94.

29. The United States Naval Academy Museum, *The Art of Henry Reuterdahl: A Retrospective Exhibition,* exh. cat. (Annapolis, Md.: United States Naval Academy, 1977), unpaginated. James W. Cheevers, "Henry Reuterdahl: 1870-1925," a copy of which was sent to the author 29 April 1980, is a more comprehensive account of Reuterdahl's life and work prepared at the time of the 1977 Naval Academy exhibition. A small collection of his illustrations are recorded on microfilm no. M55, New York Public Library Papers, Archives of American Art, Smithsonian Institution, Washington, D.C.

30. Microfilm no. N8, frames 108-9, *Century Magazine* Papers, Archives of American Art, Smithsonian Institution, Washington, D.C.

31. Cheevers, "Reuterdahl," p. 6.

32. Stella's autobiographical notes were written in 1946 for the Whitney Museum and then republished in the artist's "own language" in "Discovery of America: Autobiographical Notes," *ARTnews* LIX (November 1960): 41.

33. Ibid., pp. 41-42.

34. From a reminiscence of Pittsburgh called "White and Vermilion," quoted in Irma B. Jaffe, *Joseph Stella* (Cambridge, Mass.: Harvard University Press, 1970), p. 21. Six of the Pittsburgh drawings are also reproduced: see figs. 16-21. Illustrations of the mining environment appeared in *Survey,* January, February, and March, 1909.

35. "Notes About Stella" written by the artist, ibid., p. 20.

36. Ibid., p. 54.

37. "Factories Can Be Dramatic," *ARTnews* LI (January 1953): 51.

38. "Shore Drive Dump Painted by Artist," *Cleveland Press,* 29 January 1945.

39. Charles Burchfield, "Henry G. Keller," *American Magazine of Art* XXIX (September 1936): 586. Munich was an important international center of realist painting. Frank Duveneck came to Munich in 1870 and quickly adopted the characteristics associated with the Munich school: a broad, vigorous handling of the brush and a dark tonality. In 1878 he established a school in Munich, where many American students came to study. In 1889, Duveneck returned to America, and he began teaching at the Cincinnati Art Academy in the winter of 1890. With the exception of occasional trips to Europe and one year of teaching at the Art Students League in New York and at the Art Institute in Chicago, he remained closely associated with Cincinnati until his death in 1919. Keller's decision to study in Cincinnati may very well have been motivated by his interest in Duveneck's style of realism. Axel von Saldern, *Triumph of Realism: An Exhibition of European and American Realist Paintings,* exh. cat. (Brooklyn Museum, 1967), pp. 25-54.

40. *New York Sun,* 13 January 1945.

41. Helen Appleton Read, "The American Scene," *Brooklyn Daily Eagle,* 20 February 1927.

42. John Corbin, "The Twentieth Century City," *Scribner's Magazine* XXXIII (March 1903): 262,259. For a discussion of New York City as a source of symbols for modern American life and, as such, a source of subjects for artists, see Wanda M. Corn, "The New New York," *Art in America* LXI (July/August 1973): 58-65.

Precisionism and the Factory

The Machine as a Symbol of Order and Reason

When the art critic for *Scribner's Magazine* wrote in 1925 about the peculiarly American qualities George Bellows had drawn "from the soil," that agrarian metaphor was already a well-worn homily.[1] Bellows's background and his art were urban rather than rural, and the attempt to emphasize the indigenous character of his art by a reference to the farm was not only unoriginal but somewhat inappropriate. Early twentieth-century American critics, however, were often as enamored of romantic terminology as they were obsessed with identifying the Americanness of American art.

A similar, naive enthusiasm inspired editor Robert Coady to title his magazine the *Soil* in 1916. The few issues that were published were used by Coady as a format for making pronouncements about American art and for expressing romantic sentiments concerned not with the earth but, rather, with machinery. His basic position was set forth in a two-part essay contained in the first issues of the publication. He asserted that "there is an American art. Young, robust, energetic, naive, immature, daring and big spirited. Active in every conceivable field." The greater part of the essay consisted of a list of examples: "The Panama Canal, the Sky-scraper and Colonial Architecture. The East River, the Battery and the 'Fish Theatre.' The Tug Boat and the Steam-shovel. The Steam Lighter. The Steel Plants, the Washing Plants and the Electrical Shops. The Bridges, the Docks. . . . "[2] While his pedestrian prose was

only vaguely reminiscent of Whitman's verse, his emphasis on technology proved somewhat prophetic. The intensive industrial and commercial expansion of the 1920s was already well under way, and business was rapidly acquiring a status approaching that of a national religion. It was also the first time in the history of American art that a significant group of artists seriously concerned themselves with conveying the presence of industry and the machine.

At first glance it would appear that the stimulation for this new attitude toward technology did, in fact, grow out of the American scene, if not from the soil itself. A surge of industrial prosperity spurred the expansion of large corporations and provided confidence in technology, despite agricultural distress and a marked deterioration of labor's position following World War I. A rapid growth of construction marked the prosperity of the 1920s and created new skylines for American cities. Sixty- and seventy-story buildings soared over New York; Cleveland boasted a fifty-two-story Terminal Tower; and cities like Memphis and Syracuse pointed to buildings of more than twenty stories. New industries produced a staggering variety of new products, from panchromatic motion-picture film to antifreeze fluids to cigarette lighters. Streamlining through mechanization became an ideal for every American. As Henry Ford put it, "Machinery is the new Messiah."[3]

The machine emerged as a model of universal harmonic order and a symbol of rationalism, especially after

World War I. Factories and bridges — industrial structures built by engineers — were looked upon as patterns for a new architecture based on efficiency and reason. Functional forms were not just admired by a few artists for their aesthetic qualities, but industrial architecture and machines were in themselves regarded as art.

The real explanation for the new attitude toward technology, however, was considerably more complex than Coady implied in his 1916 essay. What he failed to acknowledge was the importance of the cultural interaction between Europe and the United States that prompted new art forms on both sides of the Atlantic.[4]

Members of the European avant-garde were among the first to express astonishment at the fantastic landscape of modern America. H. G. Wells, visiting New York in 1906, was obsessed with its "limitless bigness. . . . One has a vision of bright electrical subways . . . of clean, clear pavements . . . spotless surfaces, and a shining order of everything wider, taller, cleaner, better."[5] Dadaist Francis Picabia had his first exhibition in Steiglitz's gallery in 1913, and the *New York Tribune* recorded his enthusiasm: "I see much, much more, perhaps, than you who are used to it see. I see your stupendous skyscrapers, your mammoth buildings and marvelous subways, a thousand evidences of your great wealth on all sides. . . . Your New York is the cubist, the futurist city. It expresses in its architecture, its life, its spirit, the modern thought. You have passed through all the old schools, and are futurists in word and deed and thought."[6] American artist Charles Demuth (1883-1935) was surprised in 1921 to hear Frenchmen Albert Gleizes and Marcel Duchamp tell him "New York is the place, — there are the modern ideas, — Europe is finished."[7]

Demuth's career was one example of the creative and intellectual interactions taking place between Europe and the United States. His mature style began to develop during his Paris visit, from the winter of 1912 to the spring of 1914. He became acquainted with Picasso, Matisse, Gris, Marie Laurencin, Duchamp, as well as others, and, as a result, became involved with the cubists, the fauves, and futurists. In New York in 1915, after his return to the United States, Demuth developed a closer friendship with Marcel Duchamp, who came to this country for the first time that same year. Duchamp was an influential spokesman for modernist trends, especially from 1915 to 1920. He soon became the leader of a group of artists and intellectuals who gathered almost nightly at the 67th Street apartment of Walter and Louise Arensberg. The group eventually included Demuth and Charles Sheeler, as well as Joseph Stella — all artists who were influenced by Duchamp's dadaist ideas and his interest in the mechanistic element of cubism.[8]

Although Demuth's personal vision was partially molded by European artistic attitudes discussed in the Arensberg circle, his subject matter was predominately American. He grew up in historic Lancaster, Pennsylvania, and did most of his work in the quiet, traditional home adjoining the shop where the Demuth tobacco business had been run for generations.[9] From there he studied eighteenth- and nineteenth-century cupolas and church steeples as well as the modern chimneys and water towers of the factories in the town. Despite the wholehearted enthusiasm of his Parisian friend for America's modernity, Demuth retained a feeling of antipathy toward the machine world. Many of his titles for industrial paintings, such as ". . . *and the Home of the Brave*" or *Incense of a New Church* (Figure 14), reflect a Duchampian irony. Despite his sarcasm, he was obviously fascinated with the shapes of twentieth-century industrial architecture. In the February 1923 issue of

Figure 14. Charles Demuth,
Incense of a New Church, 1921.

the *Dial* Henry McBride wrote, "Mr. Demuth is of this era — he is aware of concrete, of immense, implacable walls of red brick, and of towering smokestacks which cut more of a figure now than church steeples do — and somehow he doesn't seem to mind being of this period."[10]

The title of Demuth's 1921 painting, *Aucassin and Nicolette* [24], was inspired by the persecuted lovers of a medieval French romance.[11] Indeed, the tapering black chimney in the foreground has been called "male-like" and the water tank "submissive."[12] Despite the playful quality of the handling of the motifs and the literary title, the composition is architectonic. Every area of the canvas is carefully blocked out; even the sky is presented in terms of interlocking bands of light.

It was the cubist concern for fundamental form which compelled the artist to deal with the nature of industrial structures rather than the picturesque features of the industrial environment. This basically rational and analytical approach to the subject marked a departure from the essentially romantic interest which had typified the earlier American portraits of industry. The powerful angular masses of actual factory buildings — in this instance, the Lorillard factory complex in Lancaster — were the basis of a pictorial system which emphasized their essential, unadorned clarity and precision.[13]

Demuth was one of the first of the American artists to exhibit characteristics of a style that would come to be known as precisionism. Artists associated with the movement tended to select vernacular structures — bridges, grain elevators, and factories — and to endow these forms with a sense of permanence and solidity. They selected subjects that were functional, efficient, geometrical, and coherent — and imposed on them an additional system of order and reason. On the one hand, their attempt to deal with the essence of structure — usually American structures — can be seen as a confron-

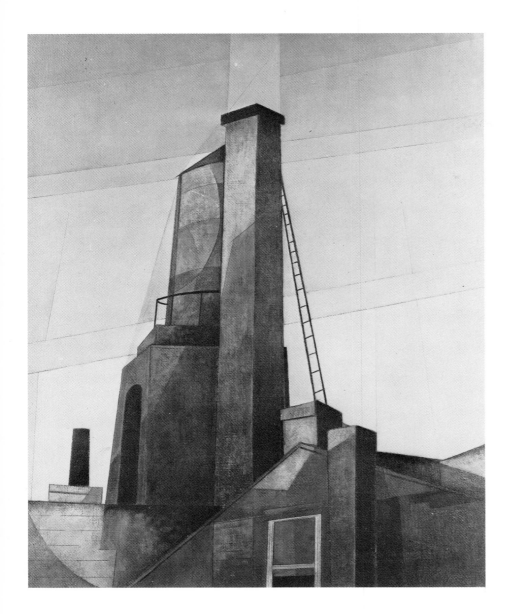

24 Charles Demuth,
Aucassin and Nicolette,
1921.

tation with modernist European trends. On the other hand, their turn to values of discipline and order must be viewed as part of a separate, international tendency.

European Influences

The exaltation of rationalism on the part of scientists, philosophers, and some artists was in some respects a reaction to the tremendous destructive power they saw unleashed during the period of the war. As a response, they called for a redirection of those energies toward constructive ends. This spirit gave rise in Europe to three main artistic movements: de Stijl, purism, and constructivism.[14] The first of these was centered around Theo van Doesburg (1883-1931), editor of the *De Stijl* journal, which functioned as a theoretical defense of the group's artistic contributions. The leaders of de Stijl attached great importance to an awareness of the prevailing intellectual and spiritual atmosphere, declaring in their first manifesto that "The war is destroying the old world with its contents: the dominance of the individual in every field. The new art has brought forward what the new consciousness of the time contains: balance between the universal and the individual."[15] Technology was welcomed as a sign of a new age that would be characterized by regularity and perfection. Artists had an important role in this spiritual revolution — to free the plastic arts from the representation of the irregularities of the natural world in order that art might herald universal, absolute harmony. Louis Lozowick (1892-1973), an American artist living in Berlin in the early 1920s, was receptive to such ideas. "Theo van Doesburg was ready to explain his theories to anyone willing to listen," wrote Lozowick in his autobiography, "and I was willing."[16]

The development of Lozowick's artistic style — like that of Demuth — was a product of international experi-ence. He made contact with, and assimilated, the styles of artists associated not only with de Stijl but also with purism and constructivism. Born in Russia, he moved to the United States in 1906 at the age of fourteen. Just before his European tour, which began in 1920, he undertook an almost programmatic study of major American commercial cities. Armed with fresh impressions of his American experience, he then immediately set himself the task of learning everything he could about the cultural life of France. During the year he spent in Paris, he made an active effort to associate himself with groups of French, Rumanian, Italian, and Russian artists. His investigations into current intellectual and artistic movements continued in Berlin, where he "began reading newspapers and magazines, going to theaters and cabarets and familiarizing [himself] with current German literature."[17] What had begun as a brief visit turned into a three-year stay.

His European experience profoundly influenced Lozowick and, at the same time, reinforced his admiration for his own adopted country. As an avid student of culture, he must certainly have noted photographs of American grain elevators, docks, and factories that appeared in *L'Esprit Nouveau* in 1920-21.[18] Edited by Amadée Ozenfant and Le Corbusier (pseudonym of Charles-Edouard Jeanneret), *L'Esprit Nouveau* was an important vehicle for the dissemination of their ideas about purism — an art based on logic with "an elevated order" as its goal.[19] Lozowick was undoubtedly struck by Le Corbusier's declaration: "Let us listen to the councils of American engineers" who "make use of the primary elements and . . . make the work of man ring in unison with universal order." In another issue he called American grain elevators and factories the "magnificent FIRST-FRUITS of the new age."[20]

Lozowick was also friendly with a large and active group of Russian artists in Berlin who were known as constructivists. Theirs was yet another postwar ideology that envisioned a new world order in which artists would have a central role. Lozowick was sympathetic to their devotion to a machine aesthetic and their ideas about the function of art in life. He actually exhibited with them in Düsseldorf in 1922. That same year, his closest acquaintance in Berlin, El Lissitzky, convinced him to travel to Moscow where he met Russian modernists Alexander Rodchenko, Vladimir Tatlin, and Kasimir Malevich, among many others. Again, he was overwhelmed by the enthusiasm expressed about American industry, writing later in his autobiography that "almost everyone evinced an immediate interest in America, not however, in its art but in its machines. 'Ah, America,' they say, 'wonderful machinery, wonderful factories, wonderful buildings.' "[21]

Jane Heap, editor of the *Little Review,* provided another American link to European utopian ideologies. She attended Ozenfant's and Le Corbusier's Pavillon de L'Esprit Nouveau at the Exposition des Arts Décoratifs when she visited Paris in 1925. She returned to New York with the idea for a Machine Age Exposition that she announced in the spring issue of the *Little Review.* The language of that announcement reflected her familiarity with purist ideas: "There is a great new race of men in America: the Engineer. He has created a new mechanical world, he is segregated from men in other activities. . . . it is inevitable and important to the civilization of today that he make a union with the artist. This affiliation of Artist and Engineer will benefit each in his own domain, it will become a new creative force."[22]

The exhibition itself was held in the spring of 1927. Sheeler, Demuth, and Lozowick served with Marcel Duchamp on the Artists' Board. The show consisted of paintings and sculptures dealing with mechanical subjects as well as actual machinery, architectural drawings, and models. Lozowick later recalled that it was Duchamp's idea to hang hand tools on chains from the ceiling.[23] Lozowick himself exhibited a number of drawings and paintings as well as stage designs for a theatrical production called *Gas.* He also wrote an essay, "The Americanization of Art," which appeared in the exhibition catalog. In it, he reiterated ideas absorbed from personal association with exponents of constructivism and purism and related those ideas to the American environment:

> The dominant trend in America today is towards an industrialization and standardization which require precise adjustment of structure to function which dictate an economic utilization of processes and materials and thereby foster in man a spirit of objectivity excluding all emotional aberration and accustom his vision to shapes and color not paralleled in nature.
>
> The dominant trend in America of today, beneath all the apparent chaos and confusion is towards order and organization which find their outward sign and symbol in the rigid geometry of the American city: in the verticals of its smoke stacks, in the parallels of its car tracks, the squares of its streets, the cubes of its factories, the arcs of its bridges, the cylinders of its gas tanks.[24]

In *Butte* (Figure 15), completed the year of the Machine Age Exposition, the urban landscape has been geometricized. The "verticals of its smoke stacks" and the "cubes of its factories" provided not only the building blocks of the composition but functioned as symbols of a dynamic new social order based on values of rationality and functional efficiency rather than human sentiment.

Figure 15. Louis Lozowick, *Butte,* 1926/27.

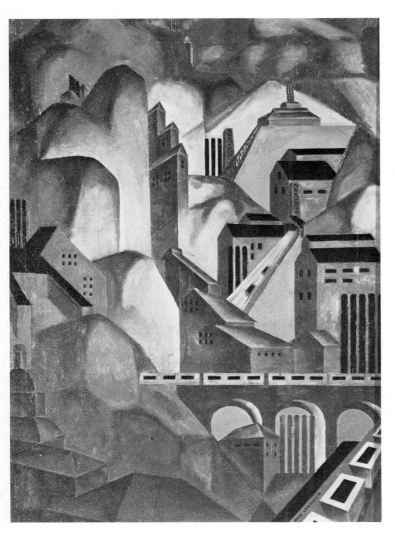

During the latter half of the decade, Lozowick turned increasingly from painting to lithography. These later works reveal a departure toward a greater degree of realistic representation. In a lithograph dating from 1929, *Tanks #2* [25], the machine is depicted as a positive symbol but is also accurately observed and convincingly portrayed. Some girders and pipes embellish the main elements of the composition — the cylinders of the gas tanks — but the work is devoid of extraneous detail. The composition is carefully controlled but not static. Ray lines, projecting into the darkness of the background, emphasize the dynamism of machine technology.

Lozowick's graphic work during the succeeding years showed a growing concern for technology, not as an isolated phenomenon, but in relation to the environment and as a product of man's creation. Looking back on his career in 1947, the artist characterized his art as "Industry harnessed by Man for the Benefit of Mankind."[25] Although no figures are visible in *From Babylon to Omaha* [26], the steaming locomotives imply their presence. No sign of human variability or imperfection, however, is allowed to encroach on the landscape. The grain elevators and railroad cars — here simplified to their essential geometric shapes — were created by man, to be sure, but in Lozowick's vision these forms are invested with the suggestion of something beyond their physical existence. Cosmic significance is inherent in the sheer size, the sense of permanence, and the apparent rationalism of this industrial environment.

25 Louis Lozowick, *Tanks #2,* 1929

26 Louis Lozowick, *Babylon to Omaha,* 193?

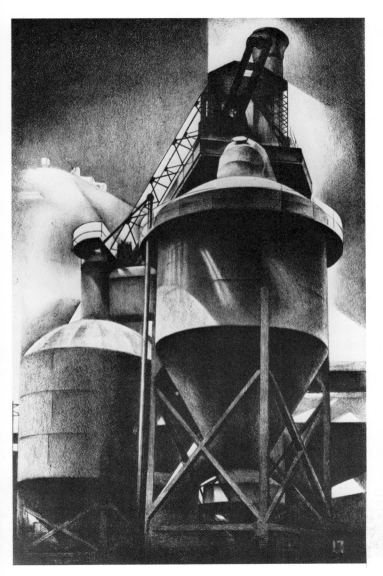

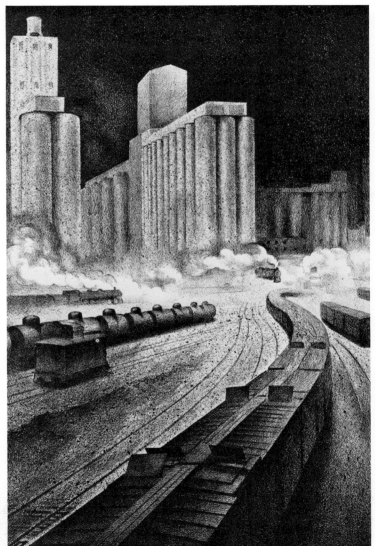

Bridges, grain elevators, turbines, docks, and blast furnaces became dominant elements in the vocabulary of a major group of American artists. The precisionists — or the "Immaculates" as they were called in the 1920s — were championed by art dealer Charles Daniel, who regularly showed their paintings in his New York gallery.[26] His consistent support, until the gallery was forced to close in 1932, was critical of the recognition of a precisionist approach to form and subject matter, as defined, somewhat matter-of-factly, by an *Art News* reviewer in 1928: "Factories, sheds, bridges and smokestacks loom large in the current Daniel showing, all rendered in the precise line, flat color and clearly defined pattern that have become trademarks of the immaculate school."[27]

Although the precisionist artists never referred to themselves as a movement or considered themselves a group, their distinctive style was influential. Elsie Driggs, for example, was temporarily attracted to the work of the Daniel Gallery artists and exhibited regularly with them from 1924 to 1932. At about the time of the gallery's closing, however, her style departed significantly from a precisionist tendency. One of her strongest paintings of the period, *Pittsburgh* [27], exhibits a less ideological than romantic interest in the shapes of a steel mill. The vibrant, almost tactile quality of the grays and blacks (described as "velvety" by a contemporary critic) reflects her own particular response to visiting the Jones and Laughlin steel complex in Pittsburgh: "The particles of dust in the air seemed to catch and refract the light to make a backdrop of luminous pale gray behind the shapes of simple smoke stack and cone."[28] The painting was immediately accepted for exhibition by Charles Daniel, who called it an example of the "New Classicism."[29]

Charles Sheeler was one of the earliest of the precisionist artists — along with Demuth — who exhibited at the Daniel Gallery. By the time he became associated with the Arensberg circle (beginning in 1917), he was already experimenting with cubist processes and beginning to develop a personal approach to the reality of form. His themes from this period — the architecture of Bucks County, Pennsylvania, and the interiors of his weekend home in Doylestown — are related to his work as a photographer. Trips from his native Philadelphia to visit Steiglitz's gallery and participate in the Arensberg gatherings, however, convinced him that "Anything stimulating and conducive to work was happening in New York," and in 1919 he moved there.[30]

While supporting himself as a commercial photographer, he continued his own work and pursued friendships with photographers such as Steiglitz, Edward Steichen, and, especially, Paul Strand. An exhibition in 1922 of his paintings and photographs at the Daniel Gallery established Sheeler's reputation on the New York art scene. The following year he began to do fashion and portrait photography for the Condé Nast publications, *Vanity Fair* and *Vogue,* and eventually worked for a variety of advertising agencies. His most important contact during this period turned out to be the Philadelphia-based company, N. W. Ayer. In 1927 its art director, Vaughn Flannery, conducted a carefully planned promotional campaign for Ford's new Model A and, in so doing, experimented with the idea of incorporating into the advertising concept the Ford Company itself. Flannery's foresight included a vision of constructive interaction between the fine and applied arts.[31] He wanted an artist — a known artist — to be involved in the Ford plant project. He hired Charles Sheeler.

27 Elsie Driggs, *Pittsburgh,* 1927.

The River Rouge complex near Detroit was the subject of Sheeler's commission. It was not only the main office of the Ford Motor Company but also the largest and most technically advanced industrial complex in the world. All phases of the production of the Model A car — from steel production to automobile assembly — were centered at the Rouge.[32] More broadly, the automobile industry was a primary symbol of the triumph of American technology. It represented the prosperity of the Roaring Twenties. The production of 4.8 million cars annually by 1929 stimulated road building, suburban housing, and created the hot-dog stand and the billboard. The industry's effect was felt beyond national boundaries. Detroit became a contemporary world mecca. "Just as in Rome one goes to the Vatican and endeavours to get audience of the Pope," wrote one British traveler, "so in Detroit one goes to the Ford Works and endeavours to see Henry Ford."[33]

Beginning in late November 1927, Sheeler spent six weeks at the Rouge plant, studying the plant and its operations and carefully composing a series of photographs. These photographs were, of course, used by the company for publicity purposes, but they also inspired Sheeler to execute a series of paintings, drawings, and a lithograph based on aspects of operations at the Rouge. His particular approach to the subject was influenced by his earlier experiments with cubist simplification of form, but more significantly, was based on his own aesthetic appreciation of utilitarian structures. He had been interested in the shapes of the barns in Bucks County because "they served the necessity of the people who built them. Forms created by industry to meet its needs," he continued, "also carry conviction and claim the attention of the artist for the same reason."[34]

Sources in the Vernacular Tradition

In the same spirit of his interest in traditional farm buildings of Pennsylvania, Sheeler was increasingly interested in Shaker crafts and architecture: "The Shaker communities in the period of their greatest creative activity, gave us abundant evidence of their profound understanding of utilitarian designing in their architecture and crafts. It was well understood and convincingly demonstrated by them, in house or table, that rightness of proportions, due regard for efficiency in the use to which it was applied and the carrying out of the plan by means of skilled craftsmanship and careful consideration of the material used, made embellishment superfluous."[35] He appreciated the severity, simplicity, and precision of Shaker design expressed in buildings and in utilitarian objects. They were all made according to principles of the perfectionist Shaker society, which included the admonition that "all things must be made according to their use."[36] Sheeler expressed a similar attitude when he said, "forms related to each other for the most direct and simplest solution of their utility invariably have a resulting beauty."[37]

It was not without significance that Shaker objects began to appear in Sheeler's paintings around 1927, approximately at the time he photographed the Rouge. The artist's interest in Shaker design and his appreciation of industrial machinery and architecture illustrate the importance to his art of forms created by a vernacular tradition. He respected the integrity and the inherent elegance of the unself-conscious, practical architecture of barns and factories.[38] Utility and efficiency were high priorities for industry, just as they had been for the Shakers. Sheeler was attracted to the clarity and geometry of industrial forms. The absence of any superfluous ornamentation permitted an honest and di-

28 Charles Sheeler,
River Rouge Industrial Plant,
1928.

rect expression of structure and function. Likewise, the simplicity and precision of Shaker architecture and crafts emphasized their essential abstract shapes. Sheeler admired the simplicity and straightforward quality of the Shakers' vision, but he was also convinced that "the language of the Arts should be in keeping with the Spirit of the Age, if statements are to be authentic" and that "since industry predominantly concerns the greatest numbers, finding an expression for it concerns the artist."[39] Modern American industry symbolized

Sheeler's age, and its functional design reflected the values of his contemporaries.

River Rouge Industrial Plant [28], a water color executed in 1928, may be his first treatment of the subject in painting. The view across the Rouge River features the plant's slag screen house. Here the impurities, skimmed off the molten iron during the casting process and transferred by rail car, were screened and the slag then moved by conveyor to be crushed and used in cement. The smokestack of the cement plant is visible at

29 Charles Sheeler,
Industrial Series No. 1,
1928.

the left in the water color. Partially visible on the right is a Hewlett crane for unloading bulk cargo such as iron ore.[40]

A lithograph entitled *Industrial Series No. 1* [29] was based on the exact scene presented in the water color, although the scene is reversed because of the printing process. Comparison of the two works demonstrates the manner in which Sheeler continually adjusted his images. Details which he was able to define with greater clarity on the lithographic stone were probably derived

from photographs. Other changes, however, are compositional refinements rather than added descriptive detail.

In the water color, for example, three stacks rise from a rooftop in the background at the right of the picture. There are four, more centrally placed stacks in the corresponding position in the lithograph. Further, they are spatially aligned with the horizontal bars they overlap, in such a way that the vertical and horizontal elements are perceived as a unit — thus emphasizing their function as design elements rather than architectural forms

in space. In the water color, the bars more clearly indicate the roof of a barnlike structure behind the stacks. The crane, on the right in the water color, has been elongated in the lithograph to present a more prominent vertical element spanning the height of the composition. The basic architectural framework of the picture, organized according to a grid of horizontals and verticals, remains the same in both works. The combination of such subtle changes therefore tightens the composition and enhances the abstract quality of the design.

Classic Landscape (Figure 16) is a final version in oil of another view of the slag screen house, this time with the cement plant silos added at the left.[41] This painting illustrates the extent to which Sheeler refined his conceptions. Every detail of reality, including the length of shadows cast, has been ordered to serve the overall architectonic statement of the picture. As in Lozowick's industrial environment, no human reference disturbs the perfect balance. The diagonal of the mound of coal at the left is parallel to the diagonals created by many of the shadows in the picture — all of which are related, finally, to the line of clouds receding into the distance from left to right. The alignment of the edge of the cloud formation with angles created by the contour of the slag house roof and the diagonal established by the severely foreshortened railroad track symmetrically corresponding to the dominant diagonal defined by the receding cloud line in the upper half of the composition all convey more than a precise rendering of reality. The concentration on basic, solid forms and the regimentation of the

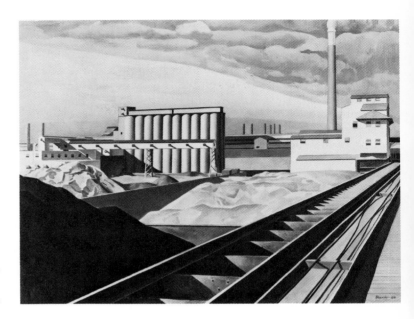

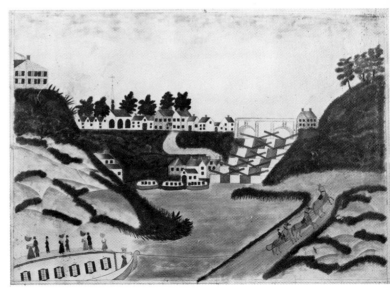

Figure 16. Charles Sheeler, *Classic Landscape,* 1931.

Figure 17. Mary Keys, *Lock Port on the Erie Canal,* 1832.

compositional structure reveal a treatment that is both visual and conceptual.

To the extent that Sheeler's art is an intellectual interpretation of reality based on certain principles of design, his painting can be related to a traditional tendency in American art. A similar interest in the aesthetic qualities of abstract patterning and design can be observed in the work of American primitive artists. *Lock Port on the Erie Canal* (Figure 17) is a water color by an untrained artist. She signed and dated her picture: "Mary Keys. 1838." Characteristic of a primitive, hers was an "essentially non-optical vision" in which "the degree of excellence . . . depends upon the clarity, energy, and coherence of the artist's mental picture rather than upon the beauty or interest actually inherent in the subject matter, and upon the artist's instinctive sense of color and design when transposing his mental pictures onto a painted surface rather than upon a technical facility for reconstructing in paint his observations of nature."[42] The artist, therefore, was not overly disturbed by the unconvincing relationship of the horses to the towpath or the figures to the roof of the boat. She attempted to convey the essential idea of people standing on deck and the boat moving along the canal. She strove to provide complete information — the figures and animals are positioned in such a way as to remain separate and distinct from one another, without overlapping. But she was either incapable or disinterested in presenting an illusionistic picture of all aspects of the scene. Instead, she created a pleasing design. The town above the lock has been simplified to an orderly row of little houses with square windows grouped in rhythmic patterns. The diagonal of the towpath corresponds to the diagonal of the hill just beyond it on the right, and the diagonal established by the hill on the left bank finds a parallel in the dirt road leading up to the town in the middle distance.

Sheeler was meticulous about analogous pictorial and organizational concerns, but similarities between his art and the primitive tradition are primarily visual. Sheeler himself acknowledged that his own artistic sensibility had a certain kinship with that of the folk artist, but he was also concerned about the validity of his art in the modern world:

> Our folk art shows us something of the character of the people of the time in which it was produced, and it often has characteristics common to the most satisfying expressions of any period: simplicity of vision and directness of statement with a considerable sensitiveness and originality in the use of the medium. This art is *naïve* and carried conviction at the time, but I feel that the *naïve* may not be reverted to now with similar conviction. Sometimes one sees an effort in that direction, but we live in an age that is already highly sophisticated and there is every evidence of a farther advance in that direction. I feel that we should be as knowing as our capabilities permit.[43]

The industrial theme continued to appear in Sheeler's work and was particularly prominent in the 1940s. Again he was stimulated by a commission — this time from *Fortune Magazine*. Over a period of two years he painted six canvases and portrayed "instruments of power" as the exquisite manifestations of human reason."[44] In *Steam Turbine* [30], completed in 1939, he depicted an interior view of what was then the world's largest steam power plant — the Hudson Avenue Station of the Brooklyn Edison Company. The scale of the machinery and its enormous kilowatt capacity represented the heights of modern technological achievement at the service of society's energy needs: the conversion of heat into mechanical energy, which produces electricity. The steel loop depicted in the center of the canvas delivers steam to one of the turbine units. The

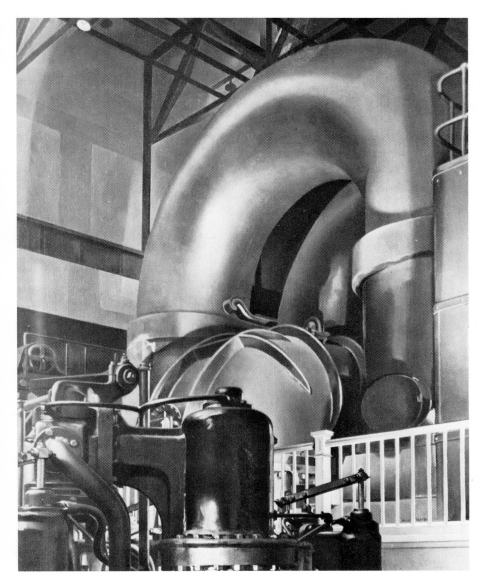

30 Charles Sheeler,
Steam Turbine, 1939.

pristine, untouched quality of the machinery, however, removes it from the realm of everyday reality. The single puff of steam escaping from the valve in the foreground is the only hint of work actually being done. Sheeler's fascination with the technological aspects of the subject was matched by his interest in the pictorial problem of arranging a myriad of varying cylindrical and circular shapes within a rectilinear space. The cool, objective approach evident here was appropriate to the impersonal precision of the machine world.

Sheeler chose as his subject matter modern technology — specifically, the bigness and boldness of American technology. He created more than a pictorial record of the industrial environment — providing an artistic statement about the nature of mechanical forms themselves. He saw in their unembellished clarity the expression of essential values of the age. And, in so doing, he fulfilled the prescription for "Beauty" written in 1860 by Ralph Waldo Emerson, who pronounced it a "rule of widest application . . . that in the construction of any fabric or organism, any real increase of fitness to its end is an increase of beauty."[45]

The precisionists' interest in machine imagery can be understood in terms of a general international trend toward the use of mechanical forms in art. Their optimistic attitude toward industrialization was a by-product of postwar utopian ideologies. But the particular character of the images they created and the subjects they chose were deliberately American. The most industrially advanced nation in the world thus artistically came of age at the time of the precisionist confrontation with the essential realities of the modern technological world.

1. Royal Cortissoz, "The Field of Art," *Scribner's Magazine* LXXVIII (October 1925): 441.

2. Robert Coady, "American Art," *Soil* I (December 1916): 3, quoted in Dickran Tashjian, *Skyscraper Primitives: Dada and the American Avant-garde: 1910-1925* (Middletown, Conn.: Wesleyan University Press, 1975), pp. 72-73.

3. For a more complete account of industrial expansion and technological innovations of the period, see William E. Leuchtenburg, *The Perils of Prosperity, 1914-32* (University of Chicago Press, 1958), pp. 178-203. Henry Ford quoted on page 187.

4. Tashjian, *Skyscraper Primitives,* pp. 72-84, discusses the limitations of Coady's perspective.

5. H. G. Wells, *The Future in America* (New York: Harper and Brothers, 1906), p. 40, quoted in Barbara Beth Zabel, "Louis Lozowick and Technological Optimism of the 1920s" (Ph.D. diss., University of Virginia, 1978), pp. 88-89.

6. Francis Picabia, "A Post-Cubist's Impressions of New York," interview in *New York Tribune,* 9 March, 1913, quoted in Zabel, "Lozowick," p. 89.

7. Charles Demuth to Alfred Steiglitz, 10 October 1921, Steiglitz Collection, Yale University Library. Also quoted in Joshua C. Taylor, *America as Art,* exh. cat. (Washington, D.C.: National Collection of the Fine Arts, Smithsonian Institution, 1976), p. 190.

8. The circle also included Francis Picabia, Albert Gleizes, Gabrielle Buffet, Marius de Zayas, Beatrice Wood, William Carlos Williams, Katherine Dreier, and Alfred Kyeymbourg. All were dominated by the energy and personality of Marcel Duchamp. Milton Brown credits Duchamp more than anyone else with influencing the American artists's adoption of the mechanistic element in Cubism, in his classic essay, "Cubist-Realism: An American Style," *Marsyas* III (1943-45): 143.

9. S. Lane Faison, Jr., "Fact and Art in Charles Demuth," *Magazine of Art* XLIII (April 1950): 124.

10. Henry McBride, "Modern Art," *Dial* LXXIV (February 1923): 218, quoted in David Gebhard, "Charles Demuth and the Twenties," in *Charles Demuth: The Mechanical Encrusted on the Living,* exh. cat. (Santa Barbara: University of California, 1972), p. 9.

11. Marcia Tucker, *American Paintings in the Ferdinand Howard Collection* (Columbus Gallery of Fine Arts, 1969), cat. no. 31, p. 24.

12. Faison, "Fact and Art," p. 124.

13. Faison, ibid., tentatively identified the structures as part of the Lorillard factory.

14. See, for example, Kenneth E. Silver, "Purism: Straightening Up after the Great War," *Artforum* XV (March 1977): 56-63.

15. First De Stijl Manifesto, quoted in Hans L. C. Jaffé, *De Stijl* (New York: Harry N. Abrams, 1971), p. 18.

16. Louis Lozowick, "Survivor from a Dead Age," Lozowick Papers, Archives of American Art, Smithsonian Institution, Washington, D.C., ca. 1969-73, chap. X, p. 3, quoted in Zabel, "Lozowick," pp. 100-101.

17. Lozowick, "Survivor," chap. X, pp. 8-9, quoted in Zabel, "Lozowick," pp. 99-100.

18. Ibid., pp. 92-93.

19. Amadée Ozenfant and Charles-Edouard Jeanneret, "Purism," in *Modern Artists on Art,* ed. Robert L. Herbert (Englewood Cliffs, N.J.: Prentice-Hall, 1964), p. 66.

20. Various articles by Le Corbusier were compiled in *Towards a New Architecture* (Paris, 1923), quoted in Zabel, "Lozowick," p. 105.

21. Lozowick, "Survivor," chap. XI, p. 6, quoted in Zabel, "Lozowick," p. 96.

22. Jane Heap, "Machine-Age Exposition," *Little Review* XI (Spring 1925): 22.

23. Information on the Machine Age Exposition is taken from an informative catalog essay in Susan Fillin Yeh, *The Precisionist Painters 1916-1949: Interpretations of a Mechanical Age,* exh. cat. (Huntington, N.Y.: Heckscher Museum, 1978), pp. 12-13.

24. Louis Lozowick, "The Americanization of Art," *The Machine Age Exposition,* exh. cat. (New York: Little Review, 1927), p. 18.

25. Lozowick's "Credo" was originally published in *100 Contemporary American Jewish Painters and Sculptors* (New York: Yiddisher Kultur Farband, 1947). The Credo is also printed in *Louis Lozowick: A Print Retrospective* (Newark, N.J.: Newark Public Library, 1969), unpaginated.

26. Precisionist work was also exhibited at the Bourgeois Galleries, the Neumann Galleries, the Whitney Studio, and Whitney Studio Club.

27. "Immaculate School at Daniel's," *Art News* XXVII (3 November 1928): 9.

28. Driggs to Friedman, 23 March 1960, quoted in Martin Friedman, *The Precisionist View in American Art,* exh. cat. (Minneapolis: Walker Art Center, 1960), p. 37.

29. Ibid.

30. Microfilm no. AAA NSH-1, frame 80, Charles Sheeler Papers, Archives of American Art, Smithsonian Institution, Washington, D.C.

31. For an account of Vaughn Flannery and Sheeler's connections with commercial photography, see Susan Fillin Yeh, "Charles Sheeler: Industry, Fashion, and the Vanguard," *Arts Magazine* LIV (February 1980): 154-58.

32. Information about Ford Motor Company's Rouge complex is taken from a comprehensive study by Mary Jane Jacob and Linda Downs, *The Rouge: The Image of Industry in the Art of Charles Sheeler and Diego Rivera* (Detroit Institute of Arts, 1978).

33. Leuchtenburg, *Perils of Prosperity,* pp. 185-88.

34. Microfilm no. AAA NSH-1, frame 101.

35. Ibid., frames 115-16.

36. Edward Deming Andrew, "The Shaker Manner of Building," *Art in America* XLVIII, no. 3 (1960): 40.

37. Microfilm no. AAA NSH-1, frame 352.

38. Kouwenhoven has noted a similarity between Sheeler's art and utilitarian pictures such as the lithographs that illustrated country histories published in the nineteenth century; see *Made in America,* pp. 184-85.

39. Ibid., frames 107, 101.

40. Information about specific structures that appear in Sheeler's paintings of the Rouge are based upon Jacob's catalog entries in *Rouge,* pp. 25, 32.

41. Ibid., p. 34.

42. Jean Lipman, *American Primitive Painting* (New York: Oxford University Press, 1942), p. 7.

43. Constance Rourke, *Charles Sheeler: Artist in the American Tradition* (New York: Harcourt, Brace & Co., 1938), pp. 183-84.

44. "Power: A Portfolio by Charles Sheeler," *Fortune Magazine* XXII (December 1940): 73.

45. Ralph Waldo Emerson, "Beauty," *The Conduct of Life* (1860), quoted in Kouwenhoven, *Made in America,* pp. 120-21.

The Art of the Depression

A New Springtime in Culture

The desire to define what was American about America was anything but new in the early 1930s, but the effort was hailed with a new sense of urgency. The American people were experiencing a major Depression, and the threat of adversity stimulated a nationwide movement to restore sustaining values and institutions. Economic and political crisis emphasized the need for introspection, self-examination, and the establishment of a cultural identity. The process of reassessment was conceived without the cosmic and universal pretensions that characterized the promises of the Machine Age. Disillusionment with those promises had already begun to appear during the prosperous 1920s. The new emphasis was local. Plans for the future would be guided by a new science, the science of the region.[1] Urban historian Lewis Mumford, in defining "The Theory and Practice of Regionalism" in 1928, stated: "The aim of the regionalist movement is to begin again with the elemental necessities of life, to provide for these on a modern economic basis, and begin again that renewal of cities and regions which will bring about a new springtime in culture." In discussing the cultural aspects of the movement, Mumford used the analogy of an orchestra, describing each population group as an individual musician who has a distinct function and who enriches the whole. He also considered the movement in terms of its technical aspects — "Our industrialism has been other-worldly: it has blackened and defaced our human environment, in the hope of achieving the abstract felicities of profits and dividends in the industrial hereafter. It is time that we came to terms with the earth, and worked in partnership with the forces that promote life and the traditions that enhance it."[2]

"Regionalism is a return to life, . . ."[3] was the way Mumford summed up the concept that he saw permeating the country in the Depression years — the desire to go back to something better, to identify and regain a quality of life somehow lost in the commitment to progress.

Inherent in the program of regionalism was a reexamination of the role of the machine. Technology had brought along with it decay, devastation of the landscape, exploitation, and dehumanization. Pictures of the malevolent influences of progress were painted by writers such as Sherwood Anderson:

Every year the factories themselves invade new towns and the towns not yet invaded by the factories are still invaded by the machine. The factories themselves every year move deeper and deeper into the agrarian sections. On every hand the machine controls our lives. Now the players do not come to the towns. They are in Los Angeles. We see but the shadows of players. We listen to the shadows of voices. Even the politicians do not come to us now. They stay in the city and talk to us on the radio.

There is a queer half world in which we live. There are the fields near the towns and the houses and

streets of the towns. There is this actuality, the town itself.

Then there is this other life, our imagination fed with new food, the inside of that factory there, the lives of these people in the talkies, the voices coming to us on the radio. We feel ourselves in some strange new world, half in, half out. We are half born men.[4]

If Mumford's "new springtime in culture" was to be achieved, technology had to be marshalled to the service of humanity. For many, the machine was no longer a valid symbol of rationalism and order. Society invested its hopes in a new order that was really a revival of old values — a sense of community, honesty, good-neighborliness, and hard work.[5]

The Great Crash undermined the credibility of businessmen and technologists who had served as contemporary legends during the prosperous 1920s. In their place, the Depression generation looked for legends in the past and searched for values legitimized by national experience. The shaping of traditions out of the nation's history became a crusade. Historical novels were written, and documentary photographs were collected. The National Archives opened, and artists turned to memorializing what came to be called the "American scene."[6]

The departure from artistic experimentation and modern European trends was marked in the 1930s by an interest in storytelling rather than style. Artists cared more for honesty than elegance. Painters of the American scene made "readable" pictures of urban and rural life in America. Their art was often flavored by nostalgic memories of the hard-working, self-reliant folk whose sense of purpose and pragmatic attitudes helped to make this country strong. Although their efforts to idealize and pay tribute to a better way of life at times detracted from their ability to make good paintings, the renewed

validity of traditional values contributed to the appeal of the American scene as a subject during the Depression years.

In its 24 December 1934 issue, *Time* magazine announced the formation of a new school of American painting. This new art, it was explained, developed as a reaction to the kind of "outlandish" art so prevalent in this country after France "conquered the U.S. art world" in 1913 (the year of the Armory Show). The straightforward representation that characterized this new school was seen as a response to that "crazy parade" of such styles as cubism, futurism, dadaism, and surrealism — movements which had inspired American artists to produce work that was "deliberately unintelligible." The return to normalcy, according to *Time,* had begun in the Midwest: "A small group of native painters began to offer direct representation in place of introspective abstractions. To them what could be seen in their own land — streets, fields, shipyards, factories and those who people such places — became more important than what could be felt about far off places. From Missouri, from Kansas, from Ohio, from Iowa, came men whose work was destined to turn the tide of artistic taste in the U.S. Of these earthy Midwesterners none represents the objectivity and purpose of their school more clearly than Missouri's Thomas Hart Benton."

Benton (1889-1975) was committed to an art based on American experiences. He was indeed well suited to represent *Time*'s idea of artistic "objectivity," because he had experimented with modernist art styles early in his career but subsequently and vehemently renounced them: "I wallowed in every cockeyed ism that came along and it took me ten years to get all that modernist dirt out of my system."[7] To Benton, the formalist concerns which predominated in early twentieth-century art

movements signified a retreat from any meaningful response to the social and intellectual climate of the time.

Benton's attitudes were in tune with the attitudes circulating among a growing segment of society. In an era of ever-accelerating social and economic change, more Americans were seeking to reestablish some continuity with their heritage. The studies of American history published at the turn of the century by Frederick Jackson Turner had identified unique qualities of American life in the experience of the pioneers who settled the West. He characterized them as having shaped an existence out of necessity. To Turner, the settlers and their descendants developed a way of life and a culture relatively unaffected by European influences. Benton, who began reading Turner in 1927, acquired a lasting respect for the farmers and freeholders who settled this country. He would always consider them the real Americans.[8]

Between 1919 and 1936, Benton worked on five large-scale mural projects which reveal his populist ideas.[9] The best known of these cycles was executed for the New School of Social Research in New York City. Its theme, *America Today,* was selected by Benton. Nine panels virtually covering three walls of a classroom (originally a boardroom) convey Benton's view of the energy, vitality, and chaos of American life — in the city, in the South and West, in the cornfields and in steel mills. Vignettes were compressed within each panel, often separated by the actual curving and angular architectural moldings. The similarity between the arrangement of unrelated pictorial items in Benton's mural and the front-page layout of a tabloid newspaper was immediately discernible. Adolf Glassgold, writing in *Atelier* in 1931, proclaimed the series "as complete a picture of the kaleidoscopic vertigo of the American temper as the news-reel or the illustrated tabloid."[10] That critic's observation emphasizes the quality of familiarity and accessibility Benton's contemporaries recognized in his

94

mural images. He not only painted the familiar and at times mundane aspects of the American scene, but he also used a familiar format.

The attitude of American life reflected in Benton's murals is generally positive. The panels depicting *Steel* [31a] and *City Building* [31b], for example, convey the sense of work being done. Benton obviously admired steel and construction workers whose living depended upon the strength of their own backs. Even the miners bent to their task are not oppressed by it [31c]. Their modest homes are perched on the side of a hill well above the contaminating blackness of the industrial environment. Hints of the destructive effects wrought by technology and big business are apparent in *The Changing West* [31d], but the oil derricks and factory complexes dominating the landscape here symbolize prosperity first of all. Only on second glance does the observer notice the cattlemen guarding their herds upon a prairie already encompassed on all sides by urban and industrial growth. The four figures confined to the lower right portion of the panel may represent the Indians and descendants of the early American settlers unable to coexist with progress.

Benton was suspicious of unbridled modernization and development, but nonetheless, he was awed by the modern manifestations of technology. He incorporated many of these dramatic forces in *Instruments of Power* [31e], one of the least successful compositions at the New School. Of all the modes of machine power he represented, the train was the most traditional, but for Benton, it held a history of personal associations. The railroad was for him "the prime symbol of adventurous life."[11] He remembered being impressed by engines dur-

31a Thomas Hart Benton, *Steel,* 1930/31.

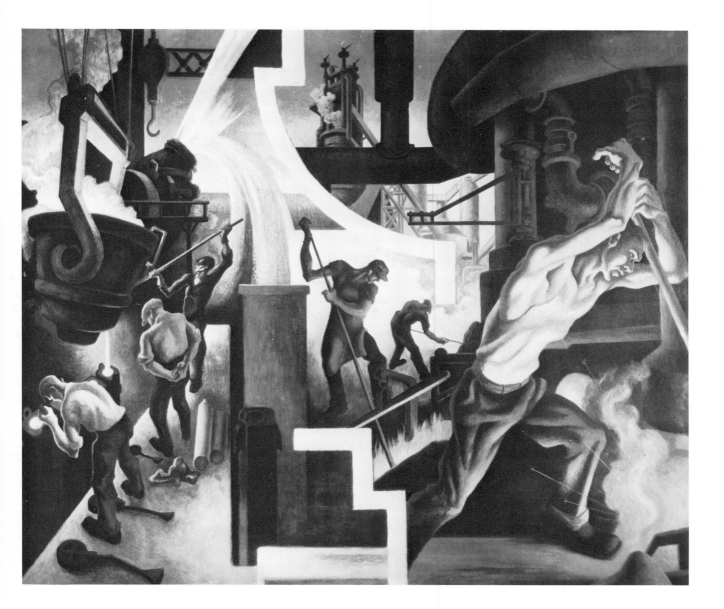

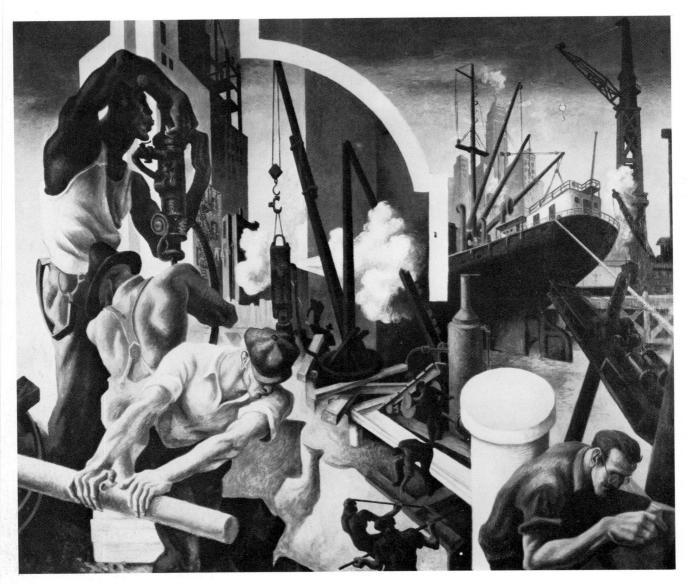

31b Thomas Hart Benton, *City Building*, 1930/31.

31c Thomas Hart Benton, *Mining,* 1930/31.

31e Thomas Hart Benton, *Instruments of Power,* 1930/31.

31d Thomas Hart Benton, *The Changing West,* 1930/31.

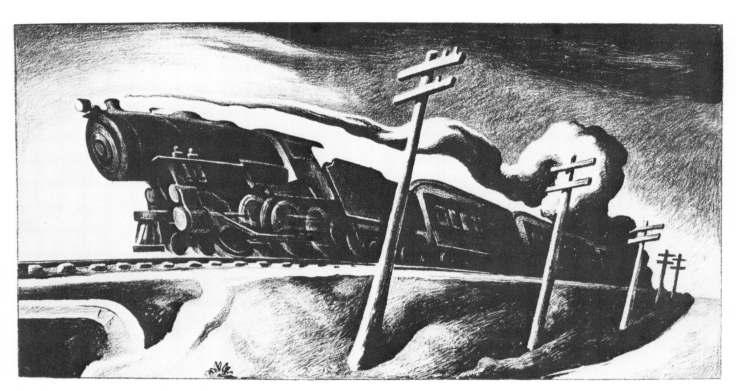

32 Thomas Hart Benton, *Going West*, 1934.

ing his childhood; they were among the first subjects he drew. The motif of the steaming locomotive from this mural design was used again later in one of his most famous lithographs, *Going West* [32]. The engine lunging toward its destination in the print is even more anthropomorphic.

Benton's feelings toward encroaching technology and the concomitant rise of urban centers in the West became still more pronounced during the 1930s. He became increasingly nostalgic about the free-spirited and colorful way of life he associated with the heartland of America — nostalgic because that way of life seemed jeopardized by irreversible social and economic changes. By 1937, when he published his autobiography, *An Artist in America,* he expressed suspicion of money-hungry businessmen, indignation about the worldly ways of people who tended to congregate around success, and fear of rapid change:

I was in the Texas Panhandle when Borger was on the boom. It was a town then of rough shacks, oil rigs, pungent stinks from gas pockets, and broad-faced, big-boned Texas oil speculators, cowmen, wheatmen, etc. The single street of the town was about a mile long, its buildings thrown together in a haphazard sort of way. Every imaginable human trickery for skinning money out of people was there. Devious-looking real-estate brokers were set up on the corners next to peep shows. Slot machines banged in drugstores which were hung with all the gaudy signs of medicinal chicanery and cosmetic tomfoolery. Shoddy preachers yowled and passed the hat in the street. Buxom, wide-faced, brightly painted Texas whores brought you plates of tough steak in the restaurants and said insinuatingly, "Anything moah I c'n do foh you all? Ah'm here to ple-e-aze, boys."[12]

The two panels in the New School murals representing *City Activities* [31f-g] convey the most explicit references to the effects of modernization on American life. The whirling, gyrating movements and the visual confusion of these compositions reflect the essential character of contemporary society's "chartless journey," as Benton described it in 1934. Family and community relationships and the value of an honest day's work were difficult to maintain in the face of "mass production, the movie, the radio, and the paved road."[13] The stimulants for social change were concentrated in the cities. And in Benton's view, exploitive business practices and the tyranny of economic power over the individual became the standard in the industrial centers.

The artist observed and documented all aspects of city life, including the bawdy burlesque shows or scenes of amorous couples on park benches. He enjoyed the sensuality of such images, even though he was convinced that the tawdry aspects of big-city life were symptomatic of moral decay and social decadence. His disapproval is obvious in his portrayal of the dance hall couple. The woman's deep red, low-cut dress identifies her "type," while her partner's sinister, inset eyes, elongated nose, and protruding chin clearly convey his intentions. The artist even more emphatically expressed his fierce sense of morals when he wrote his autobiography seven years later. Speaking in particular about the industrial South, he said, "The loudmouthed, Bible-quoting morality of its public citizens is a thin layer of hypocrisy over a lot of sexual filth. . . . Nowhere is fornication so completely in accord with the evil implications of the word."[14]

Despite such feelings of self-righteousness, Benton appreciated the diversity that was America. He denounced its cities as "Meccas for all the cunning and merciless schemes of the land," and declared them "full of life" and possessed "of a dark and strange beauty."[15] All of these

31f and **31g** Thomas Hart Benton, *City Activities,* 1930/31.

contradictory emotions energize his portraits of *America Today*.

When critics saw the entire cycle installed in the New School for Social Research, they called it a "stirring record of our raw, vigorous 'economocracy'" and "the most exciting and provocative frescoes ever done in America."[16] But not every opinion was favorable. There were those who felt that his murals degraded the American people and those who referred to his images as the work not of an artist but a rowdy schoolboy. He was most loudly derided, however, by left-wing artists who charged that his art was shallow and lacked commitment to social change. Benton's own crusty personality contributed to the prominence of his position in the skirmishes between two warring camps — the social realists, on one hand, and artists of the American scene on the other. Ire was kindled by the *Time* article that identified Benton along with Reginald Marsh, Charles Burchfield, John Steuart Curry, and Grant Wood as the American painters who were "destined to turn the tide of artistic taste in the United States." Stuart Davis published a response to that article in an editorial for *Art Front* — the newsletter-magazine of the Artists' Union. He argued that an artistic program based on subject matter drawn from the American scene and direct representation as opposed to introspection was "so general and undefined as to be valueless." Benton, in particular, was singled out. Stuart described Benton's portraits of black Americans as caricature and "third-rate vaudeville character cliche with the humor omitted." Nor did he overlook Benton's self-portrait, which had appeared on *Time's* cover: "We must at least give him credit for not making any exception in his general under-estimation of the human race."[17]

Curry, also a subject of Davis's abuse, responded in the following issue. He attempted to be conciliatory, suggesting that he considered it his own duty as an artist to portray "the humanity of the present day in relation to this environment" — an implicit admonition to artists on both sides of the conflict. He went on to compare the art of the avowed Communist Jacob Burck (b. 1904) with that of Benton. He cited Burck's painting of strikers and mine guards in which the artist was able to convey the "viciousness of life" with "real" characters and then noted, too, the "subtle characterization" in Benton's work.[18]

Benton and Burck thus found themselves in some agreement during this ideological confrontation. They were both opposed to the idea of art for art's sake and abstraction. Benton remained firm in his views on the sterility of the art of the "intellectual abstractionist" and the "emotional expressionist."[19] Although he retreated from his earlier Communist leanings and his interest in revolutionary content in art, his attitudes about the relationship between art and contemporary social climate were similar to the ideas held by the social realists. Benton was a member, along with Jacob Burck, of the Contemporary Print Group that, with its founding in 1933, announced its opposition to the purist idea of "art for art's sake" and its belief that art should reach a broad audience. Its members all concurred that an artist's efforts to make his work socially significant would naturally result in a larger public.[20] The goals of the Print Group were compatible with those of the social realists as well as the American scene painters.

Social Issues in Art — Prints about People

The Contemporary Print Group published two series of lithographs. According to a statement on the frontispiece of the portfolio, entitled *The American Scene* (1934), the prints were produced "by artists alive to contemporary social forces." Two of the artists represented in the series depicted subjects related to strikes: Jacob Burck's *The Lord Provides* [33] and Thomas Hart Benton's *Mine Strike* [34]. Both convey a clear political message — that the strikers were no match for the power of big business and the political interests of big business. Both artists abhorred the exploitation of the individual that they believed to be an inherent aspect of the capitalist system.

Other artists whose work was included in *The American Scene* series dealt with themes related to the plight of the worker. William Gropper (1897-1977), best known for his political cartoons and magazine illustrations, submitted *Sweatshop* [35]. The same biting and incisive criticism which characterized his drawings for left-wing periodicals is evident in his lithographs and paintings. Although he received his initial training under Ashcan artists Robert Henri and George Bellows and was grounded in the philosophy of an art based on life, he manifested a more graphic and persuasive realism than that of his teachers.[21] The early twentieth-century realists developed a sense of spontaneity and a love of city-life subjects, in part, from the vernacular tradition of journalistic illustration. Gropper's style was directly related, in terms of its imagery and didactic content, to magazine illustration and poster art. *Sweatshop* is an emphatic indictment of the grueling routine and inhumane conditions grimly endured by countless garment workers.

Raphael Soyer (b. 1899) was less concerned with an overt social or political message. He was relatively objec-

33 Jacob Burck, *The Lord Provides,* 1934.

tive in his portrayal of the unemployed and under-privileged whom he observed on the streets of New York City. *Waterfront* [36], his contribution to *The American Scene* series, was derived from a painting of the same subject he executed two years earlier.[22] The all-over gray tonality of the lithograph reflects the bleak existence of jobless, homeless drifters who wandered the streets or dulled their consciousness with alcohol.

The harsh reality of the 1930s and the circumstances of life and character of the people then making contemporary history concerned the social realists as well as the American scene painters. But few were in a mood for reconciliation. In fact, continued discussion between the two factions seemed to further aggravate perceived ideological disagreements. The attacks and counterattacks became increasingly bitter. Caught up in the dispute, many artists were forced to take sides, while others actually benefited by making advantageous alliances.

The public spat between Thomas Hart Benton and Stuart Davis along with the other editors of *Art Front* continued to provide lively copy for the magazine. Benton asked the editors to submit ten questions. His replies were printed in full. Jacob Burck was asked, in turn, to respond to Benton's replies. In rebuttal, Benton wrote

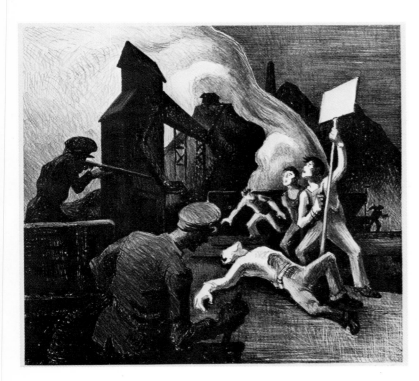

34 Thomas Hart Benton,
Mine Strike, 1933.

that Burck's response was "the result of a misunderstanding" of his position and that he actually agreed with five of Burck's points about Communist ideology. He took exception only to the use of force, saying, "I am one of those who believe that in our march toward a better production-consumption economy we had better cast aside all universal ideals of a theoretical nature, and work pragmatically with actual American forces to that end. . . ." The editors had the last word: "If Benton wants a better society he can help by being an artist of the social revolution."[23] All this rhetoric served only to intensify the original dispute.

Benton, preparing to leave the scene of the controversy and return to his beloved Midwest, declared, "I'm leaving New York to see what can be done for art in a fairly clean field less ridden with verbal stupidities."[24] His departure may also have been precipitated by his resentment about requested changes in his designs for a mural for the Post Office building in Washington, D.C., a New Deal project sponsored by the Department of the Treasury under its Section of Painting and Sculpture. Before the problem could be resolved through negotiations, however, Benton was invited to paint murals for the Missouri State Capitol in Jefferson City and to be-

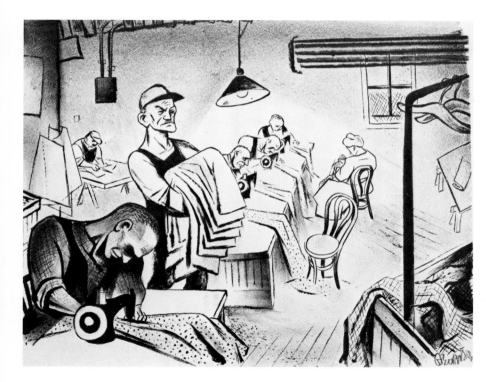

35 William Gropper, *Sweatshop,* ca. 1933/34.

come director of painting at the Kansas City Art Institute. He accepted the invitations. Thus, one of the leading American muralists, who did much to publicize mural painting in the United States, never executed a federally sponsored project.

Federal Funds for Art

The Depression was particularly difficult for many artists. Their product became an expendable luxury and their market virtually disappeared. Nearly ten thousand American artists were unemployed when Roosevelt became President in 1933.[25] The first New Deal program which established work relief for artists — the Public Works of Art Project (PWAP) — became a reality in December of that year.

The artist George Biddle (1919-1973) was largely responsible for promoting the idea of government patronage for the arts. In his proposal to his old classmate Franklin Delano Roosevelt in May 1933, he cited the example of the Mexican mural movement during the 1920s. The President of Mexico had sponsored artists to cover the walls of schools and government buildings with murals expressing the ideals of the young republic,

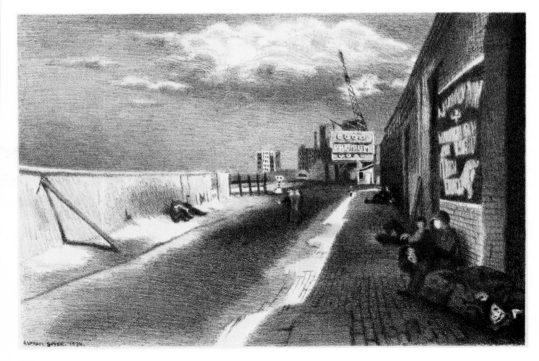

36 Raphael Soyer, *Waterfront,* 1934.

the emancipation of the workers, and the overthrow of the ruling class. Biddle's letter to President Roosevelt noted the success of that experiment and then went on to say: "The younger artists of America are conscious as they ever have been of the social revolution that our country and civilization are going through; and they would be very eager to express these ideals in a permanent art form if they were given the government's cooperation. They would be contributing to and expressing in living monuments the social ideals that you are struggling to achieve. And I am convinced that our mural art with a little impetus can soon result, for the first time in our history, in a vital national expression."[26]

The most famous of the Mexican muralists was Diego Rivera (1886-1957). A fresco he executed at Rockefeller Center provoked considerable controversy because it contained, for one thing, a portrait of Lenin. His compositions — based on large, heroic figures realistically rendered along with decorative mechanical and organic details, all compressed into a shallow space suggestive of bas-relief — set a stylistic example that influenced many American artists. José Clemente Orozco (1883-1949), another prominent Mexican muralist, painted a series of frescoes at the New School for Social Research at the same time Benton was working there. The publicity surrounding all of these projects captured the attention of the public and contributed to renewed enthusiasm for mural art.

In five months the PWAP employed 3,749 artists who produced some 15,633 works of art.[27] Many of these were mural designs that were not actually realized in public locations during the short term of the project. The PWAP afforded some relief for artists during the winter of 1933/34, but as a pilot program it also demonstrated a problem inherent in federally sponsored art patronage. A conflict existed between one goal, to sponsor works of reasonably good art for government buildings, and the other, to aid the impoverished artist. Seeking artistic quality and coping with financial need at one and the same time proved to be incompatible. PWAP ended June 1934, and two new and separate government projects were created. The first of these, the Treasury Section of Painting and Sculpture (known as the Section) functioned from 1934 to 1943. It sponsored competitions for commissions to decorate federal buildings. Artists were selected on the basis of their ability, regardless of their financial status. On the other hand, the Works Progress Administration/Federal Art Project (known as the WPA/FAP), which functioned from August 1935 to April 1943, provided work relief for indigent artists. For the most part, an artist had only to qualify for relief and to demonstrate some rudimentary professional training and accomplishment in order to be hired by the WPA/FAP.[28]

Benton was among a group of twelve artists selected by the Section for its first commissions. A number of mural and sculpture projects were planned for the newly constructed Justice Department and Post Office buildings in the capitol. George Biddle was commissioned to execute a mural in the fifth floor stairwell of the Justice Department. He chose as his theme the contrast between a society controlled and uncontrolled by justice. Since murals planned for three lower landings of that stairwell showed man, woman, and child emancipated through justice, he thought it logicial to follow up with themes linking the individual to society as a whole. Specifically, he created an ideal image of social integration in a central triptych, framing it on either side with images of a sweatshop [37] and a tenement house, "where working conditions and living conditions have been atrocious."[29] The entire mural was intended to reflect his belief that "the sweatshop and tenement of yesterday can be life planned with justice of tomorrow."[30]

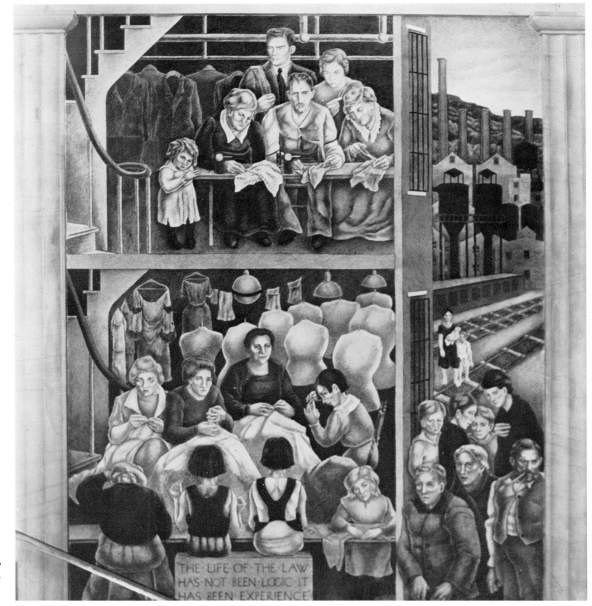

37 George Biddle,
Sweatshop, 1935/36.

When his proposal was submitted to the Commission of Fine Arts, its head, Charles Moore, not only condemned Biddle's sketches as "disturbingly busy in both pattern and scale" but denounced them as un-American, citing the dependence of his style on French and Mexican schools.[31] The spatial organization of the murals does, in fact, reflect a familiarity with Diego Rivera's work, but Biddle was only moderately successful in emulating the expressive power of the Mexican murals he so admired. Despite Moore's disapproval, the mural proceeded according to Biddle's original proposal, with the only changes ordered relating to quotations on two of the panels.

Artists who worked under New Deal projects enjoyed varying degrees of freedom in their selection of, and approach to, subject matter. Administrators encouraged artists to interpret the "American scene" but stopped short of specifically defining what that might include. It was left to the regional committees to impose their own censorship. A committee in northern California, for example, by its own admission "frowned upon imaginative and picturesque work which has seemed irrelevant to the American scene."[32]

The pervasive influence of the Mexican tradition may have contributed to an interest, at least among muralists, in realistic representation of everyday activities. New Deal murals tended to utilize contemporary imagery rather than the pseudoclassicism and allegory of the nineteenth century. William M. Milliken, director of The Cleveland Museum of Art, expressed his personal sense of relief at the modification of these grandiose styles. Speaking before the 1934 session of the American Federation of Arts, he noted: "One of the most important things that the Public Works of Art Project has brought out is a new interest in subject matter. . . . We have got back to something other than those symbolic decorations which have been a bane to so many an American building. We have got back to something that does express the life of our America."[33] A painting by Kenyon Cox (1856-1919), *Science Instructing Industry* (Figure 18), serves to illustrate the academic tradition of decorative wall painting established by nineteenth-century European and American artists such as Puvis de Chavannes, John LaFarge, and John Singer Sargent. Idealized men and women replete with classical drapes and laurel wreaths represented the standard personifications of the Arts and Sciences, Progress, and, in the case of Cox's design, Industry. By contrast, the majority of artists who participated in the revival of mural painting in the 1930s under New Deal support abandoned esoteric symbolism and embraced the idea that public art should be immediately comprehensible to a broad audience. Edward Laning (b. 1906) executed a mural under the WPA/FAP for the Alien's Dining Room on Ellis Island. His subject, like that of Kenyon Cox's, was industrial. But Laning chose to represent "The Role of the Immigrant in the Building of America" by depicting actual scenes of labor. Episodes such as *Clearing the Forest, Making Steel,* and *Laying the Rails for the Union Pacific* (Figure 19)[34] record real workers and real work without the use of allegory.

Laning's murals received a good deal of advance publicity in the form of news stories concerning his dealings with the Commissioner of Immigration and Naturalization, Rudolph Reimer. In the interest of historical accuracy, the Commissioner demanded some changes in Laning's designs. In sketches showing the construction of the Central and Union Pacific Railroad by Chinese and Irish laborers, for example, Reimer advised Laning that clean-cut, square railroad ties were not in use in 1869. Obligingly, Laning painted the ties round instead of square and also adjusted the height of the boots on his

Army officers. Press coverage of these and other changes, along with accounts of difficulties encountered in attaching the painted murals to the wall of the dining room, drew public attention to the work. Such lively and generally positive coverage provided some compensation for opposition to New Deal Art.

A series of articles carried by the *Chicago Tribune*, however, was more typical of the attitudes expressed by

Figure 18. Kenyon Cox,
Science Instructing Industry, 1898.

Figure 19. Edward Laning,
Laying the Rails for the Union Pacific, 1937.

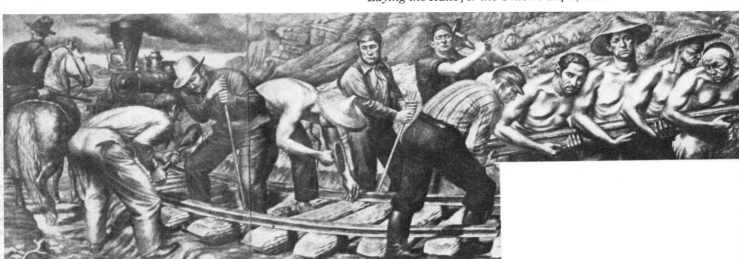

predominantly Republican newspapers and magazines. The *Tribune* reporter interviewed three downtown gallery owners and the president of a large federation of women's clubs who described the work of Chicago muralists as "un-American in theme and design," in "poor taste," of "communistic influence," and capable of exerting "an alien effect upon children and adults who view them." The entire body of WPA/FAP work in their opinion was "full of tripe," "inane," "just daubs of paint," "just junk," "disgusting," "botches of colors smeared together," and "not art of any kind." Such criticism provoked considerable opposition to the FAP and eventually stimulated a reevaluation of the entire Work Progress Administration art project.[35]

From the beginning of the New Deal art projects, mural designs destined for permanent installation in prominent locations in federal buildings were subject to relatively close scrutiny with regard to political implications or the manner in which they depicted any aspect of American life. The attitude toward industrial and technological development reflected in the murals, therefore, tended to be optimistic. Painting and the graphic media, however, were less closely supervised.[36] As a result, that work more often reflected the artist's personal viewpoint, even his criticism of the current political or social situation. Artists used a variety of stylistic vocabularies, occasionally including surrealism, cubism, and abstraction, and the subjects or designs they chose to depict reflected their own interests. The vast majority of these New Deal artists were committed to themes relevant to contemporary issues and especially the plight of the in-

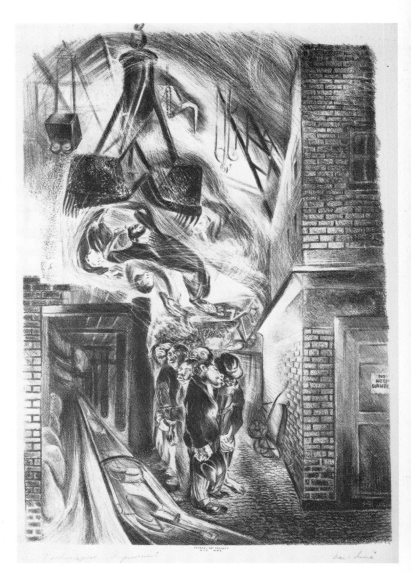

38 Nan Lurie,
Technological Improvements, ca. 1935-39.

113

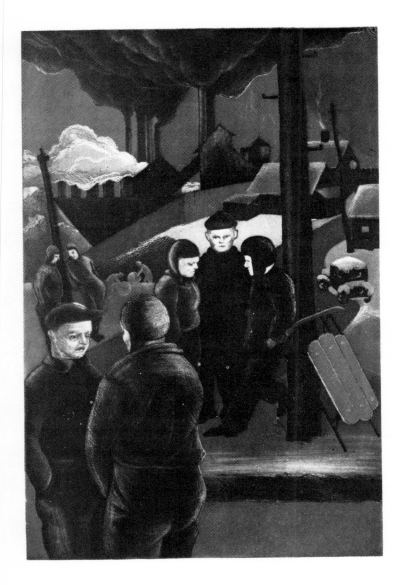

dividual in perilous times. Nan Lurie (b. 1910), for example, portrayed the desperation of factory workers seeking employment. *Technological Improvements* [38] conveys the resignation of applicants still waiting in spite of the sign posted NO HELP WANTED. Machines had taken away their jobs. *Heritage of Smoke* [39] by Frank Fousek (b. 1913) depicts the stultifying psychological as well as physical impact of the steel mills upon a winter scene of work and play.

Technical innovations developed in an effort to produce reasonably priced, widely available prints were one of the most important contributions of the graphic arts division of the WPA/FAP. Commercial print techniques of color lithography and silk screen were adopted and perfected for large-volume, quality production such as that represented by *Steel Mills* [40]. The artist, Elizabeth Olds (b. 1896), expressed her commitment to an art that would "at last flourish on a democratic scale," but admitted that reducing the price to within the range of the "average citizen" was only the first step: "there is still the problem of putting these low-priced, mass-produced prints before the people who can afford them and of interesting these people in such an art."[37]

Such democratic aspirations for a mass audience necessarily affected the choice of subject matter. Olds called for an art "vital and real to people generally" and "subject matter which seemed real and significant."[38] A concern on the part of artists with the realities of life and with the common man was evident throughout the Depression decade and interest in depicting the scenes of America was widespread, with or without New Deal sponsorship.

39 Frank D. Fousek,
Heritage of Smoke, ca. 1935-39.

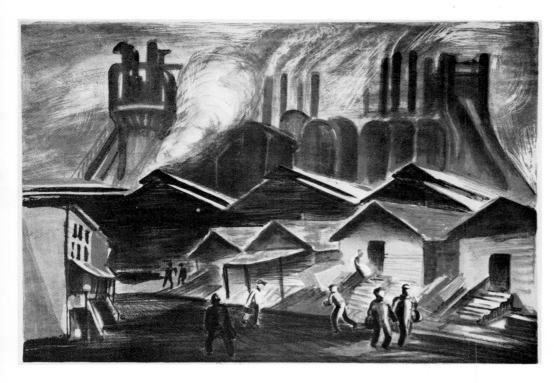

40 Elizabeth M. Olds,
Steel Mills, 1938.

Life and Work in the City

One influential group of urban realists developed in the late 1920s at the Art Students League, principally under the leadership of Kenneth Hays Miller (1876-1952). Their work represented a revival of the Ashcan school in subject matter and style. The relationship of Miller to the members of the group who were his students was similar to that of Henri to his students. Artists such as Edward Laning, Reginald Marsh (1898-1954), Morris Kantor (1896-1974), Raphael Soyer (b. 1899), and Moses Soyer (1899-1974) followed Miller's example in painting familiar urban scenes, such as pedestrians and shoppers on Fourteenth Street in New York City.[39] Marsh, who became one of Miller's most prominent students, began his career as an illustrator. First free-lancing in New York and later joining the staff of *New Yorker,* he covered movies, plays, and city life. It was primarily through his friendship with Miller that he was inspired to paint the scenes he first observed and came to know as an illustrator. Working with oil, however, was not his particular interest and he never became facile in that

medium. He had more success with water color and settled, finally, on egg tempera, preferring its draftsman-like quality. The spontaneity and the directness of his depictions of crowds, theater-goers, and shoppers were derived from his experience as a journalist-artist.

41 Reginald Marsh, *Locomotives Watering,* ca. 1932.

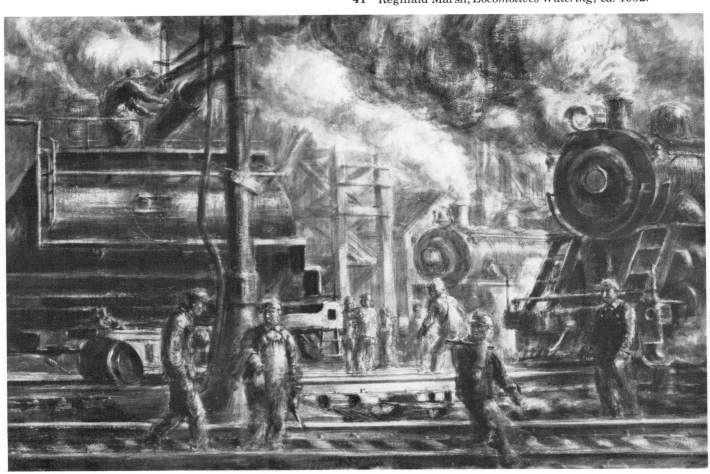

The group of artists associated with Miller primarily painted street scenes and city life, which they observed with sympathy and honesty. As a rule, these artists were not directly concerned with the industrial environment, although Marsh was attracted to commercial activity, the harbor, and railroad yards. He was stimulated by the vibrancy and the variety of such centers of people and things and movement. *Locomotives Watering* [41], for example, records the spectacle of the city at work. The suggestion of a kind of vibrating energy in the painting is partially due to the scale of the engines and the low, close-up vantage point from which they are seen. The steaming locomotives loom into the foreground of the composition, dwarfing the figures.

Marsh and the other members of Miller's Fourteenth Street school were particularly suited to the demands of mural painting. Their subjects and their approach to their subjects were appropriate to the scale and publicness of murals. Marsh received one of the Section's first commissions for murals in the new Post Office Department building in Washington, D.C. He painted in fresco two scenes of the actual handling of the mail — the transfer of mail from an ocean liner to a tugboat and the sorting of mail in a post office building. His success with the project led to another commission, this time for a major series of murals in the dome of the New York Customs House.[40] Although ports of the world and famous explorers were suggested as subjects, Marsh accepted the commission with his own ideas about a theme: "It is almost superfluous to say that I feel very proud that the honor to paint those walls has fallen to me. It's a man-sized job, with many problems — all those curves, etc., etc. Here is a chance to paint contemporary shipping with a rich and real power neither like the storytelling or propagandist painting which everybody does. I have in the past painted dozens of watercolors around N.Y.

harbor, and would like to get at it with some of this knowledge."[41]

The paintings were accurate in every detail, including the names of tugboats which represented five prominent New York companies. Eight panels illustrate the arrival of an ocean liner in New York harbor: it passes Ambrose Light, takes on a pilot, is met by a Coast Guard cutter, boarded by government officials, passes the Statue of Liberty [42a], is the site for a press interview with movie star Greta Garbo [42b], is warped to a pier by tugs [42c], and unloads cargo onto the pier [42d]. In the smaller alternative spaces, figures of the great explorers were painted in grisaille.

The artist adjusted the scale of the elements within each scene for viewing from a considerable distance from the floor of the Customs House. As a result, the panels were more broadly composed and appear less active and crowded than Marsh's water colors and tempera paintings of the same period.

The breadth and the vigor of the Customs House murals are typical of the artist's vision. Marsh maintained a fairly positive attitude toward the American scene, even in its tawdry, less fashionable aspects. That he was able to support himself by his art throughout the Depression years may have contributed to his optimistic outlook. He never applied for relief, was never involved in the passionate struggles of the Artists' Union, and never participated in artists' strikes against the WPA. Despite the fact that he was relatively sheltered from the most brutal of the Depression's effects, however, his work reveals the same character evident in much of the art produced in the 1930s — that is, a quality of intensity and emotional expressiveness. It was an emotional time. Adversity inspired anxiety, rage, a restless desire to lash out in protest, or to retreat into a memory of the past.

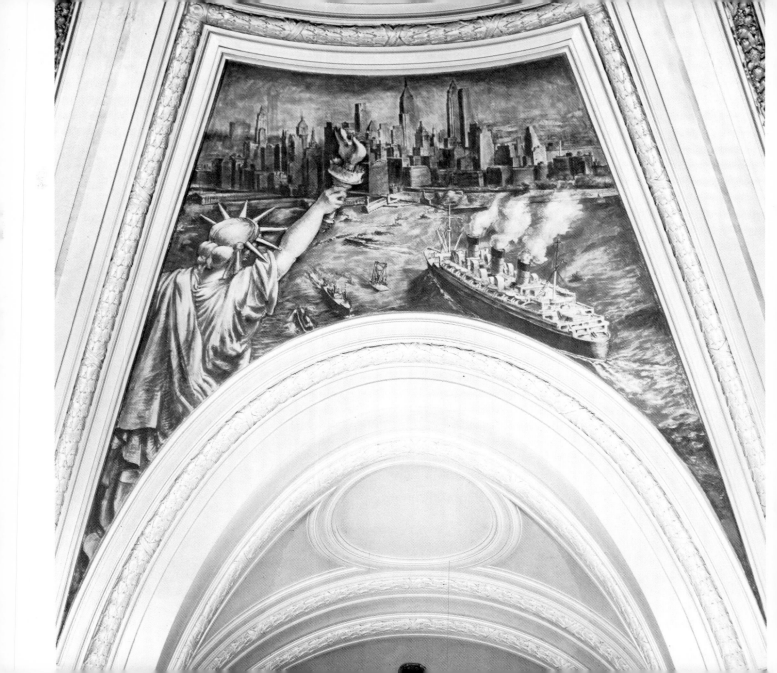

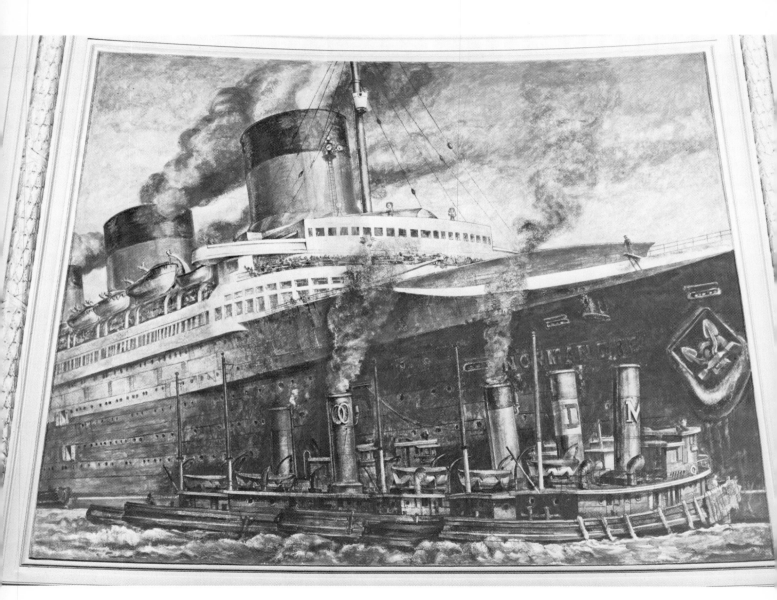

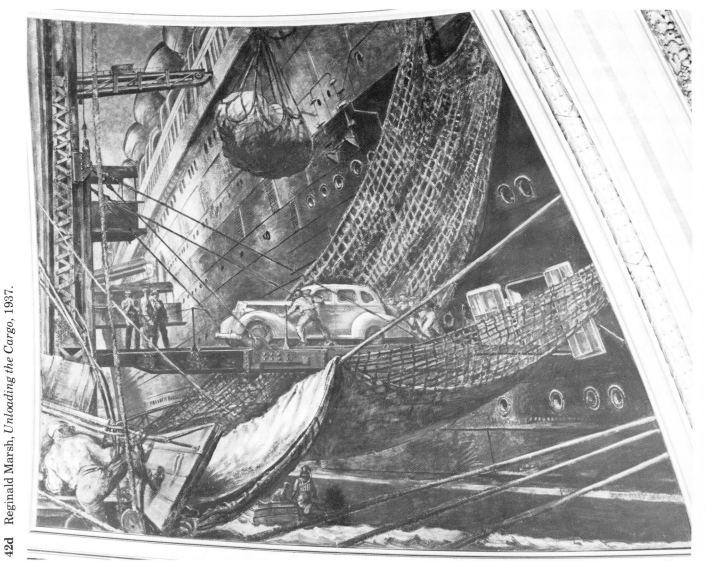

42c Reginald Marsh, *Tugs Warping the "Normandie" into Dock*, 1937.

42d Reginald Marsh, *Unloading the Cargo*, 1937.

In a mood of economic and social turmoil, the country turned inward and backward — as did the majority of American artists. They turned their attention from avant-garde styles and utopian ideologies. They were concerned with meaning in art, as were the precisionists of the 1920s, but the mood of the 1930s was different. Artists tended to focus not on broad concepts such as industry or the city but on the people themselves. Most artists were suspicious of big business, big power, and rapid urbanization. They championed the cause of the common man, the individual.

The goals and intentions of the American scene painters, the social realists, as well as the urban realists were all pragmatic in one way or another. They wanted to tell stories, convey political ideas, or warn about pernicious effects of unrestrained progress. Outright criticism of capitalism or the political situation, however, was rare, particularly in large-scale public murals, most of which were paid for by the federal government. Generally positive pictures of American life were more common. Characteristically, artists depicted real men and women involved in real daily activities. They glorified the American worker, the farmer, and the builder. Their art was activated by a self-conscious involvement with the lives of the American people and charged with their indefatigable spirit.

1. "The new science of the region" was defined as "a science descriptive of how all societies grow, fundamental to realistic planning, and important in the interrelation and coordination of the social sciences and the new cooperation between the physical and social sciences," in Howard W. Odum and Harry Estill Moore, *American Regionalism: A Cultural-Historical Approach to National Integration* (New York: Henry Holt and Co., 1938), p. 3.

2. Lewis Mumford, "The Theory and Practice of Regionalism," *Sociological Review* xx (January 1928): 133, 136, 140.

3. Ibid., p. 140.

4. Sherwood Anderson, "The Times and Towns," in *America as Americans See It*, ed. Fred J. Ringle (New York: Harcourt, Brace and Co., 1932), p. 17, quoted in Joshua C. Taylor, *America as Art*, exh. cat. (Washington, D.C.: National Collection of Fine Arts, 1976), p. 220.

5. In 1938 Lewis Mumford again took note of the changing moods of society, concluding that a major lesson had been learned and that a new attitude was emerging. The "re-location of interest from mechanism to organism" is discussed in his *The Culture of Cities* (New York: Harcourt, Brace and Co., 1938), pp. 300-305.

6. See Alfred Haworth Jones, "The Search for a Usable American Past in the New Deal Era," *American Quarterly* XXIII (December 1971): 710-24.

7. Thomas Craven, *Thomas Hart Benton* (New York: Associated American Artists, 1939), p. 11.

8. Matthew Baigell, *Thomas Hart Benton* (New York: Harry N. Abrams, 1973), pp. 62-63.

9. The first of these projects, the *American Historical Epic* (1919-26), was to consist of approximately sixty panels of which ten studies were completed. Four additional panels depicting the history of New York City, intended for the New York Public Library, were painted in 1925 but never installed. A set of eight murals, *America Today* (1930/31), was executed along the walls of a classroom in the New School for Social Research, New York City. A series of five murals, *The Arts of Life in America* (1932), was completed for the Whitney Museum of American Art and is now in the New Britain Museum of American Art. Twenty-two mural panels, *Social History of the State of Indiana* (1932/33), were painted for Indiana's pavilion in the Century of Progress International Exposition in Chicago and are now in the auditorium and other buildings of Indiana University, Bloomington. A series of murals entitled *A Social History of the State of Missouri* (1935/36) was painted on four walls of the House Lounge in the State Capitol at Jefferson City, Missouri. For a discussion of Benton's leanings toward Communism in the early 1920s and the development of his Populist ideas thereafter, see Matthew Baigell, with Allen Kaufman, "The Missouri Murals: Another Look at Benton," *Art Journal* XXXVI (Summer 1977): 314-21.

10. C. Adolph Glassgold, "Thomas Benton's Murals at the New York School for Social Research," *Atelier* I (April 1931): 286.

11. Thomas Hart Benton, *An Artist in America* (New York: Robert M. McBride & Co., 1937), p. 70.

12. Ibid., pp. 201-2.

13. Thomas Benton, "America's Yesterday: In the Ozark Mountains of Arkansas — Life and Customs on a Forgotten Frontier," *Travel* LXIII (July 1934): 11, quoted in Baigell, *Benton,* p. 74.

14. Benton, *An Artist,* p. 95.

15. Ibid., p. 30.

16. "Benton Paints Our Economocracy," *Los Angeles Times,* 4 May 1931; Glassgold, "Benton's Murals," p. 287.

17. Stuart Davis, "The New York American Scene in Art," *Art Front* I (February 1935): 6. All issues of *Art Front* are contained on microfilm no. NDA 28, Archives of American Art, Smithsonian Institution, Washington, D.C. For a discussion of *Art Front* as a document of tensions between art and politics during the 1930s, see Gerald M. Monroe, "Art Front," *Archives of American Art Journal* XIII, no. 2 (1973): 13-19.

18. John Steuart Curry, "A Letter from Curry," *Art Front* I (April 1935): 6.

19. Benton, "Form and Subject," *Arts* V (June 1924): 303.

20. Creekmore Fath, *The Lithographs of Thomas Hart Benton* (Austin: University of Texas Press, 1969), p. 30.

21. August L. Freundlich, "William Gropper, a Critique," in *William Gropper: Retrospective,* exh. cat. (Coral Gables, Fla.: Joe and Emily Lowe Art Gallery, University of Miami, 1968), pp. 12-13.

22. *Water Street* (ca. 1932) is reproduced in Lloyd Goodrich, *Raphael Soyer* (New York: Harry N. Abrams, 1972), pp. 58-59.

23. "Why Mr. Benton," *Art Front* I (April 1935): 3; "On the American Scene," *Art Front* I (April 1935): 4, 8; Jacob Burck, "Benton Sees Red," *Art Front* I (April 1935): 5, 8; Thomas Hart Benton to the Editors, *Art Front* I (May 1935): 7; Jacob Kainen to the Editors, *Art Front* I (May 1935): 7.

24. "Mr. Benton Will Leave Us Flat," *New York Sun,* 12 April 1935.

25. Francis V. O'Connor, *Federal Art Patronage 1933 to 1943,* exh. cat. (College Park, Md.: University of Maryland Art Gallery, 1966), p. 6.

26. George Biddle, *An American Artist's Story* (Boston: Little, Brown and Co., 1939), p. 268.

27. Ibid., p. 11.

28. Francis V. O'Connor, "New Deal Murals in New York," *Artforum* VII (November 1968): 41-42. See also idem, *Federal Art Patronage: 1933 to 1943* (University of Maryland Art Gallery, 1966), pp. 1-40; William F. McDonald, *Federal Relief Administration and the Arts* (Columbus: Ohio State University Press, 1969), pp. 377-482.

29. George Biddle, "Notes on Fresco Painting," *Magazine of Art* XXXI (July 1938): 409.

30. Biddle, *American Artist's Story,* p. 280.

31. Robert M. Coates, "Profiles," *New Yorker* (30 May 1936): 22.

32. *Washington Post,* 9 March 1934, quoted in Richard D. McKinzie, *The New Deal for Artists* (Princeton University Press, 1973), p. 23.

33. William M. Milliken, "How a City Can Develop Its Artists," *Proceedings of the Twenty-fifth Annual Convention of The American Federation of Arts, American Magazine of Art* XXVII (Anniversary supp. September 1934): 34.

34. See O'Connor, "New Deal Murals," pp. 44-45; Edward Laning, "The New Deal Mural Projects," in *The New Deal Art Projects: An Anthology of Memoirs,* ed. Francis V. O'Connor (Washington, D.C.: Smithsonian Institution Press, 1972), pp. 91-97.

35. *Chicago Tribune* 19, 20, 22 December 1940, quoted and discussed in McKinzie, *New Deal for Artists,* pp. 108-13. Also see his chapter, "Relief Art on the Defense, 1938-1943," pp. 149-71.

36. Painters were usually permitted to work in their own studios and were expected to submit one painting about every four to eight weeks. Graphic artists also worked in their own studios, but the prints themselves were usually produced under direct supervision in workshops maintained by the WPA/FAP. The editions, which averaged about twenty-five copies, were allocated to public institutions such as schools, hospitals, and prisons.

37. Elizabeth Olds, "Prints for Mass Production" in *Art for the Millions: Essays from the 1930s by Artists and Administrators of the Federal Art Project,* ed. Francis V. O'Connor (Greenwich, Conn.: New York Graphic Society, 1973), p. 142.

38. Ibid., p. 142.

39. Milton W. Brown, *American Painting from the Armory Show to the Depression* (Princeton University Press, 1955), pp. 182-83.

40. Financial support for the Customs House project was not available from the Treasury Section of Painting and Sculpture because it funded only new government buildings (the Customs House was already in existence). Instead, the Treasury Relief Project (TRAP), which supervised the creative activities of the Section and received its funds from the WPA/FAP, sponsored Marsh's work on the dome.

41. Marsh to Olin Dows, Chief of TRAP, August 1936, Record group 121 (Records of the Public Buildings Service), National Archives, Washington, D.C., quoted in O'Connor, "New Deal Murals," p. 49, and in Lloyd Goodrich, *Reginald Marsh* (New York: Harry N. Abrams, 1972), p. 140.

Recent Realism

Understandable and Recognizably American

Various manifestations of realism have appeared during recent decades. The emergence of the pop and new realism movements in the 1960s was a reminder of a taste in this country for recognizable subject matter in art. Although pop source material was first identified in London, pop art was known as an American phenomenon before it was widely taken up by European artists, and it continued to be seen as a reflection of American culture. The familiarity of images drawn from commercial illustration and advertising — soap boxes, soup cans, road signs, and American flags — contributed to their immediate popularity. *Time* magazine reported pop art's success with undisguised condescension, calling it "the biggest fad since art belonged to Dada. Symposiums discuss it; art magazines debate it; galleries compete for it. Collectors, uncertain of their own taste, find pop art paintings ideal for their chalk-walled, low-ceilinged, $125,000 co-op apartments in new buildings on Park Avenue."[1]

New realist or super realist artists were the successors of the pop movement. They were less involved with the objects of popular culture and satirical comment on that culture and dealt instead with the actual world, perceived directly or by means of the camera lens. Shortly after pop art's heyday, critics were only slightly more receptive to new realism, but public reaction was enthusiastic. *New York Times* critic Hilton Kramer pointed out one of the main reasons for the widespread acceptance of new realist painting when he condemned examples as "pure illustration." An American audience responded unabashedly to "a style of picture-making based on glossy, full-color photographs of the kind usually seen in magazine ads or picture postcards."[2] It was accessible, understandable, and recognizably American.[3]

Both of these realist movements can be compared with earlier expressions of the American experience, namely, American scene painting of the 1930s and Ashcan painting of the turn of the century. All of these movements were concerned with the reality of contemporary life. In recording that reality, artists frequently turned to a style related to contemporary mass-media illustration. The Ashcan artists developed a style on the basis of familiarity with nineteenth-century French illustrators and their own experiences as artist-reporters. Several of the American scene painters had also worked as illustrators and were dedicated to an art that would communicate its meaning to a wide audience. The new realists of the 1960s used as source material not only glossy, full-color advertisements from current magazines but also more recently available image formats such as picture postcards and 35 mm. slides. Thus, the accessibility of their painting was a result of style and format as well as content.

Although new realism has lost momentum as an identifiable art movement, practitioners of a realist style continue to be widely appreciated. A sampling of work by these artists demonstrates the persistence of a realist tradition in American art utilizing industrial themes.

Industrial Themes in Recent Realism

Robert Lavin (b. 1919), for example, produces portraits of industry. He receives commissions from construction companies and steel corporations. He is an academically trained artist, and thus his work represents a continuity with earlier realist traditions. He studied at the City College of New York and the National Academy Art School in the 1930s when the National Academy was considered a stronghold of conservatism and was only peripherally in contact with significant art events of the day or current stylistic developments. The Academy emphasized a rigidly disciplined study of the human figure and representational techniques in drawing and painting. Twentieth-century modernist trends were resisted, but the Academy retained a permanent place in the context of the realist tradition in this country. Artists such as Kenneth Hays Miller, Reginald Marsh, Raphael Soyer, Thomas Hart Benton, William Glackens, Robert Henri, and George Bellows were elected members of the venerable institution, and many more were taught by academicians, principally at the Art Students League.

Lavin found it difficult to begin a career as an artist during the Depression and turned to commercial art. His present style evolved from an integration of both his student experience and his professional experience as a commercial artist. He says about his work: "In a way, I feel I've devised a method of painting Social Realism and keeping it alive, but not with the same leftist or regional slant that the artists of the '30s gave it. I have a romantic attitude about it that they did not, which expresses itself in a kind of romantic realism."[4] He is enthusiastic about his subject matter, especially its beauty and drama. A painting which he considers to be among his best, *Teeming in the Open Hearth* [43], was executed in 1972 and depicts a scene observed at Granite City Steel, Granite City, Illinois. The artist called it "a picture of creation."[5] The molten mixture of iron, lime, and metal alloys is here being poured into ingot molds to make steel. The artist knew that the hearth depicted in operation would soon be shut down, and in a sense his painting is a memorialization of a spectacle that had already passed into history when the open hearth process itself was superseded by the more efficient basic oxygen furnace method.[6]

Lavin develops his compositions in academic fashion with some contemporary modifications. His usual method is to begin with sketches of the actual scene. He then structures the composition according to pictorial considerations: "I'm very influenced by the light and dark and spatial reality of Baroque art, and I conceive of the composition basically as a Baroque composition. God was not a Baroque artist, so I have to arrange the picture to my own way."[7] After the composition has been established he makes studies of individual elements, aided by his own photographs. The resulting portraits are accurate, if somewhat staged. Lavin's commissioned work is placed in executive offices or reproduced for promotional purposes.

A realist tradition in landscape has also persisted into recent decades and one of the most prominent artists in that tradition is Rackstraw Downes (b. 1939). In contrast to many modern realists, who make use of the camera, Downes uses his own sketches to record every aspect of the subject. A landscape such as *The Coke Works at Clairton, Pa.* [44] is a precise depiction of a particular place, a location on the Monongahela River near Pittsburgh where the largest plant of its kind in the world converts coke for the production of steel and industrial chemicals.[8] Details such as open doors in railroad cars passing in the foreground are carefully described. The relationship of the coke works itself to the surrounding topography is accurately defined. Moving

126

43 Robert Lavin,
Teeming in the Open Hearth, 1972.

44 Rackstraw Downes,
The Coke Works at Clairton, Pa., 1975.

cars, billowing smoke, and barges creating wakes on the river are references to daily occurrences activating the industrial environment.

Downes's interest in factual representation reflects a continuity with nineteenth-century landscapes by artists such as Russell Smith or even Thomas Eakins. The traditional elements of his painting, however, are modified by a kind of bald frankness that emphasizes his modernity. Although Downes's process is not aided by the camera, his vision is influenced by it. The continuous, horizontal view characteristic of his landscapes is unmistakably reminiscent of the Cirkut-camera panorama long associated with the documentation of graduating classes and topographical views. Although care has been taken to arrange the scene pictorially within the picture frame, everything is recorded as it existed at a moment in time, without idealization.

Photography plays a more direct role in the work of H. N. Han (b. 1939). The visual data for his paintings is first recorded on a 35mm. slide. The distance established between the artist and subject by the intervention of the unselective, monocular camera is enhanced by the use of a telephoto lens. The painting process itself is also indirect. Han projects his slides onto thin sheets of paper in order to draw the outlines of elements in the composition. Once the shapes have been cut out, the sheets of paper function as stencils through which the artist sprays acrylic paint onto the canvas.

The mechanical nature of the artist's procedure is mitigated somewhat by the pointilist paint surface he achieves. Despite a superficial resemblance to the dots of paint Seurat painstakingly applied to his canvases, Han's art is unmistakably contemporary. His realism takes into account recent developments in abstract art which emphasize basic elements such as the flatness of the canvas and the material of the paint itself. The scale of Han's painting also reflects the legacy of mural-size canvases of abstract expressionist and color-field painters.

Formalist concerns are of primary importance to this artist. He is more interested in the visual aspect of the subjects he selects, usually urban structures such as SoHo facades, bridges, and factories. Han insists that he seeks to make no particular comment about the beauty of industrial architecture, on one hand, or its intrusion onto the landscape, on the other.[9] Despite such disclaimers of disinterested objectivity, however, the very choice of urban or technological subjects and the decision to reproduce their image by means of blatantly mechanical methods imply an attitude on the part of the artist. He depicts a real, working environment in *Wilmington Factory,* but the cloud of steam is the only indication of actual activity [45]. The absence of human beings imparts a static coldness to his portrayal. More significantly, the picture is not an illusionistic rendering of the scene. Instead, the composition is disassociated from reality. Essentially, the painting presents a two-dimensional interpretation of the scene that is developed in terms of a uniform painterly treatment regardless of the actual surface qualities of the objects portrayed. Such radical detachment from the subject is a departure from earlier forms of American realism and suggests a relationship with modern concepts of alienation and distancing.[10]

The tendency to transform subject matter in accordance with formalist concerns was also characteristic of the precisionists of the 1920s. A dependence on photography and an interest in the industrial or urban land-

45 H. N. Han, *Wilmington Factory,* 1973.

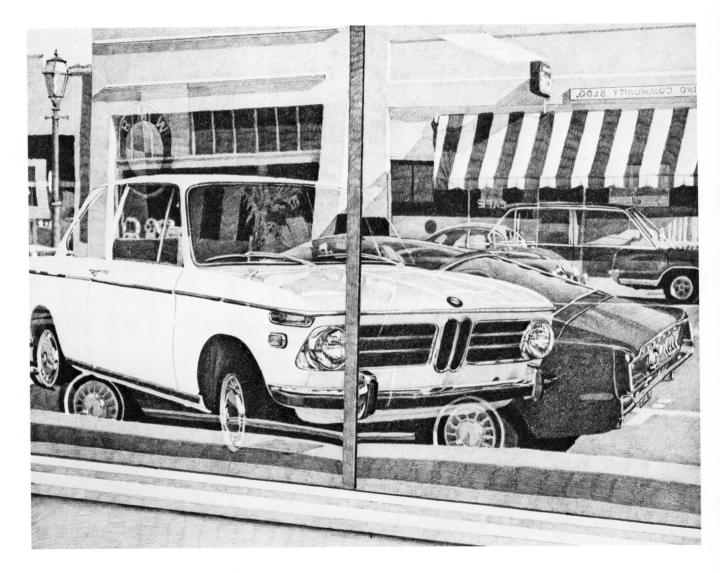

scape are also elements some recent photo-realists have in common with precisionists. The machine and the skyscraper, however, no longer symbolize a dawning utopia, but instead merely insert their presence onto the landscape. Don Eddy (b. 1944), for example, focuses on particularized views of the cityscape — car bumpers, parking lots, and store windows. His paintings and prints are based on groups of photographs: sections of several different photographs from different viewpoints are combined to establish the compositional structure and to provide the basic visual information.[11] But the artist has asserted that photographic accuracy and being "true to life" are less important than his interest in "the references between what we know, what we see, what we think we see and what's there, between the surface of the canvas and the illusion in the canvas."[12] Like Han, Eddy is less concerned with the subject matter than with a formal problem related to the adjustment of perceived reality to the surface of the flat picture plane. His interest in that problem is his primary consideration in the selection of subjects.

BMW Showroom [46] is a lithograph which demonstrates the manner in which this artist deals with the tension between the illusion of spatial depth and the actual flatness of the picture surface. The car on the showroom floor establishes the illusion of a recession into depth beyond the window in the foreground plane. Reflections of cars parked in front of the showroom and storefronts across the street suggest a dimension of space in front of the picture plane. At the same time the basic compositional structure emphasizes the integrity of the print surface itself. Linear elements are carefully aligned with a generally horizontal and vertical grid pattern. Car bumpers and chrome strips, for example, are in line with the bottom of the showroom window and the sidewalk in front of the window and the bottom edge of the composition. Vertical window panes reflected in the upper-left section of the lithograph correspond to vertical stripes in an awning reflected in the upper-right area. With the exception of a narrow section at the bottom of the picture, all elements of the composition are seen in or through sheets of glass which are almost parallel to the picture plane. The vertical division of the unifying sheet glass creates two roughly equal halves which further emphasize the carefully ordered balance of the composition.

Achieving a successful solution to a challenging pictorial problem might be seen as an artistic end in itself. A work such as *BMW Showroom*, however, involves an image from the real world as well as an intriguing arrangement of shapes. On one level, the subject of the print is the automobile itself. The automobile dealership is in the business of displaying its product in the most advantageous way possible, and the artist has further structured and formalized that presentation in the lithograph. When the composition is viewed in terms of its resemblance to a medieval diptych, the automobile thus depicted becomes the subject of a twentieth-century icon.

Refuse of the Industrial Age

The pop bottle has also been described as an icon of twentieth-century American society.[13] Returnable and disposable beverage containers are symbols of a consumer society. Their shapes have been carefully designed by packaging and marketing experts to attract the buyer's eye, sometimes even to suggest subliminal

46 Don Eddy, *BMW Showroom,* 1972.

sexual references.[14] Once empty, however, the bottles lose their appeal and are too often added to the accumulating quantity of refuse blighting the landscape. Idelle Weber (b. 1932) often depicts discarded bottles in her paintings of trash and rubbish. Her *Livery* (Figure 20), executed in 1978, presents an array of meticulously rendered, used and discarded items such as license plates, cardboard boxes, a bicycle wheel, as well as a beer and a ginger ale bottle.[15]

Weber's painting is emphatically contemporary. The labels are familiar and the pull-tab can in the lower right corner is characteristic of the efficient packaging that came into general use in the 1970s. More important than the choice of subjects, however, is the modernity of the composition — the close-up viewpoint, the cropping of the image, and the seemingly random distribution of elements across the horizontal rectangle of the painting. The unrelentingly immediate view and the unfocused composition reveal an affinity to both the unselective television image and French New Wave Cinema.[16]

A number of recent realist artists have dealt with refuse as a theme. John Salt (b. 1937) is known for his paintings of dilapidated automobiles, and Martin Hoffman (b. 1935) has depicted a variety of broken-down symbols of twentieth-century technology. *Press* (Figure 21), painted in 1973, is a particularly intriguing example of his work, especially in the context of growing interest in diagnosing the consumer personality and characterizing the consumer society in general.[17] The media and cultural resources available to the general public are unprecedented in scope and variety — television, magazines, records, and even the museums are available to a broader audience than ever before in history. Yet, as Morrell Heald, scholar of American culture, has cautioned: "If we are to believe those who fear the encroachments of an impersonal technology, our

scientific and technological virtuosity have produced a society in which art is alienated, the individual diminished, intellect trivialized and distracted."[18] *Press* is more than a picture of an outmoded piece of machinery. The image of an abandoned and rusting printing press carries with it the suggestion that the American public no longer reads. On the deserted plain portrayed in Weber's painting, the benefits of technology are outweighed by its ill effects: environmental pollution, a preoccupation with material values, and debilitating apathy.

Material abundance has produced new physical conditions and new social patterns that have challenged the quality of life in America and around the world. A total rejection of technological development and material progress, however, as Heald suggests, is as unproductive as overzealous utopianism. Referring to the often-acknowledged antagonism between scientists and humanists — rising out of the former group's flamboyant confidence in their own spectacular achievements and the latter's doubts and resentments — he also points to evidence of a promise for reunification of divergent views. Scientists have increasingly recognized the importance of creativity and imagination in the pursuit of their discipline, and at the same time experts in all fields have assumed a mutual responsibility for controlling the process of scientific and technical advancement. These conditions, according to Heald, are creating the possibility — indeed the demand — for collaboration between science, technology, and the arts "in the search for a more humane world. . . ."[19]

The relationship between the advantages and disadvantages of technology is an aspect of a mural project completed for the Department of Labor in Washington, D.C., and dedicated in March 1977. The four panels interpreting the history of labor in America by Jack Beal

Figure 20.
Idelle Weber,
Livery, 1978.

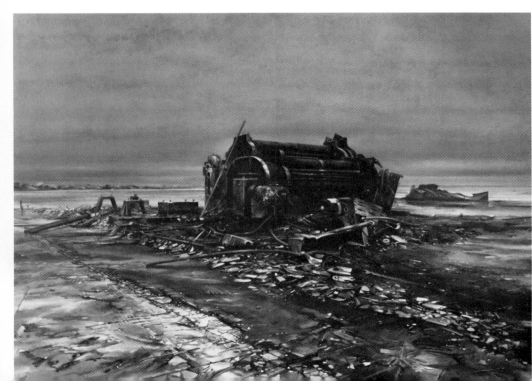

Figure 21.
Martin Hoffman,
Press, 1973.

(b. 1931) were the first publicly funded paintings commissioned for a federal building in the capitol since 1942. Many abstract sculptures have been incorporated into newly constructed government buildings during and after the 1940s, but in this particular project, realism was a specified priority from the outset.[20]

Beal created four fictional incidents to represent four centuries of American history. In the first scene, *Colonization* (Figure 22a), two seventeenth-century trappers negotiate a price for their furs with an English trader. A campfire illuminates their faces with a reddish glow in the early morning half-light. The eighteenth

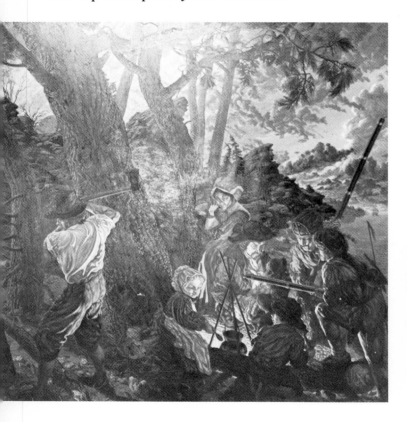

Figure 22a. Jack Beal, *Colonization*, 1977.

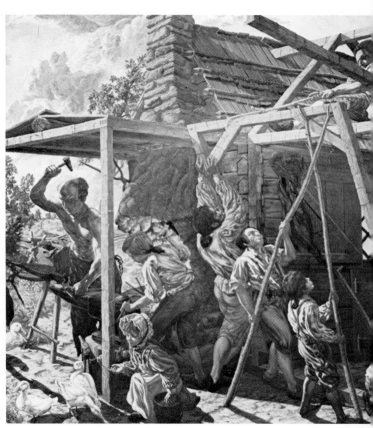

Figure 22b. Jack Beal, *Settlements,* 1977.

century is represented by *Settlements* (Figure 22b), an idyllic, midday scene of building and planting. The mood of the third panel, *Industry* (Figure 22c), is more foreboding. Young textile workers carry signs to protest child labor while a mill proprietor looks on with disdain.

Giant steel wheels suspended threateningly above the heads of small children and black clouds of smoke billowing from industrial chimneys in the distance symbolize the perils of the factory environment. *Technology* (Figure 22d), the last panel, is an ominous prediction.

Figure 22c. Jack Beal, *Industry,* 1977.

Figure 22d. Jack Beal, *Technology,* 1977.

Amid a confusing web of electric wires and a panoply of mechanical instruments and charts, scientists and technicians are intent upon examining a tree limb and a potted seedling — artifacts of a country once richly endowed with natural resources. This new and totally mechanized society is the ultimate promise of technology.

Although Beal's interest in formal problems — in arranging the elements of his composition, as well as the patterns of light and dark areas, across the surface of the picture plane — establishes his relationship to developments in abstract painting in the 1950s and 1960s, the didactic content of the Labor Department murals links the artist with earlier realist painting in America. The romanticism of his approach to subject matter and his dramatic use of lighting also relate his work to the art of the past — to nineteenth- and, ultimately, to seventeenth-century painting. Beal can be seen as continuing an aspect of academic realism, while his concern about creating art that people can understand relates him more specifically to an American taste for informational content in the tradition of Peale's *Exhuming the First American Mastodon* (see Figure 1) or Waldo's *Clark Match Works* [4].

Contemporary realist artists such as Don Eddy and H. N. Han have also portrayed artifacts of the twentieth-century environment, and their pictures function as symbols of modern America. Despite their declared commitment to formal problems of composition and pictorial structure, their treatment of subjects drawn from contemporary life connects them with the long-established tradition of realism in this country. As much as these paintings are related to twentieth-century ideas of abstraction, they are also closely linked to documentary aspects of works by Bass Otis, John Ferguson Weir, and even Charles Sheeler. Eddy and Han are also similar to earlier realist artists in their self-conscious use of popular images associated with mass media.

Although the interrelationship between fine art and the vernacular has often been characteristic of American art, the tendency to reflect popular culture in art cannot be seen as uniquely American. In the same respect, the continuing prevalence of a realist art in this country cannot be considered a distinctively national tendency. While many expressions of American realism have relied heavily on European sources, the Americanness of American art rises more essentially from the unique quality of the American experience and the artist's expression of that experience.

One important aspect of the American experience is the persistence of the effects of rapid technological change, industrialization, and urbanization. American culture necessarily reflects a particularly strong identification with commercial and industrial interests because the history of industrial development in the United States has been virtually parallel to the development of the country as a whole. The Industrial Revolution dictated the priorities of American society from the beginning of the nineteenth century, and every aspect of American life has been affected by the process of mechanization. It is no surprise, therefore, that many nineteenth- and twentieth-century artists have been involved with the observation of that process. Viewed in terms of their historical context, such images provide not only a compelling insight into the changing moods and attitudes of the American people as well as changing artistic trends, but also offer a pictorial record of a significant aspect of American history.

1. "Pop Art — Cult of the Commonplace," *Time* LXXXI (3 May 1963): 69. Basic sources on pop art include Lawrence Alloway, *American Pop Art* (New York: Collier Books, 1974); and Lucy R. Lippard, *Pop Art* (New York: Frederick A. Praeger, 1966).

2. Hilton Kramer, "And Now . . . Pop Art: Phase II," *New York Times,* 16 January 1972.

3. For additional discussion of new realism, see Gregory Battcock, ed., *Super Realism: A Critical Anthology* (New York: E. P. Dutton & Co., 1975); William C. Seitz, "The Real and the Artificial: Painting of the New Environment," *Art in America* LX (November 1972): 58-72; and Edward Lucie-Smith, *Super Realism* (Oxford: Phaidon, 1979).

4. Lorraine Gilligan, "Robert Lavin's Portraits of Industry," *American Artist* XLII (February 1979): 97.

5. Lavin to the author, 17 July 1979.

6. Telephone interview with the artist, 17 June 1980.

7. Gilligan, "Lavin," p. 96.

8. Rackstraw Downes was commissioned to execute a painting for the Bicentennial exhibition America 1976 sponsored by the United States Department of the Interior. *The Coke Works at Clairton, Pa.* is cat no. 28.

9. Telephone interview with the artist, 10 June 1980.

10. Such concepts have gained currency with sociological and psychological speculation about the implications of technological development, automation, and the concentration of political and economic power in business and government at the expense of the individual. See, for example, the collection of essays in John G. Burke, ed., *The New Technology and Human Values* (Belmont, Calif.: Wadsworth Publishing Co., 1966).

11. For a discussion of Eddy's use of photographs and his painting technique see Tom Hinson, "Eddy: New Shoes for H," *Bulletin of The Cleveland Museum of Art* LXII (December 1975): 291.

12. Nancy Foote, "Photo-Realists: 12 Interviews," *Art in America* LX (November 1972): 81.

13. See, for example, Craig Gilborn, "Pop Iconology: Looking at the Coke Bottle," in *Icons of Popular Culture,* eds. Marshall Fishwick and Ray B. Browne (Bowling Green, Ohio: Bowling Green University Popular Press, 1970), pp. 13-28.

14. Arthur A. Berger, "Soft Drinks and Hard Icons," in *Icons of Popular Culture,* eds. Marshall Fishwick and Ray B. Browne (Bowling Green, Ohio: Bowling Green University Popular Press, 1970), p. 31.

15. The presence of a photograph of similar objects in the lower left in the composition documents the artist's dependence on the camera and suggests the actual collection of litter which was the source for *Livery.* Weber formulates her compositions in the camera, sometimes adjusting the position or arrangement of elements to suit her needs. She also takes some of the objects back to her studio to observe them more closely while she works on a painting. Ellen Lubell, "Idelle Weber," *Arts Magazine* LII (September 1977): 8.

16. See Linda Nochlin, "The New Realists," in *Realism Now,* exh. cat. (Poughkeepsie, N.Y.: Vassar College Art Gallery, 1968), p. 10.

17. For one of the most widely read discussions of the consumer personality, see David Riesman, *The Lonely Crowd* (Garden City, N.Y.: Doubleday Anchor Books, 1953).

18. Morrell Heald, "Technology in American Culture" in *American Character and Culture in a Changing World: Some Twentieth-Century Perspectives,* ed. John A. Hague (Westport, Conn.: Greenwood Press, 1979), p. 163.

19. Ibid., p. 166.

20. The Labor Department building is now called the Frances Perkins Building. For a brief history of the mural project as well as the decision to commission a realist artist, see Judd Tully, "Proud New Murals for the Federal Halls," *Washington Post,* 20 March 1977. See also United States Government Printing Office, *Beal: The History of Labor in America* (Washington, D.C.: Government Printing Office, 1977).

Catalog

Bass Otis, 1784-1861
1 *Interior of a Smithy*
Oil on canvas, 50½ x 80½ inches (128.3 x 204.5 cm.), ca. 1815. Philadelphia: Pennsylvania Academy of the Fine Arts, Gift of the artist.

John Ferguson Weir, 1841-1926
2 *The Gun Foundry*
Oil on canvas, 46½ x 62 inches (118.1 x 157.4 cm.), 1866. Cold Spring, New York: Putnam County Historical Society.

Alexis Jean Fournier, 1865-1948
3 *Mill Pond at Minneapolis*
Oil on canvas, 17 x 26 (43.2 x 66 cm.), 1888. The Minneapolis Institute of Arts, The John R. Van Derlip Fund.

J. Frank Waldo, 1832-ca. 1902
4 *Clark Match Works*
Oil on canvas, 22 x 36½ inches (55.9 x 91.2 cm.), 1883. Oshkosh, Wisconsin: Oshkosh Public Museum.

W. T. Russell Smith, b. Scotland, 1812-1896
5 *View of Pittsburgh from the Salt Works on Saw Mill Run*
Oil on canvas, 11 x 16 inches (27.9 x 40.6 cm.), 1838. Pittsburgh: Collection of Virginia Lewis.

Thomas Moran, b. England, 1837-1926
6 *Smelting Works at Denver*
Water color on paper, 13¾ x 16⅝ inches (34.9 x 42.2 cm.), 1892. The Cleveland Museum of Art, Bequest of Mrs. Henry A. Everett for the Dorothy Burnham Everett Memorial Collection. 38.56

Thomas P. Anshutz, 1851-1912
7 *Steamboat on the Ohio*
Oil on canvas, 27¼ x 48¼ inches (69.2 x 22 cm.), ca. 1896. Pittsburgh: Carnegie Institute, Museum of Art, Gift of the A. W. Mellon Educational and Charitable Trust.

Winslow Homer, 1836-1910
8 *New England Factory Life — "Bell-Time"*
Wood engraving, 9¼ x 13¹⁵/₁₆ inches (23.4 x 35.4 cm.), 1868, Foster 87. The Cleveland Museum of Art, Purchase from the J. H. Wade Fund. 42.1287

Paul Frenzeny, b. France, active 1868-ca. 1889; and Jules Tavernier, b. France, 1844-1899
9 *The Strike in the Coal Mines — Meeting of 'Molly M'Guire' Men*
Wood engraving, 11 x 15½ inches (27.9 x 39.4 cm.). *Harper's Weekly* XVIII (31 January 1874): 105. Lent by the Cleveland Public Library.

William Allen Rogers, 1854-1931
10 *The Pennsylvania Strike — Miners Calling a Meeting*
Wood engraving, 15½ x 11 inches (39.4 x 27.9 cm.). *Harper's Weekly* XXXII (21 January 1888): 45. Lent by the Cleveland Public Library.

Theodore Russell Davis, 1840-1894
11 *Our Centennial — President Grant and Dom Pedro Starting the Corliss Engine*
Wood engraving, 15½ x 11 inches (39.4 x 27.9 cm.). *Harper's Weekly* XX (27 May 1876): 421. Lent by the Cleveland Public Library.

G. W. Peters, active 1895-1910
12a *Excavation for the New Pennsylvania Railway Station*
12b *The Pennsylvania Station Excavation, at Seventh Avenue and Thirty-third Street, (Looking East)*
Facing halftone plates, 9⅜ x 6½ inches (23.8 x 16.5 cm.), reproduced in *Century Magazine* LXXIV (September 1907): 688, 689. Lent by the Cleveland Public Library

Joseph Pennell, 1857-1926
13 *Edgar Thompson Steel Works, Bessemer*
Etching, 11¹/₁₆ x 8 inches (28 x 20.3 cm.), 1908, Wuerth 517. The Cleveland Museum of Art, Bequest of James Parmelee. 40.781

Joseph Pennell
14 *Stock Yards, Chicago*
Etching, 9⁵/₁₆ x 12⁷/₁₆ inches (23.7 x 31.7 cm.), 1910, Wuerth 594. The Cleveland Museum of Art, Gift of Frederick Keppel & Co., Inc., for the Frederick Keppel Memorial. 18.108

Joseph Pennell
15 *Panama: The End of the Day, Gatun Lock*
Lithograph, 21¹³/₁₆ x 16¹⁵/₁₆ inches (55.3 x 42.9 cm.), 1912, Wuerth 226. The Cleveland Museum of Art, Gift of Myron T. Herrick. 21.431

Louis Orr, 1879-1966
16 *Ports of America: Great Lakes Ports: Buffalo*
Etching, 9¹/₁₆ x 7¹/₂ inches (23.1 x 19.1 cm.), ca. 1928. The Cleveland Museum of Art, Gift of Yale University Press in memory of Amasa Stone Mather. 29.128

Adolf Arthur Dehn, 1895-1968
17 *The Petroleum Age*
Ink and lithographic crayon on paper, 18 x 16½ inches (45.7 x 41.9 cm.), 1921. New York: Collection of Virginia Dehn.

Ben Shahn, b. Lithuania, 1898-1969
18 *For Full Employment After the War (Welders)*
Offset lithograph, 29¾ x 39⅜ inches (75.6 x 100 cm.), 1944. Trenton: New Jersey State Museum Collection, Gift of Circle F.

John Sloan, 1871-1951
19 *Wake of the Ferry, No. 1*
Oil on canvas, 26 x 32 inches (66 x 81.4 cm.), 1907. The Detroit Institute of Arts, Gift of Miss Amelia White, Santa Fe, N.M.

George Bellows, 1882-1925
20 *Pennsylvania Station Excavation*
Oil on canvas, 30¼ x 38¼ inches (76.8 x 97.2), 1909. The Brooklyn Museum, A. Augustus Healy Fund.

Henry Reuterdahl, 1871-1925
21 *Blast Furnaces*
Oil on canvas, 31½ x 40 inches (77.4 x 101.6 cm.), 1912. The Toledo Museum of Art.

Joseph Stella, b. Italy, 1877-1946
22 *Pittsburgh Night*
Charcoal on paper, 16 x 22 inches (40.6 x 55.9 cm.), 1920. Pittsburgh: Carnegie Institute, Museum of Art, Director's Discretionary Fund.

Carl Frederick Gaertner, 1898-1952
23 *The Pie Wagon*
Oil on canvas, 41⅝ x 60¼ inches (105.7 x 153 cm.), ca. 1926. The Cleveland Museum of Art, Gift of Mrs. Carl Gaertner. 53.371

Charles Demuth, 1883-1935
24 *Aucassin and Nicolette*
Oil on canvas, 23⁹/₁₆ x 19¹/₂ inches (59.8 x 49.5 cm.), 1921. Ohio: Columbus Museum of Art, Gift of Ferdinand Howald.

Louis Lozowick, b. Russia, 1892-1973
25 *Tanks #2*
Lithograph, 14⅝ x 9 inches (37.1 x 22.8 cm.), 1929. Smithsonian Institution, National Collection of Fine Arts, Museum Purchase.

Louis Lozowick
26 *Babylon to Omaha*
Lithograph, 12⅝ x 8⅛ inches (32 x 20.6 cm.), 1933. Ohio: Columbus Museum of Art, Thomas Ewing French Collection, Bequest of Janet French Houston.

Elsie Driggs, b. 1898
27 *Pittsburgh*
Oil on canvas, 34¼ x 40 inches (87 x 101.6 cm.), 1927. New York: Collection of Whitney Museum of American Art.

Charles Sheeler, 1883-1965
28 *River Rouge Industrial Plant*
Water color on paper, 8 x 11¼ inches (20.3 x 28.5 cm.), 1928. Pittsburgh: Carnegie Institute, Museum of Art, Gift of G. David Thompson.

Charles Sheeler
29 *Industrial Series No. 1*
Lithograph, 8³/₁₆ x 11³/₁₆ inches (20.8 x 28.3 cm.), 1928. The Cleveland Museum of Art, Gift of Mrs. Malcolm L. McBride. 53.567

Charles Sheeler
30 *Steam Turbine*
Oil on canvas, 22 x 18 inches (55.9 x 45.7 cm.), 1939. Youngstown, Ohio: The Butler Institute of American Art.

Thomas Hart Benton, 1889-1975
31a *Steel*
31b *City Building*
31c *Mining*
31d *The Changing West*
31e *Instruments of Power*
31f-g *City Activities*
Egg tempera and distemper on linen mounted on panels, from the series *America Today*, 1930/31. Each panel approximately 7½ x 9 feet. New York: New School for Social Research. Photoreproductions.

Thomas Hart Benton
32 *Going West*
Lithograph, 12⁷/₁₆ x 23½ inches (31.5 x 59.7 cm.), 1934. The Cleveland Museum of Art. The Mr. and Mrs. Charles G. Prasse Collection, Gift of Leona E. Prasse. 57.202

Jacob Burck, b. 1904
33 *The Lord Provides*
Lithograph, 12 x 9 inches (30.5 x 22.8 cm.), 1934. The Cleveland Museum of Art, Gift of Mrs. Malcolm L. McBride. 44.329

Thomas Hart Benton, 1889-1975
34 *Mine Strike*
Lithograph, 12 x 9 inches (30.5 x 22.8 cm.), 1933. The Cleveland Museum of Art, Gift of Mrs. Malcolm L. McBride. 44.332

William Gropper, 1897-1977
35 *Sweatshop*
Lithograph, 9½ x 12 inches (24.1 x 30.5 cm.), ca. 1933/34. The Cleveland Museum of Art, Gift of Mrs. Malcolm L. McBride. 44.334

Raphael Soyer, b. Russia, 1899
36 *Waterfront*
Lithograph, 8¹⁵/₁₆ x 13⁷/₁₆ inches (22.7 x 34 cm.), 1934. The Cleveland Museum of Art, Gift of Mrs. Malcolm L. McBride. 48.430

George Biddle, 1919-1973
37 *Sweatshop*
Left section from the fresco *Society Freed through Justice*, 13 x 10½ feet, 1935/36. Washington, D.C.: Department of Justice Building. Photoreproduction.

Nan Lurie, b. 1910
38 *Technological Improvements*
Lithograph, 18 x 11¾ inches (45.7 x 29.8 cm.), ca. 1935-39. The Cleveland Museum of Art, Lent by the WPA Art Program, Chicago. 1888.43

Frank D. Fousek, b. 1913
39 *Heritage of Smoke*
Aquatint and mezzotint, 10¾ x 6⅞ inches (27.3 x 17.4 cm.), ca. 1935-39. The Cleveland Museum of Art, Lent by the WPA Art Program, Ohio. 4105.42

Elizabeth M. Olds, b. 1896
40 *Steel Mills*
Lithograph printed in colors, 11⅜ x 17 inches (28.9 x 43.2 cm.), 1938. The Cleveland Museum of Art, Lent by the WPA Art Program, Chicago. 1939.43

Reginald Marsh, b. Paris, 1898-1954
41 *Locomotives Watering*
Tempera on panel, 24 x 36 inches (61 x 91.4 cm.), ca. 1932. The Cleveland Museum of Art, Gift of the Estate of Felicia Meyer Marsh. 79.64

Reginald Marsh
42a *The Harbor, the Skyline, and the Statue of Liberty*
42b *The Press Meeting a Celebrity*
42c *Tugs Warping the "Normandie" into Dock*
42d *Unloading the Cargo*
Fresco murals executed for a series in the New York Customs House, 1937. Each panel approximately 16 feet wide at base and 8 feet high. Photoreproductions.

Robert Lavin, b. 1919
43 *Teeming in the Open Hearth*
Oil on canvas, 28 x 37 inches (71.1 x 94 cm.), 1972. Huntington, N.Y.: Collection of the artist.

Rackstraw Downes, b. England, 1939
44 *The Coke Works at Clairton, Pa.*
Oil on canvas, 18⅛ x 46½ inches (46 x 118.1 cm.), 1975. Ardmore, Oklahoma: Collection of Mr. and Mrs. Jerome M. Westheimer.

H. N. Han, b. China, 1939
45 *Wilmington Factory*
Acrylic on canvas, 44⅞ x 66⅞ inches (114 x 169.9 cm.), 1973. New York: Collection of Holly and Horace Solomon.

Don Eddy, b. 1944
46 *BMW Showroom*
Lithograph, 20⅛ x 25⅛ inches (51 x 63.9 cm.), 1972. The Cleveland Museum of Art, Purchase, Dudley P. Allen Fund. 75.140

Comparative Illustrations

Figure 1. Charles Wilson Peale, 1741-1827. *Exhuming the First American Mastodon.* Oil on canvas, 50 x 62½ inches (127 x 158.8 cm.), 1806. Baltimore, Maryland: The Peale Museum, Gift of Mrs. Harry White in memory of her husband.

Figure 2. Joseph Wright of Derby, b. England, 1734-1797. *The Blacksmith's Shop.* Mezzotint after Derby by Richard Earlom, 24 x 17 inches (61 x 43.2 cm.), 1771. Harvard University, Fogg Art Museum, Bequest of Francis Calley Gray.

Figure 3. *View of Columbus O. from Capitol University.* Lithograph in colors, 20¹⁵/₁₆ x 39¹⁰/₁₆ inches (53.2 x 100.7 cm.), ca. 1867. Drawn and printed by E. Sachse & Company, published by J. T. Palmatary. The New York Public Library, Astor, Lenox and Tilden Foundations, Prints Division, I. N. Phelps Stokes Collection.

Figure 4. Thomas P. Anshutz, 1851-1912. *Ironworkers: Noontime.* Oil on canvas, 17 x 24 inches (43.2 x 61 cm.), 1880/81. Permission of The Fine Arts Museums of San Francisco, Gift of Mr. and Mrs. John D. Rockefeller 3rd.

Figure 5. Thomas P. Anshutz. *Steamboat on the Ohio.* Pastel on paper, 7½ x 11½ inches (19 x 29.2 cm.), ca. 1896. Greensburg, Pennsylvania: The Westmoreland County Museum of Art, William A. Coulter Fund.

Figures 6-8. Photographs of boys on the waterfront, probably by Thomas P. Anshutz. Smithsonian Institution, Archives of American Art, Thomas P. Anshutz Papers.

Figure 9. Frank E. Schoonover, 1877-1972. Untitled, illustrated in *McClure's Magazine* XX (February 1903): 45.

Figure 10. Adolf Arthur Dehn, 1895-1968. *Butadiene Storage Spheres.* Water color reproduced in *Lamp* XXVI (December 1943): 14.

Figure 11. William Glackens, 1870-1938. *The Old and the Young Stand Side by Side.* Illustrated in *Saturday Evening Post* CLXXVIII (19 May 1906): 13.

Figure 12. John Sloan, 1871-1951. *At Six o'Clock the Waves of People Sweep Across Broadway.* Illustrated in *Saturday Evening Post* CLXXIX (13 April 1907): 7.

Figure 13. G. W. Peters, American, active 1895-1910. *The Twentieth-Century Woman on a New York Ferry-Boat.* Illustrated in *Leslie's Illustrated Weekly,* no. 2689 (21 March 1907): 1.

Figure 14. Charles Demuth, 1883-1935. *Incense of a New Church.* Oil on canvas, 25¹/₂ x 19¹³/₁₆ inches (64.8 x 50.3 cm.), 1921. The Columbus Museum of Art, Gift of Ferdinand Howald.

Figure 15. Louis Lozowick, b. Russia, 1892-1973. *Butte.* Oil on canvas, 30 x 20 inches (76.2 x 50.8 cm.), 1926/27. Smithsonian Institution, Hirschhorn Museum and Sculpture Garden.

Figure 16. Charles Sheeler, 1883-1965. *Classic Landscape.* Oil on canvas, 25 x 32½ inches (64 x 82 cm.), 1931. Michigan: Grosse Pointe Farms, Estate of Mrs. Edsel B. Ford.

Figure 17. Mary Keys, unknown. *Lock Port on the Erie Canal.* Water color, 15¼ x 20¼ inches (38.7 x 51.5 cm.), 1832. Utica, New York: Munson-Williams-Proctor Institute.

Figure 18. Kenyon Cox, 1856-1919. *Science Instructing Industry.* Oil on canvas, 24 x 29 inches (61 x 73.7 cm.), 1898. Cleveland: Case Western Reserve University.

Figure 19. Edward Laning, b. 1906. *Laying the Rails for the Union Pacific.* Oil on canvas, this section approximately 9 x 22 feet, 1937. New York: Ellis Island, Alien's Dining Room.

Figure 20. Idelle Weber, b. 1932. *Livery.* Oil on canvas, 33 x 73 inches (83.8 x 185.4 cm.), 1978. New York: Collection of O. K. Harris Works of Art.

Figure 21. Martin Hoffman, b. 1935. *Press.* Acrylic on canvas, 60 x 80 inches (52.4 x 203.2 cm.), 1973. University of New York at Potsdam, Art Gallery.

Figures 22a-d. Jack Beal, b. 1931. *The History of Labor in America.* Oil on canvas, four panels, each 12¼ x 12½ feet, 1977. Washington, D.C.: Frances Perkins Building.

Selected Bibliography

Baigell, Matthew. *Thomas Hart Benton.* New York: Harry N. Abrams, 1973.

Baur, John I. *Revolution and Tradition in Modern American Art.* Cambridge, Mass.: Harvard University Press, 1951.

————. "The Machine in American Art." *Art in America* LI (August 1953): 49-52.

Braider, Donald. *George Bellows and the Ashcan School of Painting.* Garden City, N.Y.: Doubleday & Co., 1971.

Brown, Milton W. *American Painting from the Armory Show to the Depression.* Princeton, N.J.: Princeton University Press, 1955.

Cantor, Jay E. "The New England Landscape of Change." *Art in America* LXIV (January/February, 1976): 51-54.

Cheney, Sheldon. *Art and the Machine: An Account of Industrial Design in Twentieth-Century America.* New York: McGraw-Hill, 1936.

Cilovsky, Nicolai, Jr. "George Inness and the Hudson River School: The Lackawanna Valley." *American Art Journal* II (Fall 1970): 36-57.

Ekirch, Arthur Alphonse, Jr. *The Idea of Progress in America, 1815-1860.* New York: Columbia University Press, 1944.

Friedman, Martin. *Charles Sheeler.* New York: Watson-Guptill Publications, 1975.

————. *The Precisionist View in American Art,* exh. cat. Minneapolis: Walker Art Center, 1960.

Hills, Patricia. *The Working American,* exh. cat. Washington, D.C.: Smithsonian Institution, 1979.

————. *Turn-of-the-Century America,* exh. cat. New York: Whitney Museum of American Art, 1977.

Hunter, Sam, and Jacobus, John. *American Art of the 20th Century.* New York: Harry N. Abrams, 1973.

Jacob, Mary Jane, and Downs, Linda. *The Rouge: The Image of Industry in the Art of Charles Sheeler and Diego Rivera.* Detroit, Mich.: Detroit Institute of Arts, 1978.

Jaffe, Irma B. *Joseph Stella.* Cambridge, Mass.: Harvard University Press, 1970.

Jones, Alfred Haworth. "The Search for a Usable American Past in the New Deal Era." *American Quarterly* XXIII (December 1971): 710-24.

Klingender, Francis D. *Art and the Industrial Revolution.* Rev. and ed. by Arthur Elton. New York: Schocken Books, 1970.

Kouwenhoven, John A. *Made in America: The Arts in Modern Civilization.* Garden City, N.J.: Doubleday & Co., 1948.

Leuchtenburg, William E. *The Perils of Prosperity, 1914-32.* Chicago, Ill.: University of Chicago Press, 1958.

Marx, Leo. *The Machine in the Garden.* New York: Oxford University Press, 1964.

Morison, Samuel Eliot; Commager, Henry Steele; and Leuchtenburg, William E. *A Concise History of the American Republic.* New York: Oxford University Press, 1977.

Nochlin, Linda. "The New Realists," in *Realism Now,* exh. cat. Poughkeepsie, N.Y.: Vassar College Art Gallery, 1968.

Novak, Barbara. *American Painting of the Nineteenth Century: Realism, Idealism, and the American Experience.* New York: Praeger Publishers, 1969.

Perlman, Bennard B. *The Immortal Eight: American Painting from Eakins to the Armory Show (1870-1913).* New York: Exposition Press, 1962.

Scott, David W., and Bullard, E. John. *John Sloan: 1871-1951.* Washington, D.C.: National Gallery of Art, 1971.

Seitz, William C. "The Real and the Artificial: Painting of the New Environment." *Art in America* LX (November 1972): 58-72.

Sweeney, J. Gray. *Themes in American Painting,* exh. cat. Grand Rapids, Mich.: Grand Rapids Art Museum, 1977.

Taylor, Joshua C. *America as Art,* exh. cat. Washington, D.C.: National Collection of Fine Arts, 1976.

von Saldern, Axel. *Triumph of Realism: An Exhibition of European and American Realist Paintings, 1850-1910,* exh. cat. Brooklyn, N.Y.: Brooklyn Museum, 1967.

Wecter, Dixon. *The Age of the Great Depression, 1929-1941.* New York: Macmillan, 1948.

Weisberg, Gabriel P. *The Realist Tradition: French Painting and Drawing, 1830-1900,* exh. cat. Cleveland, Ohio: Cleveland Museum of Art, 1980.

Zabel, Barbara Beth. "Louis Lozowick and Technological Optimism of the 1920s." Ph.D. diss., Charlottesville, Va.: University of Virginia, 1978.

Themes in Art Series

This volume is one of a series of paperback books about art, art history and artistic expression published by the Art History and Education Department of The Cleveland Museum of Art under the general editorship of Dr. Gabriel P. Weisberg, curator of art history and education. These books are available at The Cleveland Museum of Art or through Indiana University Press, Bloomington, IN 47405.

American Folk Art: From the Traditional to the Naive by Lynette I. Rhodes. 120 pp., 88 b&w illus., 6 color plates, 8½ x 7¼ inches, 1978. LC 77-9240, ISBN 0-910386-42-0.

The Artist and the Studio in the Eighteenth and Nineteenth Centuries by Ronnie L. Zakon. 68 pp., 40 b&w illus., color cover, 8½ x 7½ inches, 1978. LC 78-51885, ISBN 0-910386-40-4.

Between Past and Present: French, English and American Etching 1850-1950 by Gabriel P. Weisberg and Ronnie L. Zakon. 76 pp., 49 illus., 8½ x 7¼ inches, 1977. LC 76-53113, ISBN 0-910386-33-1.

Chardin and the Still-Life Tradition in France by Gabriel P. Weisberg with William S. Talbot. 94 pp., 77 b&w illus., 4 color plates, 8½ x 7¼ inches, 1979. LC 79-63386, ISBN 0-913086-51-x.

The Drawings and Water Colors of Léon Bonvin by Gabriel P. Weisberg, with an essay by William R. Johnston. 64 pp., 43 b&w illus., 5 color plates, 8½ x 7¼ inches, 1980. LC 80-20902, ISBN 0-910386-62-5.

Idea to Image: Preparatory Studies from the Renaissance to Impressionism by Mark M. Johnson. 84 pp., 96 b&w illus., 8½ x 7¼ inches, 1980. LC 79-93194, ISBN 0-910386-58-7.

In the Nature of Materials: Japanese Decorative Arts by Marjorie Williams. 48 pp. 8¾ x 11 inches, 33 b&w illus., 1977. LC 76-51970, ISBN 0-910386-32-3.

Materials and Techniques of 20th-Century Artists by Dee Driscole and Dorothy Ross, under the guidance of Gabriel P. Weisberg, Andrew T. Chakalis, Karen Smith, and June Hargrove. 48 pp., 31 b&w illus., 7½ x 9 inches. 1976. LC 76-29167, ISBN 0-910386-37-4.

The Public Monument and Its Audience by Marianne Doezema and June Hargrove. 72 pp., 62 b&w illus., 8½ x 7¼ inches, 1977. LC 77-25428, ISBN 0-910386-38-2.

Science within Art by Lynette I. Rhodes. 72 pp., 48 b&w illus., color cover, 8½ x 7 inches, 1980. LC 79-93193, ISBN 0-910386-57-9.

A Study in Regional Taste: The May Show 1919-1975 by Jay Hoffman, Dee Driscole, and Mary Clare Zahler. 72 pp., 70 b&w illus., 8½ x 7¼ inches, 1977. LC 77-78145, ISBN 0-910386-36-6.